TYPE*Sense*

MAKING SENSE OF TYPE ON THE COMPUTER

SECOND EDITION

SUSAN G. WHEELER
GARY S. WHEELER

Prentice
Hall

Upper Saddle River, New Jersey 07458

Library of Congress Cataloging-in-Publication Data

Wheeler, Susan G.
 Typesense: making sense of type on the computer/Susan G. Wheeler, Gary S. Wheeler.-2nd. ed.
 p. cm
 Includes bibliographical references and index.
 ISBN 0-13-021804-9
 1. computerized typesetting. 2. Computerized typesetting - United States. I. Title: Type sense. II. Wheeler, Gary S. III. Title

Z253.3 .W48 2001 00-027099
686.2'2544-dc21

Publisher: Bud Therien
Editorial Assistant: Wendy Yurash
Production Editor: Joe Scordato
Prepress and Manufacturing Manager: Nick Sklitis
Cover Design: Bruce Kenselaar

This book was set by the author in 10/13 Minion and was printed and bound by Courier Companies, Inc. The cover was printed by Phoenix Color Corp.

© 2001 by Prentice-Hall, Inc.
Upper Saddle River, New Jersey 07458
© 1996 by International Thomson Computer Press

Printed in the United States of America
10 9 8 7 6 5 4 3 2 1

ISBN 0-13-021804-9

Prentice Hall International (UK) Limited, *London*
Prentice Hall of Australia Pty., *Sydney*
Prentice Hall Canada Inc., *Toronto*
Prentice Hall Hispanoamericana, S.A., *Mexico*
Prentice Hall of India Private Limited, *New Delhi*
Prentice Hall of Japan, Inc., *Tokyo*
Pearson Education Asia Pte. Ltd., *Singapore*
Editoria Prentice-Hall do Brazil, Ltda., *Rio de Janeiro*

CONTENTS

FOREWORD

Four years ago, when I discovered the first edition of Susan and Gary Wheeler's *TypeSense: Making Sense of Type on The Computer,* I wrote: "*TypeSense* is one of those rare books that provides pleasurable bedside reading yet belongs within reach of your computer."

Everything I said in my review of the first edition is even truer today. The second edition of *TypeSense* is significantly better than the first. The strengths of the original version remain; it's just that there's more to enjoy and more to learn from. There are more examples, more thought-provoking quotes and expanded sections on topics like line spacing and mixing typefaces. Nevertheless, the second edition retains the first edition's informal, conversational writing style. This is a warm and friendly book that reads like a conversation with a good friend.

Like the first edition, the second edition of *TypeSense* is tightly organized and exquisitely laid out. Topics are introduced in a logical order, proceeding from global to specific. Its layered page layout combines numerous examples presented in a way that prevents the illustrations from interfering with continued reading, like its predecessor (quoting again from my original review):

> *TypeSense* provides enough of a historical perspective to show you where type came from, but avoids unnecessary concentration on the past. It's one of the few type books that constantly emphasizes the environment that type is used in. Instead of viewing type as an end in itself, type is viewed in the context of message content.

TypeSense begins with the "grand scheme" and works its way logically through pages, paragraphs, sentences and letters. Along the way, it describes and shows the importance of carefully controlling the nuances of typography, emphasizing how minute changes in letter and line spacing can make major differences in a publication's appearance and readability.

As I previously wrote in a review of the first edition, "Because of its superb organization and in-depth content, you can quickly turn to *TypeSense* for advice on the smallest details of hyphenation, punctuation, letter spacing and fractions." Without losing its essential warmth and "humanness," the second edition of *TypeSense* contains an encyclopedia of information about the subtlest points of typography.

Perhaps the best story I can tell regarding the second edition is that, during the month since I received a pre-publication proof of it, I've read it from cover to cover with pleasure on three separate occasions—and learned something new each time.

The second edition of *TypeSense* is a timeless classic. In an era of disposable computers and disposable computer books, *TypeSense* is a carefully crafted and beautifully produced book you'll keep long after you discard your current computer—and even its next two replacements. *TypeSense* is for you regardless of whether you're a teacher, a student, or simply someone who wants to make your message emerge as clearly and transparently as possible.❧

Roger C. Parker
Dover, NH

Over a million and a half readers throughout the world own copies of books written by Roger C. Parker, including the classic *Looking Good in Print: A Guide to Basic Design for Desktop Publishing*. His books have been translated into over 37 languages.

INTRODUCTION

&

THE NEW
COMPUTER
TYPOGRAPHER

Since the early 1980s the explosive growth in the development and use of graphics, page-layout, and multimedia computer applications has put type and typesetting capabilities in the hands of more people than ever before. Keyboards are everywhere. Graphic designers, accustomed to sending their type to professional typesetters before preparing finished art, and typists, accustomed to preparing typed copy as finished documents, converged in the microcomputer arena with access to identical hardware and software. Misconceptions confused everyone. The computer's ability to create professional-quality newsletters, brochures, product catalogues, and advertisements without the apparent need for a professional eye helped these misconceptions grow.

Somewhere in the flurry of *new*-ware excitement, every computer user's ability to create these same product catalogues and brochures was assumed. The professional turf of typesetters, designers, and layout artists was trampled in a rush to get the fastest processor, the biggest color monitor, and the latest software upgrade. Questions often heard included: Did you get 2.0 yet? What is it like? Do you need to read the manual?

Granted, there is extensive computerized assistance available for the fledgling designer, writer, or illustrator using the latest *art*-ware. Software manufacturers include automated features, such as on-line help, in their products, or offer specialized software, such as clip art and templates, to assist computer users in making decisions outside their primary area of

expertise. Design templates provide professionally designed page formats to the desktop publisher unfamiliar with page-layout principles. Software grammar checkers and composition prompts aid the unpracticed writer by flagging common errors and assisting with composition development. Clip art offers the computer user with modest drawing skills an array of illustrations and graphics suitable for most generic visual text enhancements.

But what of type? What about all those letters, symbols, figures, and punctuation marks hidden beneath all those keys on the keyboard? What software support or typography checker identifies and corrects common typography and typesetting errors? What on-line help answers these questions: Of the five dashes available, which one goes here? Where is that dash located?

Before the computerization of the workplace, graphic designers, commercial artists, editors, and others knew their way around a type case and would specify type styles, sizes, and characters for a professional typesetter to use. In addition, the typesetter automatically converted some typewriter nomenclature into typeset characters. The double hyphen that isolates a phrase at the end of a sentence, for example, was converted to an em dash when typeset. A good typesetter knew what to do without being asked.

Typesetters, the professional artisans who passed their skills along to the next generation of typesetters through daily example and mentoring, knew the rules of hyphenation for line breaks, knew when to insert ligatures in typeset copy, and knew which of the five dashes to use (and where to find them). In all the currently available software and hardware, where is the accumulated knowledge of the professional typesetter? When did their expertise with type, their *type sense*, get programmed into page-layout, graphics, and word-processing applications? Do all keyboard-savvy computer users know this inherently?

Everyone who uses a keyboard professionally needs type sense. Type sense is to placing letters on a page as common sense is to growing up. It is a graphic designer's educated seventh sense, right after the sixth one. Where is it learned? Is it really needed? In the past, when a company needed a brochure, advertisement, or flyer, the project was given to an artist—a commercial artist. The job titles varied, but a brochure fell within the purview of an artist. It was hands off for everyone else. "Why, I can't even draw a straight line!" was a common refrain. The brochure was routed to an artist who designed it, specified the type, and sent it to a type professional—without question. Artists had the education and

training to make visual decisions regarding design, graphics, color, and type. Artists had the visual sense, the color sense, and the type sense necessary for those jobs. After all, they could draw a straight line!

In the current computerized work environment, the strict lines of responsibility that connected the manufacturer to the marketing director to the art director have blurred. Computer users sit in front of computers burgeoning with software capable of executing tasks across many professional specialties. Where are the mentors to sit by their sides and pass along their experience through words and by example? For the computer artist, where is the typesetter from the local foundry when it is time to choose that dash or even find all of them? (They do not even appear on the keyboard.)

<center>ℬ</center>

TODAY THERE IS A NEW BREED of professionals working across multiple disciplines, using all their common sense to make decisions in unfamiliar specialties, connected by nothing more than their need to get the job done—in a hurry. When the job includes type, whether for a sales catalogue, newsletter, or flyer, the keyboard-savvy professional needs the skills of an artist when making visual decisions on the page and the type sense of a typesetter when making type decisions within every sentence, in every paragraph, and on every document page.

For this professional, this new *type artist,* working with type on a computer *is* typesetting. Typefaces purchased for the administrative assistants in the corporate headquarters are the same faces purchased for the professional typesetters in the local type houses. The new computer type artists may not sit in type houses, but they use the hardware and software of those typographers who do. It is time all type artists knew what the keys beneath their fingers can do.

FROM THE
FOUNDRY
TO THE
COMPUTER

Tʏᴘᴏɢʀᴀᴘʜʏ ɪꜱ ᴛʜᴇ ᴀʀᴛ and process of working with and printing from type. Creating type, arranging type, designing type—all fall within its scope. In the discipline of typography there are two major categories of practitioners: those who produce type and those who set type. Type producers create objects, forms, or computer files from which letters are re-created. High-quality type produces distinctive and legible letters (as well as symbols, figures, and punctuation marks) each time it is used. These letters are consistent in style and structure. Typesetters work with and arrange type to create readable words and paragraphs on a page. They pursue typographic quality. Their pages of type are easy to read, uniform in color, and enhance, not confuse, the message contained in them. To attain typographic quality, typesetters need legible, reusable letters and symbols in a variety of styles. They also need control of the horizontal space between letters in a word or a line (*letterspacing*) and control of the vertical space between lines within and between paragraphs (*leading* or *line spacing*). All three factors aid or hinder a typesetter's ability to achieve a high level of typographic quality. Most often, the work and goals of both type producers and typesetters intersect.

At the time of Gutenberg's invention of the first practical reusable type in 1454, typography was perceived by its practitioners as an invisible art form. Type (and the letters it re-created) was a vehicle that delivered someone else's message and did not detract from it. Gutenberg's first type was designed to look like handwriting. Readers, accustomed to

Typography … remains a difficult, subtle, and exacting art. And even though a certain degree of technical skill is relatively common, typographic mastery is the province of the perceptive and the prerogative of the few.

——————————— Rand
Design, Form, and Chaos

Alphabet *A set of letters or other characters (arranged in a customary order) with which one or more languages are written.*

Typeface *The distinctive, visually unifying design of an alphabet and its accompanying punctuation marks and numbers. It includes all point sizes of that typeface.*

Type family *All stylistic variations of a single typeface, such as light, medium, bold, extra bold, and italic.*

Font *All the letters, numbers, and punctuation marks of one size of one specific typeface, for example, 12-point Minion Semibold.*

handwritten books, would have viewed with suspicion the new typeset books with foreign-looking letterforms. Typeset copy that re-created a handwritten appearance made readers comfortable with what they saw.

Today's typeset copy continues this role as message bearer. After finishing a novel, a reader is not likely to praise the type designer for a legible typeface—consistent in style and structure. Nor would the reader praise the typesetter for the page's typographic quality—uniform in color with skillfully crafted line breaks. Instead, the reader might compliment the author on the clarity of the content or the cleverness of the prose. *Type? What about it?* Type in this example achieved functional invisibility. Well-set type delivers an author's ideas and thoughts with a clarity of voice equal to that of a skilled orator. Poorly set type decreases readability, garbling the message like a speaker mumbling to the floor, and increases the chance the text will not be read at all.

In the four hundred years following Gutenberg's invention, type producers and typesetters were separate artisans. Each practiced a craft that demanded skilled knowledge of specific tools, materials, production techniques, and aesthetic principles. As Gutenberg's methods were refined and as the craft of typography evolved, the interests of these two artisans influenced one another. The materials of type limited or enhanced the typesetter's abilities. For example, the range of typefaces available in the late fifteenth century was limited in part by what images were possible to cast from a metal alloy. Foundry type production techniques could not achieve the halftone typefaces available with the phototypography production techniques of the 1960s. In addition, phototypesetting techniques freed typesetters from the limited control of letterspacing and line spacing of their linecasting typesetting machines of the early 1900s.

Today's digital type technology for type production and typesetting involves computer programming languages, computer applications, and electronic hardware. The typographic quality achieved by digital typesetters is affected by hardware resolution, software interfaces, application capabilities, and the functional characteristics of available digitized typefaces. Digital typography involves many components. Poor typographic quality can result from hardware problems, software problems, interface problems, human problems, or combinations of any and all. Today's type artist cannot achieve typographic quality without knowledge of both aspects of the discipline—type production and typesetting.

The current vocabulary of type is an amalgamation of all the type production and typesetting methods from Gutenberg's time forward. The word *leading,* which once referred to the lead material used in a typesetting procedure, now refers to the *visual* result achieved by the lead strips used in that original procedure. For today's type artist, who might be unfamiliar with type's history, using the name of an inert metal as a term to describe the horizontal white space beneath letters on a glowing cathode-ray tube may be confusing or unfamiliar (and hard to remember). Although the materials and type-production techniques have changed, typesetting principles are the same. The terminology describing them is rooted in techniques and developments of the past.

Display type *Type set in 14-point or larger, used for headlines, titles, and similar attention-getting situations.*

Text type *Type set below 14-point, used in advertisements, books, newsletters, and other continuous-reading situations.*

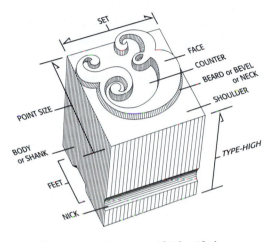

FIGURE 1-1: *Type sort with identified components*

JOHANN GUTENBERG OF MAINZ, GERMANY, is recognized as the inventor of the first practical, movable, reusable type (c. 1454). Gutenberg was an entrepreneur, an engraver, and a goldsmith. All his characteristics came to bear on his invention—the development of a metal-casting technique for reproducing pieces of hard, durable metal type, called *foundry type.* Gutenberg's foundry type was cast from a metal alloy of lead, tin, antimony, and copper. Each piece of foundry type (fig. 1-1), called a *sort,* represented a single character in a type font. While the English-language alphabet consists of 52 letters (upper- and lowercase), a typical foundry type font with figures, punctuation marks, spaces, ligatures, and alternate characters could include 150 sorts. Gutenberg's first type font contained over 300 sorts. He felt many unique characters

METAL TYPE

and ligatures duplicating the flourishes and distinctive character of handwriting were needed to assure acceptance by his readership.

FOUNDRY TYPE

WILLIAM CAXTON
(1421–91)
English merchant-diplomat turned printer. In 1476 established the first printing house in England to produce English-language books. His interest in printing was an extension of his work translating French literature into English for the Duchess of Burgundy.

≈

ALDUS MANUTIUS
(1450–1515)
Venetian printer, typographer, and businessman. Collaborated with Francesco Griffo to produce typefaces, such as Bembo. His work influenced type designers throughout Europe. Printed more than 1,200 book titles.

≈

FOUNDRY TYPE WAS THE PRIMARY MEANS of setting type through 1890. Individual fonts were kept together in a shallow drawer, called a *type case*. Each case was divided into small compartments, one for each font character. A compartment's size and location were standard, determined by frequency of use. A skilled typesetter quickly selected letters and spaces from the case by hand and positioned them (from right to left and upside down) in a metal composing stick (fig. 1-2), set to the proper line length, held in his other hand. When a single type line was complete, a thin strip of lead was placed on top of it. The lead strip ran the length of the type line and separated one line from the next. The lead was only as high as the type body, so it was not high enough to contact the inking roller and did not print. Leading (available in different thicknesses) enhanced readability by isolating lines of type between the horizontal bands of white space it created on the page. Type set without leading was *set solid*—solid type, no leads.

After filling the composing stick with several lines of type, the typesetter transferred the type to a larger type tray, called a *chase*. This procedure was repeated several times until the entire page was set and the chase contained all the required sorts. Once all the type was positioned correctly, the typesetter locked down the chase to prevent the type from moving out of position. Copies of the type, or *proofs*, were

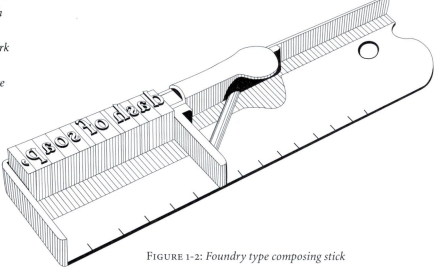

FIGURE 1-2: *Foundry type composing stick*

made on a proofing press by running an inked roller across the face of the type, laying paper on top of the inked type, and applying even pressure. The procedure transferred the inked letterforms to the paper. Foundry type was developed to withstand repeated impressions and to produce crisp, accurate letterforms.

Letterspacing in foundry type had limited flexibility. The amount of space on either side of a letter was determined by the width, or *set,* of the type's body. If adjacent faces were too close together, the typesetter would insert a thin space (or hair space) between them. If a pair of letters was too far apart, the solution was not so simple. With the type's set predetermined, moving two letters closer required carving away some of the type's metal body. Typesetters were unwilling to permanently alter sorts, unless they were for display type, where letterspacing problems would be more visible. Such alterations for text type were not usually cost-effective. For the most frequent problem letter pairs, however, type designers developed ligatures. A *ligature* was a single character (and a single sort) created from the physical union or the designed alteration of two separate letters. Ligatures for the letters *f-f-i, f-f-l, f-f, f-i,* and *f-l* were common, and still are. Improving text letterspacing using ligatures was faster than altering each offending sort.

Another solution for tight, adjacent letters was actually to extend the portion of the letter (the lowercase italic letter *f* was the usual recipient of this treatment) beyond the body of the type. The sort for such an overly friendly letter contained a kern. The *kern* was the portion of a letter that extended beyond the type body. When the lowercase *f* was positioned adjacent to a lowercase *o* for example, the *o*'s body supported the *f*'s kern. The kern had to be supported or it would break under the pressure of the proofing press. Removing letterspacing from between letters in foundry type required customized sorts, but there was a limit to how many a type founder would include in a font.

GUTENBERG'S FOUNDRY TYPE TECHNIQUE survived without major revision until the end of the nineteenth century when various parts of the process were mechanized. As foundry type production became more mechanized, foundry typesetting came under scrutiny for a mechanized alternative as well. In 1884, Ottmar Mergenthaler invented a typecasting system that challenged the use of hand-set foundry type for text composition. Mergenthaler's Linotype linecaster enabled operators to enter copy using a typewriter-style keyboard. The linecaster operator

Baseline *The imaginary horizontal line upon which all typeset letters appear to stand or rest.*

Roman *A letterform that is at right angles to the baseline.*

Italic *A letterform that is structurally redesigned from its roman origin to slant to the right at varying angles as it rests on the baseline.*

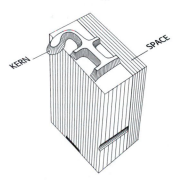

Foundry type sort with kern and word space

CAST TYPE

CLAUDE GARAMOND
(c. 1490–1567)
*French type designer and
punch cutter. Credited with
establishing the first type foundry
where type was designed, produced,
and sold. Designed italic typefaces
to complement roman type and
established type family
relationships.*

≈

WILLIAM CASLON I
(1692–1766)
*British patriarch of
influential type-founding family.
Started as a gun-barrel engraver.
Caslon typeface became the
British printing standard after its
introduction in 1725. Used for the
first printings of the Declaration
of Independence and the
Constitution of the United States.*

≈

PHOTOTYPOGRAPHY

controlled all typesetting and typecasting operations within the type-setting machine from in front of the keyboard.

With each keystroke, a lightweight reusable letter matrix, or *mat*, dropped from its place within the *magazine* (compartment of matrices) located above the typesetter's head. A metallic tinkling sound accompanied each matrix as it made its way from the magazine to the assembling line. Once all the matrices and spaces were in place on the line, the operator flooded the matrices with molten lead, creating a single line of type, or *slug.* After the slug cooled, the slug and matrices separated. The slug moved into position in the *galley* (similar to a foundry type chase) and the matrices returned to the magazine. When making corrections, the Linotype operator would recast an entire line and replace the original slug with the corrected one. While the linecasting procedures sound logical, it was a mechanical marvel that all steps were accomplished within a single, although ungainly looking, machine whose operator sat in front of a keyboard.

Several type manufacturers developed typecasting machines by mechanizing different stages of the typesetting procedure; these included the Monotype and the Ludlow casting machines. Typefaces designed for use in typecasters were more stylistically limited than their foundry type predecessors. Letters could not extend beyond the edge of the type body. The delicate handling required by a kern, for example, was impractical with these typecasters. The set of an italic *f,* for example, was more narrow than its foundry type counterpart. These design differences enabled foundry type to continue as an alternative form of typesetting for display (since linecasters seldom set type above 14 points) and for text typesetting. Although foundry typesetting was slower, the technique produced higher typographic quality when set by an experienced typesetter and remained in demand for some text jobs. Mechanized linecasters became the standard for jobs where speed was paramount, such as setting newspapers.

BOTH FORMS OF METAL TYPE, foundry and cast, coexisted for more than seventy years without a major challenge to their production techniques. During this period, typesetters worked within the limitations of both. Although handsetting made it more expensive, foundry type provided clear reproductions of a wide variety of typefaces that were suitable for display type. Cast type provided speed for setting type. Its shortcomings—standardized letterspacing and type design limitations—were offset by the increased speed for setting large quantities of

text. In the 1950s, interest grew in an otherwise overlooked type production technique—phototypography. Phototypesetting exceeded the speed of the linecasters and its range of type designs and letterspacing controls went far beyond that of foundry type.

Phototype production simplified the lengthy production process required for making foundry sorts or linecaster matrices. As long as an artist could draw the typeface on paper, it could be converted to a font—as film. A phototypesetter used a single film font to reproduce a single letter thousands of times. If the film font was not scratched or similarly damaged and if the components of the photomechanical process remained clean and regularly maintained, the type set was crisp and true.

Although phototypography currently is taking the brunt of the competition from the next development in typographic history—digital typography—this technique is still in use. While phototypesetting machine designs vary from manufacturer to manufacturer, the principle for setting phototype is the same. Phototypesetting uses a light source, a film font, a lens and/or a prism, light-sensitive photographic paper, and chemical developer. The film font is a film negative—the letterforms are clear and the remaining areas are solid black. Light passes through the clear letter shape and exposes that area on the photographic paper. Lens and prisms inserted between the film and the light-sensitive paper change the style, size, and weight of the projected letter image.

After the typesetter exposes all the letters on the paper, the paper is placed in a chemical bath for developing. The chemical developer changes the exposed areas to solid black, and the unexposed areas (protected by the black film) remain white.

In some display phototype systems, the operator positions and exposes each letter individually on the photographic paper after inserting the proper lens for letter style, size, or weight. Such precise operator-controlled letterspacing enables the artist to specify, or experiment with, unique letterspacing treatments. An operator can position a letter at any distance from another letter, at varying distances from another letter within the same word, or on top of another letter. As with metal foundry type, such labor-intensive typesetting is more costly.

The faster keyboarded phototypography systems use sizes ranging from 4 to 36 points, depending on the manufacturer. Setting the type employs two different procedures—entering the copy and formatting codes, and setting the type. First the operator enters the copy on a keyboard and proofs it on the display screen. All type formatting codes,

JOHN BASKERVILLE
(1706–75)
English printer and typographer. A perfectionist, he designed his own printing press, made his own ink, and devised a method, called hot pressing, for making paper smooth. All this was necessary to print his fine-stroked types. Although criticized by many of his contemporaries, Baskerville's printing improvements had a profound effect on the industry's future.

≈

PIERRE SIMON FOURNIER
(1712–68)
French punch cutter, typographer, and printer. Developed a point system for measuring type used for printing music in 1735. This was the first numerical type-sizing system. Fournier's point measured 0.0137 inch. Designed and cut 147 original alphabets.

≈

Françols-Ambroise Didot
(1730–1804)
Member of a famous French family
of printers and type founders.
Revised Fournier's point system for
measuring type. Developed in 1785,
the Didot point (0.01483 inch)
currently used on the
European continent.

≈

Giambattista Bodoni
(1740–1813)
Italian printer, type designer, and
typographer. Approached
typographic printing as a means to
create art, rather than to
communicate a written message.
An admirer of Baskerville's,
Fournier's, and Didot's work,
Bodoni cut one of the first
modern typefaces.

≈

William Morris
(1834–96)
British designer and writer.
A driving force in the Arts and
Crafts movement of the nineteenth
century. He devoted his later years
to reviving typographic quality in
printing and type design.

≈

or instructions, for the job, such as size, letterspacing, leading, and style, are typed in also. The keyboard operator saves the copy and codes to a disk, cassette, or paper tape (depending on the manufacturer). The operator then inserts the disk into a separate typesetting machine and checks that the required typefaces are installed in the machine. Some typesetting jobs are limited to a maximum number of faces due to the machine's storage capacity.

Once initiated, the type is set according to the information on the disk, using a mechanized phototypesetting procedure. Following the information on the disk, the machine locates a letter on the film, sets the lens for the required size or weight, sets the prism to position the letter correctly on the paper, and triggers a light burst. The projected letter shape of light passes through the lens and the prism and exposes the photographic paper. Once every letter is exposed, the machine sends the paper through a chemical bath to develop the image on the paper. The set type emerges from the typesetting machine as black letters on white paper (or film, if available).

Phototypography was viewed originally as only an alternative means of setting type, but designers soon realized that phototypography offered an alternative means of *using* type. New capabilities, such as letter distortion and infinite control of letterspacing, caused designers to take another look at type and triggered a new form of graphic expression. Designers used type as an illustrative component, a graphic element, and a means of visually conveying an idea. Master type designer Herb Lubalin (1918–81) was part of a typographical movement in the 1960s that began probing the previously unexplored uses of type.

The ease with which phototype was produced gave new life to the decorative and novelty typeface designs of the 1800s and the wooden typefaces popular from 1830 to 1870. New typefaces were made from any object (animal, vegetable, or mineral), any substance, any geometric or organic design element, and from any vantage point. This explosion of interest in type prompted the foundation of the International Typeface Corporation (ITC) in 1970. At the outset, ITC was set up to coordinate typeface development and to offer type designers financial and artistic protection for their designs. While ITC was successful with its first goal and initiated a typeface revival of sorts, the goal of type design protection was more elusive.

Piracy continues to plague type designers. There is no provision in the current law enabling typeface designers to receive a copyright for their work. A trademark can be given to the name of a typeface, but the

letterforms themselves are unprotected. As technology continues to improve, type designers continue to denounce the pirating of their designs. A foolproof solution is still not available today.

EVERY SUCCEEDING TECHNOLOGY for type production and typesetting has added new possibilities for type and artistic expression. Each also has built on the foundation of goals common to all, such as legibility and readability of text and language, effective communication, and a desire to transparently provide the vehicle connecting writer to reader. The Monotype linecasting machine relied on the manual placement of matrices before casting a line of type. Early phototypesetting machines, such as the Intertype Fotosetter, looked and operated remarkably like Mergenthaler's Linotype linecasting machine. Matrices were dropped into position and were exposed line-by-line on photographic paper.

Transition from one typesetting technology to another proceeds smoothly if what is *new* operates similarly to what is *old*. This similarity minimizes the operator's decrease in productivity by forming a bridge from what was to what is. Before digital typography became available to a new breed of typesetter (the type artist) in the early 1980s, computerized typesetting machines used digital font descriptions from which to expose letter shapes on photographic paper.

Digital typography is the last step in a journey that brought typesetting capabilities from the foundry to the computer screens of type artists in studios and offices. Today's type artists follow a tradition of typographic principles previously passed along to succeeding generations of typesetters by skilled typographers working in type foundries. Today's type production techniques influence the typographic quality these type artists strive to attain. Understanding how computer and printer technology transfer type from the screen to the printed page determines the typographic quality of the type artist's typeset page.

It all gets down to language—not an author's words on the page, but the computer's language that writes, displays, and prints a computer file. A first-year foreign language student cannot read or understand all the words in the foreign-language text. The instructor's lectures in the language translate into sentences riddled with missing words and phrases. The full meaning of those words and the nuances of those stories are lost. The beginner cannot comprehend all the information. By the end of the course, it is hoped, instructor and student exchange complex messages with subtle meanings that both parties understand.

DIGITAL TYPOGRAPHY

NELSON C. HAWKS
(1840–1929)
American businessman, typographer, printer, and inventor. Responsible for developing, promoting, and shepherding to adoption the American point system, despite the resistance and competitive suspicion of the American type foundry community.
≈

FREDERIC W. GOUDY
(1865–1947)
American type designer and type founder. A sedulous, prolific type designer, who twice lost his studio, equipment, and designs to fire. Established his own type foundry in 1925.
≈

PAUL RENNER
(1878–1956)
German type designer. Designed the geometric sans serif typeface, Futura. This face so intrigued the type community that it initiated a host of similar typefaces from designers worldwide.

≈

Typeface Names *Copyright laws do not apply to type designs. Typeface names, however, are registered as trademarks to the original manufacturer. If a typeface is available under an unfamiliar name, the type distributor has not licensed the font from the original trademark holder. The font's mechanics and quality will differ from the original.*

Computers and printers, like instructors and students, communicate with one another using language—computer language.

Digital typography describes individual letterforms as a mathematical description—a mathematical graphic recipe. The description directs the computer to position key points, to connect those points with lines, and to bend those lines to shape the letter's outline (fig. 1-3). *Digital* means using numbers to describe something, such as letter shapes. People's homes and offices are connected by digital addresses called telephone numbers. The number, rather than a name, identifies the person's location and enables the connection.

Digital fonts are available in two different forms: bitmapped fonts and outline fonts. A bitmapped font, or *screen font,* defines letters as groups of dots arranged on a grid with *x,y* coordinates, also known as paint images. Each letter's shape is defined as preset pixel locations on a grid, or *bitmap.* Just as art students create designs on graph paper by carefully darkening each grid square, so too does the computer remember a letter's shape as selected pixels (the grid squares) on a bitmap (the computer screen or printed page). The selected pixels can be black, white, colored, or grayed. Bitmapped fonts on a video monitor usually have a fixed resolution, typically 72 dots per inch (dpi). This resolution gives diagonal and curved edges a stair-stepped, rather than a smooth, edge. The on-screen smoothing is dependent on the bitmap resolution and the presence of smoothing or anti-aliasing software.

An outline font, also called *printer font* or *scalable font,* defines letters as objects, also known as draw or vector objects. Each letter's shape is a mathematical formula containing point locations and shaped, connecting line segments. Outline fonts are not locked in a preset resolution. The resolution of the display or output hardware determines the smoothness of the letters' edges. Type artists should use outline fonts and high-resolution imagesetters for professional-quality typesetting.

Outline fonts come in several file formats written in different computer languages. The major outline font formats are PostScript Type 1 and TrueType. A Type 3 font format is available in a smaller capacity. These font formats have different strengths, features, and characteristics. Adobe multiple master typefaces use an enhanced PostScript Type 1 format. These typefaces are software-modified, rather than an independent font format. The multiple master typefaces offer type artists such expanded controls that they are treated separately here. While most font formats can coexist on a single computer system, a type artist must be aware of potential surprises (or problems) triggered by this coexistence.

The native language of the Macintosh computer is QuickDraw. It is built into the computer's permanent memory on ROM chips. Macintosh video signals typically use the QuickDraw language to display images. Before displaying any file (or elements within a file) on screen, the Mac needs a QuickDraw version of it. If QuickDraw is the file's original format, the display is accurate. If the file format is not QuickDraw, the Mac displays a QuickDraw equivalent of it. This conversion does not change the original file. The QuickDraw display version, however, might vary from the original. All Mac applications contain the conversion software necessary to display their files accurately on a Mac display. Some applications are better at it than others.

Many digital typefaces available today are written in the PostScript computer language. Adobe Systems developed the PostScript page-description language and introduced it in the early 1980s. Most high-end graphics programs, such as Illustrator and FreeHand, create PostScript-language files or use PostScript graphic elements within their files. PostScript files can specify four kinds of descriptive information—text in specific typefaces; bézier objects; bitmapped images of varying resolutions, such as halftones; and colors in RGB (red, green, blue), HSB (hue, saturation, brightness), and CMYK (cyan, magenta, yellow, and black) color models. To accurately display PostScript files or elements, the Macintosh display must receive an accurate QuickDraw equivalent.

Most outline fonts, Type 1 and TrueType, come with bitmapped versions even though they use the outline font for printing and, almost always, displaying. For displaying, scaled outline fonts in small point sizes distort significantly. In those situations having a 9-point bitmapped version is easier on the eyes. It may be harder, however, on the mind when it emerges from the printer. Printers have a seek-and-print order too, and it can differ from that of the display. The good-looking bitmapped font used for the display is not the same width as the outline font used by the printer. In extreme cases, line breaks can change, tabs are thrown off, and a whole host of other headaches (surprises) can appear. The same (or different) discrepancies can occur when using the same typeface from different manufacturers or in different file formats (unless the same master font was used to create both).

Because of these hardware protocol differences, it makes sense to keep bitmapped fonts to a minimum and to keep fonts segregated by font file format. Type-utility software, such as Suitcase or Font Reserve, is an easy way to separate and manage fonts located on the Mac. Such

OSWALD B. COOPER
(1879–1940)
American lettering artist, graphic artist, and type designer. Known for his custom, promotional lettering for advertisements, posters, and logos. The Packard typeface was developed from his lettering.

WILLIAM ADDISON DWIGGINS
(1880–1956)
American graphic artist, book designer, calligrapher, marionette maker, and type designer. Designed typefaces, such as Caledonia, Eldorado, and Metro, for use on the Linotype linecaster.

software enables the type artist to open sets of typefaces as needed, keeping others closed and hidden from view. The display and printer cannot default to something they cannot find.

When the computer downloads a font to the printer (PostScript Type 1 or TrueType), the printer driver recognizes, downloads, and processes it correctly for printing. Inexpensive, little-known file formats may not make the downloading journey if their names do not appear on the printer driver's manifest. (A printer driver cannot pass along or process what it does not recognize.)

Adobe PostScript Type 1

ARTHUR ERIC ROWTON GILL
(1882–1940)
British type designer, artist, calligrapher, stonemason, and social critic. Designed his first typeface, Perpetua, for Monotype at the request of Stanley Morison.

~

STANLEY MORISON
(1889–1967)
British typographer and type historian. Oversaw an ambitious type-design program for Monotype, commissioning new designs and reviving classical designs, such as Bell, Bembo, and Baskerville. Designed the Times New Roman typeface for the London Times.

~

ADOBE POSTSCRIPT TYPE 1 FONTS (PST-1), introduced in 1984, are outline fonts written in the PostScript language. Each font file contains a maximum of 256 characters. Consequently, in a single type family (Times, for example), each family member (roman, italic, bold, and bold italic) is a separate font file. Each family member displays alphabetically as a separate entry in an application's font menu. Adobe's Type Reunion software, a separate system extension, clusters all family members in a submenu under the typeface's name. For example, *Times* appears in the font menu with *Roman, Italic, Bold,* and *Bold Italic* listed in a type family hierarchy in the submenu. When working with large font families, Type Reunion (or similar product) is a must-have.

For type artists seeking access to more typeface family members, such as semibold or black, many typeface packages come with more than the basic four. Each is a separate file. For access to additional characters within a single type font, type manufacturers, such as Adobe, offer expert collections as extensions of select typefaces. Purchasing a typeface and its expert collection offers the type artist additional characters that could not fit in the standard 256-character file. Expert collections include characters such as small caps, titling caps, text figures, fractions, swash letters, and ornaments. Using an expert collection increases the level of typographic quality a type artist can achieve.

Because a single type family requires a minimum of four files, PST-1 font files are compressed. Each font ranges from 35 to 50 kilobytes. This keeps the amount of hard disk space and printer RAM devoted to fonts at a minimum. To display and print PST-1 fonts, the type artist needs three items: the typeface's outline font file; a 10-point bitmapped font of the typeface; and Adobe Type Manager (ATM), the PostScript-interpreter software.

Adobe PST-1 font files (the outline font file) contain information required to render each typeface for display or printer output according

to the type designer's specifications. The information in each PST-1 font is encrypted. These specs fall into two information categories—outline and hints. The outline information uses cubic bézier mathematical formulas to describe each letter's shape. Bézier equations use control points and control point handles to extrapolate the outline of each letter. This technique results in fewer control points along the letter's outline path without jeopardizing the accuracy of the typographic forms and keeps printing time reasonable (fig. 1-4). The number of control points within the same type format depends upon the intricacy of the letter's outline (fig. 1-3).

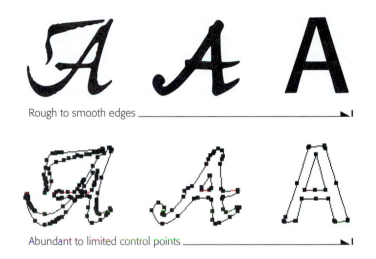

Rough to smooth edges

Abundant to limited control points

FIGURE 1-3: *Control points determine letter-edge quality*

Hints are special instructions that maintain the quality of a typeface's typographic features on a printer below 600 dpi and in type sizes below 14 points. A typeface's design nuances so easily seen at 96 points might not be worth rendering at 6 points. For example, a cupped serif on a 6-point typeface might be impossible to render on a 300-dpi printer. Instead of the gentle bowing curve typical of a cupped serif, such a printer might make the serif appear as if a rectangular bite was taken out of it. (Cupped serifs do not lay flat on the baseline. They bow upwards slightly.) The hints for that typeface could instruct the printer to render the bottom of the serif perfectly horizontal, thereby eliminating the problem. Some hints pertain to a single letter and others pertain to the entire typeface.

BEATRICE BECKER WARDE
(1900–69)
American typographer and type historian. Worked in Britain for most of her professional life. In 1927 published research (under pseudonym, Paul Beaujon) proving that a typeface previously attributed to Claude Garamond was created by Jean Jannon.

Hints include information concerning character alignment (making sure all the letters sit on the baseline correctly), curves and strokes (creating the most visually accurate curves or strokes with different resolutions), and other visual subtleties in a typeface design. Hints could aptly be called "notes on nuances." No matter what the term, hints are the next best thing to having the type designer on site adjusting the print quality for the best possible results.

Printers and displays need one more category of information to print type accurately on a page or to display type on a screen; these are the rendering instructions. A font file contains all the instructions the typeface might need for any printer at any type size. The rendering instructions are located in the PostScript interpreter. The Adobe Type Manager (ATM) software interprets the information in the font files, determines which instructions are applicable to the printer and type size at hand, and prepares that information for the printer or the display. Preparing a file for printing is called raster image processing, *RIP-ing,* or rasterizing. PostScript printers contain a PostScript interpreter in their ROM chips or on a cartridge or board installed in the printer. A Quick-Draw printer requires the computer and its operating system to process the file for the printer and, therefore, ATM must be installed on the primary hard drive. Referring to ATM as an interpreter, rather than a rasterizer, acknowledges its use with the display as well as the printer.

Adobe typeface families include four style versions—roman (regular), italic, bold, and bold italic. Adobe Type Manager needs only one bitmapped font, the roman version, to get the information it needs for scaling the other styles. Not all Type 1 fonts are linked in this manner; some may require all four bitmapped fonts for accurate scaling.

Keeping ATM as a stand-alone piece of software enables rendering capabilities to be upgraded. Type artists can upgrade the PostScript interpreter software only, rather than their entire typeface libraries (a thought that would make any type artist shudder).

To read, understand, and render all the nuances contained in these PostScript files, a high-volume type artist with PST-1 fonts should have a PostScript, or PostScript-compatible, printer. It is possible to print PST-1 fonts from a non-PostScript printer, but the results are not acceptable to the typographic eye.

TYPE 1 FONTS

BEGINNING IN THE SPRING OF 1989, Adobe Systems started moving away from the PostScript Type 1 font format as its proprietary format. At first, it licensed the Type 1 font-production software to other large

typeface manufacturers, such as Linotype, Bitstream, and Monotype, but finally it released the software to the public. The PostScript computer language is still the pride and property of Adobe. The move away from Type 1 as Adobe's own opened up this file format to wider distribution by other manufacturers, but also opened the door to a wider range of typeface quality. The number of characters, for example, might not be consistent with a typical Adobe PST-1. Some of these third-party Type 1 fonts might not work with Adobe's PostScript interpreter, ATM. The Type 1 font format was so long associated with Adobe that it is easy to make the assumption that a Type 1 font is an Adobe font. For the type artist with limited typeface funds, staying with the larger type manufacturers is a safer path to take for quality typefaces.

TYPE 3 FONTS

THE TYPE 3 FONT FILE FORMAT is a user-defined PostScript outline font format. Unlike Adobe's PST-1 fonts, Type 3 fonts are not compressed or encrypted and may or may not be hinted. Adobe Type Manager does not work with Type 3 fonts. Font manufacturers use the PostScript language to define most, but not all, font features. *User-defined* is another way of saying that the quality of these typefaces varies widely. Designers might find these fonts suitable for logo development, decorative initial-letter creation, or other large, single-character uses.

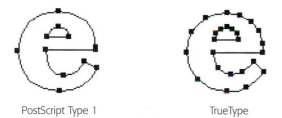

PostScript Type 1 TrueType

FIGURE 1-4: *Font format control-point comparison*

APPLE TRUETYPE

APPLE TRUETYPE FONTS (TT), introduced in 1991, were developed by Apple in a joint venture with Microsoft for use on the Macintosh and PC platforms. TrueType fonts are outline fonts written in the TrueImage page-layout language, developed by Microsoft. TrueType uses square B-spline mathematical formulas to extrapolate type outlines. This mathematical system uses many more control points (fig. 1-4) along the letterform's outline (path), than the PST-1 fonts. TrueType fonts are hinted, but not compressed or encrypted as are Adobe PST-1 fonts. Lack

of compression makes TT fonts 50% to 70% larger than Adobe PST-1 fonts, although a type artist could use a third-party compression program to save disk space. TrueType fonts average approximately 70 kilobytes per font file.

TrueType fonts were designed to work on non-PostScript printers. They do work on PostScript printers also. To use TT fonts on the Mac, the type artist needs one item: the typeface's outline font file. The number of font characters in each font is the same as the PST-1 fonts, so each family member (roman, italic, bold, and bold italic) is a separate font file. TrueType fonts come with bitmapped display fonts, but they are not necessary. With the potential discrepancies between type on the display and type on a printed page, it is wise to save disk space and ignore the bitmapped fonts. (When using any type-utility program, always check their requirements for the bitmapped fonts before removing.)

For the type artist, the fundamental difference between TT and PST-1 is the location of the rasterizer, the software that prepares the file for the printer. With PST-1, a PostScript interpreter (the PostScript rasterizer) is needed either in the printer or on the computer's hard drive or both for accurate display and print quality. With TT fonts, the rasterizer is in the font; this accounts for the increased TT font size. Any improvement to the rasterizer requires a repurchase of the font.

A second significant difference concerns hinting. Hints for TT fonts are not limited to the small text sizes and low-resolution printers. Because they were developed for non-PostScript printers, TrueType hints work at all sizes—refining, retooling the letters with each and every use. Display type continues to benefit from hinting, as does text type.

The TT font format is an open format. It is not licensed to Apple or Microsoft and anyone is free to use it to create type fonts. While this encourages more type designers to use this font format, it also means that the quality of the fonts (and number of characters in the font) can vary significantly depending upon the expertise and commitment of the typeface designer. Since TT hinting applies to all type sizes and since the rasterizing software is in the font file, this open format is trickier to program for the novice typeface designer. As with Type 1 fonts, the type manufacturer's name can steer the novice font buyer away from the end product of the novice type designer.

For type artists whose work does not revolve around the PostScript world of graphics, page-layout, and illustration programs, TT brings the ease and accuracy of well-crafted typefaces into the less expensive world of non-PostScript printers. The home computer user or

GUDRUN ZAPF VON HESSE
(1918–)
German type designer and calligrapher. Her designs include Diotima, Adriadne, and Nofret.
~

HERBERT LUBALIN
(1918–81)
American graphic designer, typographer, and type designer. Created visuals with type to replace illustrations or photographs. Cofounded International Typeface Corporation. Designed Avant Garde Gothic, Lubalin Graphic, and Serif Gothic.
~

the word-processing or spreadsheet computer user will enjoy the range of fonts. For professional and semiprofessional graphic artists, whose work spends most of its time in a PostScript file format outputting to high-quality imagesetters, TrueType does not offer unique capabilities or fonts. For type artists who manipulate the paths and points of letter-forms to create typographs, the fewer points of PST-1 fonts are prefer-able. With the PostScript language as the mainstay of the professional graphics computer world, why change computer languages now? Any language translation problems will compromise typographic quality.

ADOBE INTRODUCED MULTIPLE MASTER (MM) technology in 1991. While not a new type format, multiple master technology enables a type artist to create additional Adobe PST-1 fonts from two or more master designs within a single typeface family. A minimum of two master de-signs is required for this technology to work, hence the name *multiple master.* A type artist creates the fonts needed from within the Adobe application, Font Creator, provided with each MM font. The newly cre-ated *custom fonts* are stored in the system folder or in a fonts folder outside the system folder accessed by type-utility software, and they appear in application font menus ready for use. Due to the enhanced nature of these MM typefaces, a single font file is larger than average. For example, the Minion Regular font file is 40 kilobytes, whereas the Min-ion Regular MM font file is 156 kilobytes.

Multiple master typefaces enable the type artist to adjust a maxi-mum of four design attributes. These attributes, called *design axes,* are for weight, width, optical size, and style. Not all MM typefaces provide four-axis control. The Minion MM typeface, for example, provides con-trol for three of the four design axes. The Myriad MM typeface is a two-axis typeface.

The *weight axis* determines the stroke weight of the typeface, re-sulting in a *dynamic range* from light to bold, for example. An MM type-face with weight-axis control provides the artist with two master type-faces representing each end of the axis, light on one end and bold on the other. The artist can stop at the desired stroke weight at any point be-tween the two extremes.

The *width axis* determines the width, or *set width,* of each indi-vidual character. The axis extremes are condensed and extended. Con-densed has the narrowest characters; extended has the widest charac-ters. The artist can stop at any width along the axis. A type artist working with an MM typeface offering two design axes, weight and

EPHRAM "ED" BENGUIAT
(1927–)
American type designer and graphic designer. Designs comprise over 500 faces, including ITC Souvenir, ITC Bookman, Benguiat, Benguiat Gothic, ITC Korinna, *and* Panache.
~

width, for example, can manipulate both axes simultaneously, producing a light extended typeface family member.

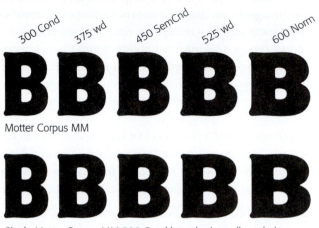

Motter Corpus MM

Single Motter Corpus MM 300 Cond letter horizontally scaled

FIGURE 1-5: *Custom fonts/horizontal scaling comparison*

The *optical size axis* sets optimal legibility for any point size within the dynamic range. Type artists producing lengthy documents, newsletters, and other examples of continuous-reading text should find this design axis intriguing. It is the modern-day equivalent of cutting typefaces one font at a time. When punch cutters cut the designs for foundry type, they took care to maintain the typeface's design characteristics in each font they cut. Cutting the typeface's serifs was easier in the larger 36-point font than in the 8-point font. The smaller font required the addition of extra weight here and there to maintain the serif's appearance and its ability to print successfully. Without these enhancements, the serif might be too thin to reproduce well.

When typography entered the digital realm, type sizes were scaled from a single master. Hinting was included to compensate for the small-size and low-resolution situations that would jeopardize the typeface's design characteristics. Multiple master's optical size axis is a return to the days when each font received the punch cutter's individual attention and expert adjustment. Examples of an optically sized MM typeface compared with the same size of a globally scaled digital typeface show a heightened level of legibility and a resulting improvement in readability. The masters for an optical size axis MM typeface are a small–point-size font and a large–point-size font, one for each end of the axis. The type

ADRIAN FRUTIGER

(1928–)

Swiss type designer. Designed typefaces for specific typesetting methods, such as phototypography and digital typography. Typefaces include Univers, Serifa, Frutiger, and Centennial.

∿

artist enters any point size within the dynamic range (between the axis extremes) and an actual type *font* (according to the true definition of the word) is generated with optimized design features. (Buying an MM typeface to manipulate this feature alone is a worthwhile investment for the type artist producing long, continuous-reading documents.)

The fourth design axis is the *style axis*. The style available for customizing varies between MM typefaces and is determined by the MM type designer. For some MM typefaces, the style is the serif. The dynamic range runs from sans serif to serif or from wedge serif to hairline serif. For other MM typefaces, the style is the amount of contrast between the letter's strokes. The style category has a broad interpretation.

A multiple master typeface package includes the master designs and *primary fonts* (PST-1 fonts of various typeface family members, much like an expanded typeface package). Both custom and primary fonts can appear on an application's font menu if loaded correctly. Both sets of fonts are listed by typeface name (Minion MM, for example) and numeric design axes positions (350 wt 500 wd 10 op). Multiple master typeface technology is not for everyone. It is for those type artists who understand the principles of typography (most of which are covered in this book) and who want to alter type designs using a built-in safety net provided by the actual type designer. (See "Using Multiple Master Typefaces" in chapter 7.)

❦

TYPOGRAPHIC HISTORY IS FILLED with the intriguing men and women dedicated to furthering the field of typography using their own unique perspective. Punch cutters, merchants, printers, entrepreneurs, type historians, and type designers, with diverse backgrounds as engravers, goldsmiths, diplomats, marionette makers, and graphic designers, all contributed to the field in important ways. They worked in the service of the sacred and profane; for cardinals and kings; as employees of type foundries, advertising agencies, publishing houses, and print shops; as lone entrepreneurs pursuing a passion for typography with elusive financial rewards. Some were lionized, while others were not recognized during their lifetimes.

With all its passionate, outspoken, and reticent participants, this rich history provides the critical foundation, the design history, and the tools for the type artists of today. No matter the tool or technique used to set type, the goal is the same—communication: conveying a message

SUMNER STONE
(1945–)
American type designer. Designs include ITC Stone Sans, ITC Stone Serif, ITC Stone Informal, and ITC Bodoni.
≈

JOVICA VELJOVIĆ
(1954–)
Serbian type designer and calligrapher. Designs include ITC Veljovic, ITC Esprit, Ex Ponto, and Linnea MM.
≈

ROBERT SLIMBACH
(1956–)
American type designer. Designs include Giovanni, Minion, Poetica, Utopia, Adobe Garamond, Caflisch Script, and Minion MM.
≈

CAROL TWOMBLY
(1959–)
American type designer.
Designs include Charlemagne,
Trajan, Lithos, Adobe Caslon,
Viva MM, *and Nueva* MM.

from the author to the reader. No matter what the format, the printed page or the electronic screen, the vehicle is the same—type. Communicating with clarity and style is possible with an understanding and appreciation of the contributions, ideas, and type sense of many individuals. Each stimulates today's type artists toward continuing and extending the typographic heritage.

ROLLERCOASTER

FIGURE 1-6: *Rollercoaster typograph*

SPEAKING THE
LANGUAGE
OF
LETTERS

W HEN WORKING WITH TYPE and the subsequent letters the type produces, the type artist enters a world of new terms, the typographic nomenclature. This collection of terms enables all type professionals at all points in the typographic chain—type designers, graphic artists, service bureau operators, typesetters, and others—to converse about this topic clearly and accurately. The proper use of language in all fields identifies the novice from the expert. The type artist who refers to an ampersand as the "squiggly thing that means *and*" does not engender confidence from an author or supervisor. People do not confidently leave their car with a mechanic who refers to the engine as the "big clunky thing under the hood that goes *rum-rum*." It is wiser to keep driving. The correct use of language identifies a person's level of knowledge in a given field.

The language of letters breaks into four categories representing specific aspects of type. These categories are type anatomy, type measurements, typeface styles, and type family members. Since digital type artists see type as letters and symbols either on a screen or on a printout, the primary terms of interest to them are those identified in this venue, in other words, that which is seen. Setting digital type is not a mechanical process, as was foundry type. The type artist's primary means of interacting with the individual letters comes either on screen or on a page.

The beauty of a letter depends on the harmonious adaptation of each of its parts to every other in a well-proportioned manner, so that their exhibition as a whole shall satisfy our esthetic sense—a result gained only by blending together the fine strokes, stems, and swells in their proper relations.

———————— Goudy
*The Alphabet and
Elements of Lettering*

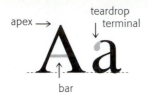

apex → teardrop terminal ↓

bar

ascender ←

bowl

stress → aperture

TYPE ANATOMY

Type anatomy refers to the names of the letter's parts—the arm, stroke, spine, swash, and leg, to name a few. "The horizontal thing attached to the top of the vertical thing" is not sufficient here. It is no coincidence that type anatomy adopts many terms from human anatomy. Gutenberg was concerned that the reading public would not accept his type unless the letterforms were familiar to them. It might have been from this concern that the adoption of human body part names originated.

The anatomical elements of type fall into three categories: strokes, endings, and spaces. A *stroke* is a general category that refers to the primary structural components that define the overall appearance of a letterform. Vertical, horizontal, and diagonal marks establish the letter's structural form. An *ending* is a design treatment used to define the beginning and ending of a stroke. An ending completes a stroke in a style complementary to the letterform's overall design style. A *space* refers to the negative area in and around a letterform. This area does not print, but it is visually important for style, legibility, and readability. As a general point of reference that defies all categories, the two terms *head* and *foot* refer respectively to the top and bottom of a letter.

The names of these elements and their definitions are listed by categories in the following sections. Category terms are presented in order of frequency. The most common terms, more frequently seen, are listed first, leading to those less frequently seen.

STROKES

Stroke Besides being the name for this general category of letter components, when lacking a more specific name, the term *stroke* is applicable to any straight or curved line used to define a major

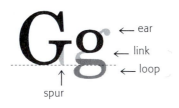

← ear
← link
← loop
spur

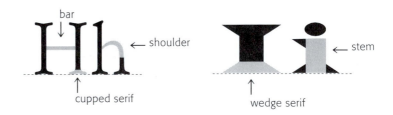

bar ↓ ← shoulder ← stem

cupped serif wedge serif

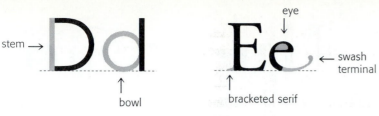

stem → / bowl ↑

eye ↓ / swash terminal ← / bracketed serif ↑

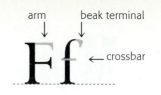

arm ↓ / beak terminal ↓ / crossbar ←

structural portion of a letter. The diagonal line in the middle of the uppercase *N* is a stroke.

Stem A major vertical stroke within a letter, such as in the uppercase *L, E, B, K* and the lowercase *l, d,* and *b*. The stem does not include any serifs or other stroke endings.

Hairline An extremely thin line used as a stroke or a serif.

Ascender A portion of a stroke in a lowercase letter that extends beyond the mean line or above the lowercase *x*. Ascenders are in the lowercase *b, d, f, h, k, l,* and comparable letters.

Descender A portion of a stroke (not limited to lowercase letters) that extends below the baseline, such as in the lowercase *g, j, p, q,* and *y,* and in some typefaces, the uppercase *J*.

Bar A horizontal stroke that connects two strokes, such as in the lowercase *e* or uppercase *A* and *H*.

Crossbar A horizontal stroke that crosses another stroke, such as in the lowercase *t* and *f,* and the uppercase *T*.

Arm A horizontal or upward diagonal stroke that is attached to the letter on one end and unattached on the other, such as in the uppercase *E, F, L, X, Y, K,* the lowercase *x,* and comparable letters.

Tail A downward diagonal stroke attached to the letter on one end and unattached on the other, such as in the uppercase *K, Q, R, X,* and lowercase *k, x,* and comparable letters. The tail of the uppercase and lowercase *K* is referred to by some as a *leg*.

Spine The main curved stroke in the uppercase and lowercase *S*.

Bowl A curved stroke that creates an enclosed space within a letter, such as in the lowercase *a, b, d, p, q,* uppercase *B, P, R,* and other comparable letters.

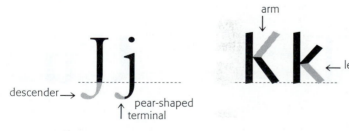

descender → / pear-shaped terminal ↑

arm ↓ / leg ←

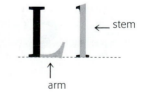

stem ← / arm ↑

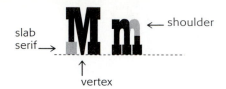

slab serif → M n ← shoulder

↑ vertex

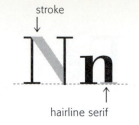

stroke ↓ N n

hairline serif ↑

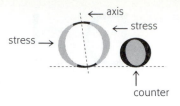

← axis
stress → O ← stress
o
↑ counter

Shoulder The curved portion of a stroke, such as in a lowercase *h, m,* and *n,* that does not create an enclosed space within the letter.

Loop The elliptical stroke at the bottom of the lowercase *g.*

Stress The thickened portion of a curved stroke that determines a direction (vertical, horizontal, or diagonal) in which the letterform appears to lean.

Bracket A curved or sloping shape that smoothly joins a serif to a stroke or stem. Also called a *fillet.*

Link Short stroke that joins the bowl of the lowercase *g* to its loop.

Apex Section of the top of a letter where two straight strokes or stems join and create an angle, such as in the uppercase *A, M,* and *N.*

Vertex Section of the bottom of a letter where two straight strokes or stems join and create an angle, such as in the uppercase and lowercase *V* and *W.*

ENDINGS

Serif A cross, or finishing, stroke at the beginning or end of the major strokes of a letterform. Serifs can extend from both sides of a stroke or just one. A serif enhances a typeface's readability by moving the viewer's eye horizontally along a line. Some serifs are described by their shape, such as *bracketed, cupped, hairline, slab,* and *wedge.*

Terminal Stroke-end treatments, such as tapering or adding a shape, that are not serifs. Some terminals are described by their shape, such as *ball, beak, hooked, pear-shaped,* or *teardrop.*

Swash An extended or decorative flourish that replaces a serif or terminal on a letter.

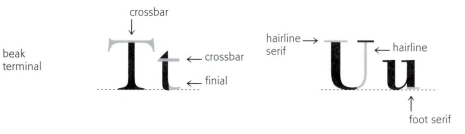

spine → S s ← beak terminal

crossbar ↓ T t ← crossbar
← finial

hairline → U u ← hairline
serif
↑ foot serif

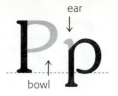

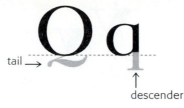

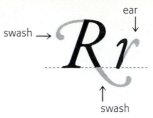

Swash Terminal A lowercase letter with a long swash extending from it on the right side. This letter is used if it occurs at the end of a word.

Finial The tapering end of a stroke, as on the lowercase *e* or *c*.

Ear The short protrusion from the top of the lowercase *g* and *p*. Also applied to the arm of the lowercase *r*, depending upon the typeface.

Spur Small downward extension on some styles of the uppercase *G*.

Counter The fully or partially enclosed negative space within or adjacent to a letterform.

Eye The enclosed counter in the upper portion of the lowercase *e*.

Aperture The amount of space between two points in a letter forming an opening into an interior portion of a letterform. An aperture is created by the end of a stroke and its position relative to the rest of the letter. The aperture in the letter *C* is created between the two endpoints of this single, curved stroke. The aperture in the lowercase *e* is created between the right end of its bar and the tip of its finial. Apertures are also in the letter *S* and lowercase *e* and *a*.

Typefaces and type fonts are measured using a unit of measure called a *point*. For digital typography, the point is standardized to $1/72$ inch (1 point = $1/72$ inch) or 72 points equal 1 inch (72 points = 1 inch).

The evolution of the point system for measuring type has had a long and international history involving both individuals and establishments, including the two prominent French typographers Pierre S. Fournier (1712–68) and François-Ambroise Didot (1730–1804); the American businessman and printer Nelson C. Hawks (1840–1929); the

SPACES

TYPE GUIDELINES AND MEASUREMENTS

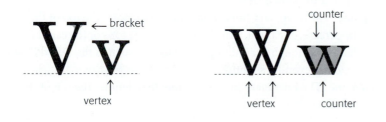

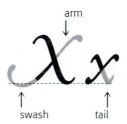

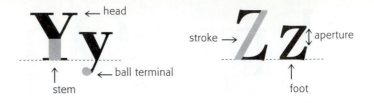

American printer and inventor Benjamin Franklin (1706–90); the French monarchy of 1723; and the American Type Founders' Association. It was not until 1886 that the American Type Founders' Association adopted the American point system. The British adopted the same measurement system in 1898.

In this Anglo-American point system, a single point measures 0.013837 inches (72 points = 0.996264 inch). In the Didot point system, used in continental Europe, a single point measures 0.0148 inches (72 points = 1.0656 inch). When type was transferred to the digital arena, the point system was converted to even measurements (72 points = 1 inch). The standard video screen resolution of 72 dots per inch made this easier.

A type font is not characterized globally as simply big or small. Digital type artists are concerned with the overall height of the type font as well as all the internal points of reference within the font. Enlarging or reducing the overall type font size does not solve all type problems. A problem of decreased readability in a paragraph, for example, may lie with the proportions of x-height to cap height, not the font's overall size.

Measuring a type font involves two categories of information: guidelines and measurements. A *guideline* is the location of a specific point of reference from which measurements are calculated. A *measurement* is the distance from one point of reference to another within the type font. The guidelines and measurements are listed by category in the following sections. The terms are presented alphabetically.

GUIDELINES

Baseline The imaginary horizontal line upon which all typeset letters appear to stand or rest.

Cap line The imaginary horizontal line that denotes the top of the uppercase, or capital, letter *X*. Indicates the tops of the capital letters, although curved uppercase letters, such as the *O* and *C*, will extend beyond it slightly.

Mean line The imaginary horizontal line that denotes the top of the lowercase letter *x*.

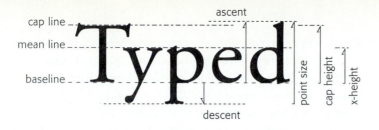

FIGURE 2-1: *Type guidelines and measurements identified*

Ascent The vertical distance from the baseline to the top of the highest character in the type font. This location varies from font to font.

Cap height The vertical distance from the baseline to the cap line.

Descent The vertical distance from the baseline to the bottommost point in the type font. This location varies from font to font.

Point size The vertical distance from the bottommost point in the type font to the topmost point in the type font. The *point size* is the sum of the *ascent* and the *descent.*

X-height The vertical distance from the baseline to the mean line. This term loosely refers to the height of the lowercase letters, such as *x, a, o,* and *s.* The term *large eye* refers to a typeface with a large *x*-height.

TYPEFACE STYLES REFER to the ways in which letter parts are designed and connected. Some typeface styles are dramatically different; others are more subtly distinct. Seeing these differences and identifying the major design category to which a typeface belongs is not a goal in itself. The purpose of such distinctions is to help the type artist more easily see the subtle differences between typeface styles, to enhance typeface selection for projects, and to sharpen the eye for proofing documents. Just as the experienced car mechanic can hear the faint, telltale *ping* that identifies a specific car malady, so too can the experienced type artist quickly pick out the wayward italic *a* in a sea of roman letterforms.

AS WITH OTHER ASPECTS OF TYPE, the terminology used to describe typestyle characteristics is unique, although not extensive. These terms describe a typeface's style in the broadest terms. The stylistic terms are presented by frequency of use.

Roman Describes a typeface whose letters stand vertically on, or at right angles to, the baseline. Most continuous-reading text is ro-man, since it is the easiest to read.

Typeface
Roman

Typeface
Italic

Typeface
Oblique

Typeface
Serif

Typeface
Backslant

Typeface
Sans Serif

Typeface
Script

TYPEFACE
CLASSIFICATIONS

ABCDEF
abcdefghijklmn
opqrstuvwxyz

The Goudy Text typeface follows the black letter design traditions of the fifteenth century.

Italic Describes a typeface that is structurally redesigned to slant or lean to the right as it rests on the baseline. Effectively used to identify a word(s) having a unique contextual role within roman text.

Oblique Describes a typeface that slants or leans to the right as it rests on the baseline; also referred to as *machine italic.* An oblique typeface is not a redesigned roman typeface, but rather a slanted roman typeface. The angle of oblique can be set, depending upon the typesetting technology used. An oblique typeface is not interchangeable with italic for role identification within roman text because it is structurally too similar to roman.

Serif Describes a typeface that has serifs on the ends of its strokes. Highly suited for continuous-reading text because the serif enhances horizontal eye movement along a type line.

Backslant Describes a typeface that slants or leans to the left as it rests on the baseline. The angle of backslant can be set depending upon the typesetting technology used. Suited for display use only.

Sans Serif Describes a typeface whose strokes end bluntly. A sans serif typeface does not have finishing treatments at the ends of its strokes.

Script Describes a typeface that imitates cursive handwriting. Many of the letters are created with a single, continuous stroke. Some typefaces have connecting strokes to join adjacent letters; other scripts have freestanding letters.

As the stylistic terminology listed suggests, type artists need a language with which to communicate general type styles and typeface characteristics to one another. They need a typeface classification system as a means to impose order on the thousands of typefaces available. There are multiple existing systems for classifying typefaces that represent the viewpoints of typographers from different parts of the world. For type artists entering the world of typography from varied backgrounds, some of these systems are too specific and detailed. The categories listed here are based in part on these existing typeface systems, but leave out the heavy, condensed gothic letterforms used by Gutenberg and other typographers in his time period, categorized as *black letter* types.

When classifying type, the term *roman* reappears in its second usage. In the context of type classification, *roman* refers to the open, round letterform structure of the English alphabet that is based on the well-proportioned, open, curvilinear forms of the 23-letter Roman

alphabet. (The letters *U, W,* and *J* were added to the English language by 1400 to make the final 26 letters.) The traditional roman typefaces, introduced in the early 1470s by Nicolas Jenson, were based on the ninth-century Carolingian minuscule (a further refinement of the original Roman alphabet letterforms) and set a path for generations of type designers to follow.

The typefaces that continued and refined this tradition can be divided into eight classifications: humanist, old style, transitional, modern, slab serif, sans serif, script, and decorative. While each category can be subdivided into finer distinctions, these general groupings help today's type artist make stylistic sense of the vast number of available typefaces. Not all typefaces assigned to a category will display every stylistic characteristic of its category. Typeface designers maintained past stylistic influences, while incorporating their own style changes. As those new style changes found their way into other typefaces, new classifications were formed. The typefaces responsible for the evolution are assigned to the category they most represent. Type classification is not an exact science, but a blend of colors.

Within these eight classifications, comparing the treatment of four structural components helps the type artist see the distinctions between classifications. These telltale components are vertical and horizontal proportions, stroke weight, stress position, and serif treatment. There are many more ways to make typefaces unique, but by looking first at these four characteristics, the type artist can get a summary snapshot.

ABCDEFGHIJKLMNOPQRSTUVWX
abcdefghijklmnopqrstuvwxyz!?&12341234

FIGURE 2-2: *Centaur is in the humanist classification*

Humanist. The humanist classification refers to typefaces with wide, squarish proportions; medium- to heavyweight strokes with little contrast between stroke weights; slanted stress placement; and heavy cupped serifs with a rounded calligraphic quality. The head and foot serifs on the lowercase letters are slanted in relation to the baseline. Humanist typefaces are the first-generation roman typefaces diverging from the calligraphic, imitation handwriting of the black letter faces. They continue the uneven page textures of their predecessors, which is why this classification is not readily sought for use as a text face for

AefgHkp

Centaur has low stroke contrast, cupped serifs, slanted stress, and a slanted bar in the lowercase *e.*

AefgHkp

Adobe Garamond has medium stroke contrast, a low *x*-height, slanted stress, and ascenders that extend above the cap line.

AefgHkp

Baskerville has increased stroke contrast, vertical stress, high legibility, and easy readability.

continuous reading. These faces are easily identified by a distinctive slant to the bar of the lowercase *e.* This category includes the Centaur, Jenson, and Stempel Schneidler typefaces.

Old Style. The old style typefaces have a taller, more vertical stance since the ascenders extend beyond the cap height. This projects a more elegant appearance, but suggests a lower *x*-height. Stroke contrast within a single letter is medium and the stress placement is slanted. Old style typefaces use thinner, bracketed serifs that are more uniformly drawn than their predecessors. The head and foot serifs on the lowercase letters are slanted. The bar of the lowercase *e* is horizontal. The old style category includes the Garamond, Bembo, Caslon, Palatino, and Caxton typefaces.

ABCDEFGHIJKLMNOPQRSTUVWXY
abcdefghijklmnopqrstuvwxyz!?&12341234

FIGURE 2-3: *Adobe Garamond is an old style typeface*

Transitional. The transitional classification contains narrow typefaces with an increased contrast between stroke weights within letters and a predominantly vertical stress placement. The serifs are bracketed and usually, although not always, horizontal for the head and foot of the ascenders. The horizontal serifs and the higher contrast between stroke widths make this category very readable. The legibility and reproduction quality of these typefaces is high, making them prime candidates for use in early reader materials, newspapers, and magazines. The transitional category is the largest of the previously described categories. It includes the New Century Schoolbook, Bookman, Baskerville, Times Roman, Caledonia, and Cheltenham typefaces.

ABCDEFGHIJKLMNOPQRSTUVWX
abcdefghijklmnopqrstuvwxyz!?&123456

FIGURE 2-4: *Baskerville is in the transitional classification*

Modern. The modern classification displays narrow letters with an extreme contrast between stroke widths in letters. The vertical stress further enhances the narrow set. Serifs appear as evenly or mechanically drawn hairlines and slightly bracketed, if at all. The head and foot serifs on lowercase ascenders are horizontal. The extreme contrasting stroke

weights and the vertical stress placement are distinguishing characteristics of this classification, the most exaggerated of which earned the name *fat face.* Typefaces in this category represent one end of the typeface spectrum, with the calligraphic styles of the humanist typefaces at the other. The extreme thick and thin stroke weights keep some typefaces in this category suitable for display purposes only. At small sizes, text can look too blotchy. The modern category includes the Didot, Bodoni, Linotype Centennial, and Walbaum typefaces.

Bodoni has extreme stroke contrast, a narrow set width, vertical stress, and hairline serifs.

ABCDEFGHIJKLMNOPQRSTUVW
abcdefghijklmnopqrstuvwxyz!?&123

FIGURE 2-5: *Bodoni is in the modern classification*

Slab Serif. The slab serif typeface classification is distinguished by its dominant slab serifs and wide, rectangular set. The stroke weights match the serif weight, with or without brackets. Contrast between strokes is low with vertical stress placement. Although sometimes referred to as *square serifs,* the slab serifs form thick rectangular pads under each stroke. The term *Egyptian* was given to this type grouping because it was reminiscent of the slab form of architecture the Egyptians followed when building the pyramids. A second grouping of typefaces from this category first appeared in the early twentieth century. These typefaces were geometric in structure with unbracketed slab serifs at each stroke's end. The slab serif category includes the Antique, Clarendon, Memphis, Rockwell, and Beton typefaces.

AefgHkp

Memphis has stroke weights that match the serif weight.

ABCDEFGHIJKLMNOPQRSTUVWXYZ
abcdefghijklmnopqrstuvwxyz!?&1234

FIGURE 2-6: *Memphis is a slab serif typeface*

Sans Serif. The sans serif typefaces were first introduced in 1816 to the dismay of many type designers. Type without serifs—*sans* meaning *without*—was so odd looking that it was dubbed *grotesque.* The first grouping of British sans serif typefaces kept the term *grotesque* or *grot,* but the American typefounders preferred the term *Gothic* to describe their sans serif types. The grotesque typefaces are narrow in width with an overall rectangular appearance. Curves are achieved by rounded corners rather than true curves. The stroke weight is consistent, but

AefgHkp

Frutiger is a highly legible sans serif typeface.

AefgH

Boulevard capitals have a wide set width and an elegant swash that gives a graceful start to a word.

AefgHkp

Galahad has the calligraphic edge of newly written letterforms.

narrows at junctures or curves. This grouping includes the Grotesque, Alternate Gothic, Franklin Gothic, News Gothic, Helvetica, and Univers typefaces. Univers was one of the first typefaces to be designed as a type family—with 21 family members, all logically numbered.

As with the slab serif typefaces, there was a geometric grouping of sans serif typefaces based on the same streamlined geometric structures. This grouping includes the Futura, Kabel, Gill Sans, Avant Garde, and Spartan typefaces. The third grouping of sans serif typefaces combines the calligraphic stroke treatment of the humanist typefaces with this serif-less structure. This produced some elegant sans serif typefaces that include the Optima and Bernard Fashion typefaces.

ABCDEFGHIJKLMNOPQRSTUVWXYZ
abcdefghijklmnopqrstuvwxyz!?&123

FIGURE 2-7: *Frutiger is in the sans serif classification*

Script. The script typeface classification includes those typefaces trying to duplicate the flowing qualities of excellent penmanship. The typefaces in this category range widely with letter width, stroke-weight contrast, and stress placement. The two features useful for subdividing this classification are joined letters and unjoined letters. Examples in this category include the Snell Roundhand, Mistral, Brush Script, Bernard Cursive, Commercial Script, and Bank Script typefaces.

ABCDEFGHIJKLMNO
abcdefghijklmnopqrstuvwxyz!?&1234567890

FIGURE 2-8: *Boulevard is a script typeface*

Decorative. The decorative classification contains all the rest. These typefaces are so visually distinct that they are unsuitable for use as continuous-reading text faces. These typefaces project a strong appearance and evoke an emotional response from the reader. They seemingly create words from stamp-pad letters, rolled pieces of metal, neon lights, toothpaste, and weathered pieces of wood. They are elaborately illustrated letterforms or stark, structurally incomplete letterforms. They transport the viewer to the stone age, the Old West, a music hall, the circus, and the days of the American Revolution with their unique stroke treatments and adornments. The decorative category is

the hardest to define and the easiest to identify. It is where old categories are combined and new ones are created. Typefaces included in this diverse category are Cooper Black, Belwe, Stencil, Playbill, Sapphire, Caslon Antique, Neon, Neuland, Benguiat, Broadway, Prisma, Calypso, and many more.

ABCDEFGHIJKLMNOPQRSTUVWXYZ
abcdefghijklmnopqrstuvwxyz!?&1231234

FIGURE 2-9: *Galahad is a decorative typeface*

A TYPE FAMILY INCLUDES all the stylistic variations of a single type-face. Within the Helvetica type family, for example, there are Helvetica Light, Regular, Bold, Condensed, Extended, and combinations of all and more. Type artists learn to recognize the general descriptive character-istics of these terms, but there is no uniform weight that is *light, me-dium,* or *bold.* Adrian Frutiger was the first type designer to create an entire type family at once. When introduced in 1957, Frutiger's sans serif typeface Univers had 21 variations, distinguished by a system of num-bers rather than names. He identified these variants as a *palette* of type. The idea of numbers did not catch on with the typesetting community, but the idea of having logical, extended families, or collections, of type-faces did. Many type artists believe the more family members a typeface has, the more visual distinctions can be made on the page.

When purchasing digital typefaces, the type artist chooses from type families of varying sizes. Some, such as Times, contain the basic set: roman, italic, bold, and bold italic. Other typefaces come with more extended families, such as Adobe's Frutiger, for example. It comes with nine family members: light, light italic, roman, italic, bold, bold italic, black, black italic, and ultra black. Each is a separate font file, accessed separately in the font menu or the Frutiger submenu (using Adobe Type Reunion). This single extended type family offers the type artist a greater range of typographic possibilities.

Adding a type family's expert collection to the font menu doubles the typographic possibilities. Adobe's Minion type family, together with its expert collection, provides 22 different type family files: regular, italic, semibold, semibold italic, bold, bold italic, black, and ornaments. It also includes the small caps, old style figures, display, and swash characters for most weights. Expert collections extend a type family to its fullest,

TYPE FAMILY MEMBERS

Times

Aa*Aa* **Aa*Aa***

Roman/Italic Bold/Italic

Frutiger

Aa*Aa* Aa*Aa*

Light/Italic Roman/Italic

Aa*Aa*Aa*Aa*

Bold/Italic Black/Italic

Aa

Ultra Black

Times and Frutiger type families

and for the thoroughly smitten type artist, they are a must. The multiple master typefaces can make even larger type families by creating all the weights, widths, or styles in between the primary family members.

WITHIN A SINGLE TYPE FONT, there are a host of different characters—all with different purposes. (With digital typefaces, the type font spans several font files.) Characters in a type font go far beyond the common uppercase letters, lowercase letters, figures, and punctuation marks available on a typewriter keyboard. They include small caps, text figures, titling figures, ligatures, ornaments, and diphthongs (fig. 2-10), to name a few. (When a type family sends out invitations to the annual reunion, all sorts show up.) The characters in a type font divide into five categories: letters of the alphabet, figures, punctuation marks, joined characters, and symbols.

TYPE FONT ANATOMY

ABCDEFGHIJKLMNOPQRSTUVWXYZ
Uppercase letters (majuscules)

abcdefghijklmnopqrstuvwxyz
Lowercase letters (minuscules)

ABCD ABCDEFGHIJKLMNOPQRSTUVWXYZ abcd
Small caps

ABCD 1234567890 abcd 1234567890
Titling figures Superior figures

abcd 1234567890 ABCD 1234567890
Text figures Inferior figures

¼ ½ ¾ ⅛ ⅜ ⅝ ⅞ ⅓ ⅔
Case fractions

' ' . , ; : " " - – — / / { } [] () Á á É ö Ñ ñ Ü ü
Punctuation marks and diacritics

fi fl ff ffi ffl ſh ft ct ß st & æ Æ œ Œ
Joined characters (ligatures and diphthongs)

$ ¢ £ ™ © ® ¶ = + ≠ ± ÷ ' " ° ❦ ❧ ✿ ✾ ❁
Symbols

FIGURE 2-10: *Font anatomy character sampler*

THE LETTERS OF THE ALPHABET, or *graphemes,* include all the capitals, or *uppercase,* and the lowercase letters. Within this seemingly simple category, there are many variants: capital letters, display caps, titling caps, small caps, and lowercase letters. The *capitals,* or majuscules, are the large letters drawn proportionally for use within text. Used as capitals at the beginning of a sentence and with proper nouns in text, these letters draw attention to a location (beginning of a sentence) or a single word (proper noun). The strokes are drawn to optically match the stroke weights of the lowercase letters and serve as companion letters within the text.

The *display caps,* on the other hand, are designed and drawn separately to work in display sizes, 14 points or larger. These caps are not scaled from the uppercase, but are drawn separately, emphasizing subtle details visible in the larger sizes. They are suitable for use in headings and titles that accompany the other family members of the text type.

Titling caps refer to a type font of capital letters only. They are drawn to the height of the type size (almost), rather than the cap height. They are not meant for use with lowercase letters and do not maintain the same color as the text faces. Some typefaces use the terms *display caps* and *titling caps* interchangeably and conform to the definition of the former.

Small caps are capital letters that are the approximate size of the *x*-height. They are redesigned, or recut, to maintain the stroke weight and proper proportions for use with the lowercase letters. The term *true cut* refers to such redrawn letters. *Fake small caps* are scaled down from capital letters, rather than redesigned. These pseudo-small caps do not maintain proper stroke weights and appear too light on the text page. (See "Titling Caps and Small Caps" in chapter 6.)

The *lowercase letters,* or minuscules (developed from the Carolingian minuscule alphabet from the ninth century), are designed for use in text. Lowercase letters create word-specific shapes that assist readers in identifying words more quickly consequently increasing their reading speed.

Originally, the type case used to store foundry type was divided into halves horizontally. The capital letters were in the top cubicles, or the upper half of the case. The small text letters were in the lower half of the case. Over time, the terms *uppercase* and *lowercase* evolved to represent the letters in that part of the case.

ABCDEFGHIJ
KLMNOPQRS
TUVWXYZ

Capital letters

ABCDEFGHIJ
KLMNOPQRS
TUVWXYZ

Display capitals

ABCDEFGHIJ
KLMNOPQRS
TUVWXYZ

Small capitals

abcdefghij
klmnopqrs
tuvwxyz

Lowercase letters

FIGURES

THE FIGURES, OR NUMERALS, in a font fall into five categories. They are titling figures, text figures, superior figures, inferior figures, and fractions. A *true cut figure* is redrawn for its particular size and usage to blend with the weights of the surrounding letters. As with small caps, scaling the titling figures, for example, to create the smaller inferior or superior figures decreases their stroke weight and weakens their color on the page. A true superior figure maintains consistent typographic color and typographic quality.

$$12345678901234567890^{1234567890}{}_{1234567890}$$

FIGURE 2-11: *Titling, text, superior, and inferior figures*

The *titling figures* are the visual equivalent of uppercase letters. They are the size of the cap height, do not extend below the baseline, and have a uniform height. These are the numbers on the top row of keys on the keyboard. Titling figures—also referred to as *ranging, lining, capital, aligning,* or *modern figures*—are designed for use with capital letters in headlines or in tabulated materials. In text, these figures are too overpowering and disturb the color and texture of the text.

1234567890

Titling figures

The *text figures* are the lowercase letters of the number world. They are the size of the *x*-height, with ascenders and descenders extending from some of the figures, and they have a stroke weight comparable to a lowercase letter. Definitely harder to access than their bigger counterparts, the text figures are worth finding in a type font. Titling figures call too much attention to a number within a sentence—in a street address, for example. Instead, using a text figure blends the number nicely into the rest of the text, eliminating the unnecessary emphasis. If a number is present with lowercase letters or small caps, that number should be a text figure. Text figures also are referred to as *lowercase, old style, nonranging,* or *hanging figures.*

1234567890

Text figures

The *superior figures* are smaller than the text figures, but align top and bottom. They are redesigned and resized titling figures. They are positioned to align along the top with the font's ascenders. Superior figures are used as superscript for exponents and footnoting and as numerators in fractions.

1234567890

Superior figures

The *inferior figures* are the same size as the superior figures, but they sit on the baseline. In this location, they serve as the denominator in a piece fraction. When the figure is lowered below the baseline, it serves as a subscript.

1234567890

Inferior figures

Fractions used to come as a single character on the old Royal manual typewriters, for instance. They were simple to use, limited in quantity (¼ and ½), and fit nicely with the surrounding letters. With all the figures in a typeface from which to choose, they are no longer that simple. There are three types of fractions: case fractions, piece fractions, and level fractions. The single-character fraction from the bygone days of the manual typewriter is the equivalent of the *case fraction*. It is a single character—designed and positioned for proper stroke weight and color. (Its name originated from the days of foundry type when it came out of the case as a single sort.) A *piece fraction* is constructed by the type artist using a superior figure for the numerator, a fraction bar (or *solidus*), and an inferior figure for the denominator. The *level fraction* is constructed using titling figures separated by a slash (or *virgule*).

WITH ALL THE LETTERS AND NUMERALS available for putting thought to paper, punctuation marks and diacritics are needed to fine-tune those words for emphasis and clarity. Punctuation marks are used alone at the beginning of sentences, in the middle of sentences, and at the end of sentences. For all their many purposes, punctuation marks are typeset characters that must fit within the page's typographic texture. If a dash, for example, careens into the adjacent letter, causing a blotch in the texture, its role is weakened. Correct letterspacing around punctuation marks is important, just as it is around letters. If an exclamation point is placed within the quotation marks, when it should have been outside of them, the meaning of the statement is weakened. Typographic quality enhances delivery of the written message—it should not confuse it.

Just as the type artist chooses the correct caps for a situation, the correctly sized punctuation for those caps is important as well. There are fewer choices to make in this category, but there are choices. There are at least six dashes available—the hyphen and the en, em, three-quartersem, figure, and swung dash. To enclose material in text, there are two brackets available—square and angle—as well as braces and parentheses. Choosing the right punctuation mark for the situation (when a choice is available) is important, but inserting the mark comfortably into the text is equally important and more frequently required.

Diacritics are placed in text at the same time as the letter they accompany. The *a* acute (á), the *e* circumflex (ê), and the *o* with an umlaut (ö) are properly spaced when they are set simultaneously. These marks are essential to the different languages that use them, but each

¼ ½ ¾ ⅛ ⅜ ⅓ ⅔
Case fractions

¼ ½ ¾ ⅛ ⅜ ⅓ ⅔
Piece fractions

1/4 1/2 3/4 1/8 3/8
Level fractions

PUNCTUATION MARKS AND DIACRITICS

. , ; : " " ' ' ! ?
Punctuation marks

- – — — - ~
Hyphen and en, em, threequartersem, figure, and swung dash

[] ⟨ ⟩
Square and angle brackets

{ } ()
Braces and parentheses

À à É è Ö ö Ñ ñ
Letters with diacritics

language requires the same level of typographic quality for a seamless delivery of its message.

JOINED CHARACTERS

JOINED CHARACTERS INCLUDE TWO (sometimes three) letters set as a single character. They can be physically joined, such as *diphthongs* (æ); precisely aligned, such as the *f-i ligature* in the Bembo typeface (fi); or joined so long ago, that now it is viewed by many as a character by itself, such as the *ampersand* (&).

Æ æ Œ œ

Diphthongs (aesc and ethel)

Diphthongs were born from a need to indicate an unique sound. A *diphthong* is a merging of two vowels to create a particular sound. Several sounds did not carry over well from Latin into the English language. The diphthongs, *aesc* and *ethel,* are found in words making this crossover. Some words, such as *encyclopædia,* have been in the English language so long that the use of the aesc was dropped—*encyclopedia.*

The pursuit of typographic quality necessitated the use of ligatures, also called *tied letters.* The ascender of the lowercase *f* in many type fonts was so effusive that it extended into its neighbor's set width. With some neighbors, such as the lowercase *o,* making the *f*'s ascender a kern on its foundry type body solved the problem. Letters such as the lowercase *i* and *l,* however, would not relinquish any horizontal territory; thus the need for the *f-i* ligature and the *f-l* ligature. (Originally, the term *ligature* referred only to the stroke connecting the two letters.)

fi fl ff ffi ffl

Minion ligatures

fi fl ff ffi ffl

Bembo ligatures

The lowercase *f* and all its various forms—*ff, fl, fi, ffl, ffi*—are not the only ligatures. Decorative ligatures are available on a typeface-by-typeface basis depending upon the type designer's interest. Ligatures for *s-t* and *c-t* are available in the typeface Adobe Garamond and Minion, although they are not essential for consistent text color, since a lowercase *s* does not naturally collide with a lowercase *t.* The *eszett* (ß) is an *s-s* ligature used in German language typesetting, but was used in the past when setting English.

ct st ct st

Adobe Garamond and
Minion decorative ligatures

The ampersand is a union of the two lowercase letters *e* and *t* from the Latin word *et* (et per se and). These two joined characters create a recognizable symbol for the word *and* that, if done well, fits within the design parameters of the typeface.

& & & &

Some ampersands show their
e t heritage better than others.

SYMBOLS

THE REST OF THE MARKS, symbols, signs, and ornaments possible in a type font fall into the general category of *symbols*—characters that represent a word, monetary system, mathematical function, or flourish. Some of these symbols are designed to fit within the design structure of

CHAPTER TWO

their parent font. Others, such as mathematical symbols, might be in a separate symbol or pi font. Ornaments are not always included, but when they are, these small flowers, flourishes, moons, and leaves add a bit of typographic grace beyond that which the typeface design projects.

৵

UNDERSTANDING TYPE from the inside out unlocks its mysteries and capabilities. Being able to identify its components, to talk about its structure, and to distinguish its stylistic differences are as important to a type artist as a car's components, structure, and style are to a professional car mechanic. All the characters in a typeface are the visual tools type artists use to set type. Knowledge of all the characters at the fingertips, as well as of the structure and style of type, lays the foundation for successfully using type on a page. Type that entices its reader into the subject matter is like a high-performance luxury car.

elephant

FIGURE 2-12: *Restructured letters function as graphics*

SETTING
TYPE
ON A
PAGE

Communicating information from one person to another employs various formats. People hear news on the radio, see documentaries on television, and read commentaries in the newspaper. People also receive information by "mail"—faxes, e-mail, voice-mail, and the more conventional envelope-with-a-stamp-on-it-mail. Passing along information to one person or to many people occurs between individuals and corporations, amateurs and professionals, as well as families and neighbors. Communicating information to others concerns such diverse groups as medical health service providers and municipal law enforcement agencies. Even the traditional mail carriers want to get the word out about their services, their stamps, their mail trucks, and more.

Print media—words and images on paper—constitutes a sizable proportion of these communications. A page (in a book, in a booklet, as a direct mailer, or as a single advertisement on a larger page) is a collection of written and pictorial elements placed together for a single purpose—to communicate a particular message. A writer wants to tell the reader something specific. The message can be promotional—the company has a product or service to sell. The message can be informational—a new pet owner receives a booklet on kitten care from the veterinarian.

To design a page is to design a map for the reader's eye to follow. This page-map leads the reader to and through all the page elements—the headline, subheads, text, and visuals. Designers are to the page what

the auto club is to a road map. The auto club plans the route the motorist takes through the countryside or city. The designer plans the route the reader takes through the visual landscape of the page. Unlike the designer, the auto club can not relocate states to improve the trip. A designer, on the other hand, can arrange, scale, and select the page elements to communicate the message expeditiously and effectively.

All the visual elements on the page work to enhance a communication—to make the reader's understanding of the message particular and clear, rather than general or vague (unless general and vague are the sender's intent). Word for word, the text elements typically outnumber all others on the page. Surprisingly, they can be the elements most often overlooked and least considered.

WELL-EXECUTED PAGE TYPOGRAPHY enhances the act of reading. Typeface selection, type measure, and type alignment are some of the type decisions that enhance readability. On the page, however, the typographic elements are design components as well. Type is not just a designed element, but an element of design. The same decisions that affect readability also affect page design. Typeface selection, type block placement, and use of white space integrate the typographic elements into the overall design of the page and expedite the reader's movement around the page. It is not enough to get all the type on the page—using it effectively shows it was worth putting there.

When working with words, it all gets back to reading. How is it done? What is expected? What makes it hard work? A discussion of reading begins with the definition of two words: *legibility* and *readability*. They are not interchangeable. *Legibility* refers to the reader's ability to identify letters. It is a characteristic of typeface design. If the reader is unsure whether a letter is a lowercase *o* or *e,* then the letter is not legible. The reader cannot make a correct identification. *Readability* refers to the reader's ability to identify and comprehend words, sentences, and paragraphs easily. It is a characteristic of typography. Setting a page in a legible typeface enhances the page's readability, but it does not guarantee it. Legibility is a result of the type designer's work. Readability is a result of the type artist's work.

THE PRIMARY DETERMINANT of legibility is typeface design. The design style imposed on the letters of the alphabet by the type designer might distort the letter shapes beyond recognition and decrease legibility; or it might enhance the appearance of the letter shapes and increase

TYPOGRAPHY AND READING

Legibility and readability control reader interaction with type on the page.

LEGIBILITY

The type designer determines a typeface's degree of legibility.

Letter structure affects legibility.

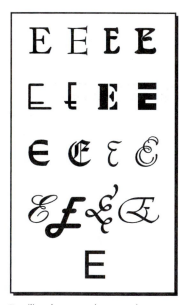

Familiar character shapes enhance legibility.

legibility. A type designer's treatment of structural anatomy determines the reader's ability to recognize the characters within a typeface. An uppercase *E* with only two arms can appear to be an *F* or a *C*. The size of the eye in a lowercase *e* controls the ease with which the reader identifies the *e*. If it is too small, it may look like a lowercase *c*.

The human brain works diligently to find patterns in visual elements. If a type designer imposes an unorthodox design style on a typeface, the reader can identify the letters once they become accustomed to the style's characteristics—but only if they are applied to strokes, curves, stems, and serifs uniformly. This may be a time-consuming task, but unorthodox design styles applied consistently are decipherable by those willing to take the time to do so.

Concern for typeface legibility is not new. Typographer and type designer Morris Fuller Benton (1872–1948), son of Linn Boyd Benton, the inventor of the Benton matrix cutter for foundry type production, did extensive eyesight and reading comprehension research before designing his Century Schoolbook typeface in 1924. Century Schoolbook became the mainstay for textbook type design, as well as the standard for legibility issues in typeface design. Morris Fuller Benton, the most prolific American typeface designer, has been called "the unknown father of American typeface design," due to his vast, diverse contribution of designs—Souvenir, Franklin Gothic, Stymie, Broadway, Clearface, and Hobo, to name a few (Haley 1992).

In his *Essay on Typography*, the typographer Eric Gill (1882–1940) wrote, "Legibility, in practice, amounts simply to what one is accustomed to." Handwriting is a good example of this statement. People can read their own handwriting, but many have difficulty identifying even one or two letters in someone else's. Writers probably can identify all letters in their own handwritten sentences and paragraphs. Writers are accustomed to the shapes and angles of their personal handwriting style. That is not to say because something is legible to a single reader, it is legible to all readers. When choosing a typeface for a page, it should be legible to the widest audience possible.

Typeface features that enhance legibility are open counters (*x*-height is one determinant of this), familiar character shapes, medium stroke contrast, and avoidance of extremes in stroke weight, stroke contrasts, and serifs. Enlarging a typeface cannot make an illegible typeface legible. If a typeface chosen for continuous-reading text is not legible, it is time to select a new one.

CHAPTER THREE

ALL DECISIONS MADE by the type artist affect readability. Every typographic decision on the page, in a paragraph, and in a sentence dictates the ease with which the reader travels through the type blocks to the message's end. (A *type block* is a shaped area of type [usually rectangular, but not always].) If the reader becomes confused, tired, or discouraged while reading (or thinking about reading) a document, the message is not delivered.

For example, if the type blocks are too wide, the reader can lose the way back to the beginning of the next line and begin rereading the original line. If the lines are too close together, an alluring ascender or a devilish descender can divert the reader into an adjacent line. Reading the first half of one line with the second half of another seldom makes sense. Confusion is caused also if the headline's type style is too informal for its content. In this instance, confusion causes the reader to stop reading and wonder about the veracity of the message. Most typographic decisions influence readability, directly or indirectly.

Letter Case and Readability. When reading conditions are good, an experienced reader reads 300 words or more per minute. Such readers use the word's shape created by the accumulated letters to identify each word, rather than the shape of each individual letter. The faster they identify a word, the sooner they proceed to the next one and so forth over and over throughout the paragraph. It is only when readers come upon an unfamiliar word shape that they are forced to sound out the word letter by letter and syllable by syllable. A familiar word is just as puzzling when it does not appear in its customary shape. If the type artist removes all the unique visual clues from a familiar word, by setting it in uppercase, for example, readers proceed slowly, forced to identify the word one letter at a time.

The word *typography* has a unique word shape. The rise and fall of ascenders and descenders give it a distinctive form. The word *trigonometry* uses many of the same letters, but since the placement of ascenders and descenders differs, the resulting word shape does too. If both words are set in uppercase letters—*TYPOGRAPHY* and *TRIGONOMETRY*— the unique characteristics of their word shapes disappear. Words set in all caps have relatively uniform word shapes. Their individual distinctiveness is eliminated. Setting a sentence in all capital letters forces the reader to view each word carefully, thereby decreasing reading speed. Setting a sentence in uppercase and lowercase letters quickly enables the reader to identify and comprehend familiar words.

The type artist controls the readability of a page.

Lowercase letters create identifiable word shapes.

Uppercase letters eliminate word-shape distinctions.

Readers use word shapes, not individual letters, to identify words.

Type set in all uppercase letters adds emphasis and decreases reading speed.

Readability OR *READABILITY?*

Zapf Chancery is not designed for all-caps usage.

Heavy stroke weights give emphasis to headings.

Heavy stroke weights diminish legibility of text type.

counter size

counter size

counter size

Heavy stroke weights in small sizes diminish legibility.

counter size

counter size

counter size

Lighten stroke weights as type size decreases to improve legibility.

When readability issues are not critical, as with short word groupings (headlines and subheads), using all uppercase letters (the visual equivalent of shouting) can get the reader's attention, give emphasis to a word, or make type look bigger without changing its point size. Not all typefaces should be set in all uppercase letters. Script or cursive typefaces, such as Zapf Chancery, have elaborate swash caps designed to call attention to the beginning of a word. Setting a word with all swash capitals draws attention to every single letter and destroys the word's visual cohesion. Such an inappropriate use of these beautifully designed swash letters is a visual nightmare. It is safe to say that almost all script, cursive, and swash typefaces should not be set in all capital letters.

Type Weight and Readability. The nineteenth century was a time of change and experimentation in printing and type-production techniques, due in part to an increased need to get information to people in the form of books, posters, and newspapers. It was during this time that boldface or bold type was introduced, much to the chagrin of some typographers. Bold letterforms are harder to read than book-weight letterforms, because their counters are smaller. The smaller counter diminishes legibility. Typefaces with weight distinctions of *black, ultra, bold,* and *extra bold* are suitable for headlines. These visually dynamic letters pop off the page and call attention to their message. In display sizes, the reduction of counter size does not slow the reader significantly, because only a few words are affected. Bolding provides needed emphasis, as do capital letters, when used selectively for subheads and captions. Black or ultrabold type is suitable only in display sizes, such as 24 points and above. The increased size maximizes counter size and improves legibility. For smaller sizes, the type artist uses semibold type.

Heavy stroke weights are unsuitable in text sizes for continuous text. Here the diminished legibility coupled with the small size tires the reader, slows reading speed and comprehension, and provides ample reason to stop reading. An entire paragraph set in a 12-point bold typeface is difficult to finish.

Point size is directly related to stroke weight. As the point size of a bold typeface increases, so do its stroke weight and counter size. The proportions of stroke to counter remain the same, but the surface area increases. Conversely, as the point size of a bold typeface decreases, so too does the surface area of its stroke and counter. Choosing a lighter-weight typeface, as the point size of text decreases, keeps the counters large enough for easy identification and improves readability. The

weight distinction *book* indicates that this stroke weight is appropriate for continuous text—books, for example.

Type Style and Readability. Type families also include style distinctions, such as *roman, italic,* and *oblique,* for the typographic page. Roman typefaces are the most readable of all, since theirs is the most familiar character shape. Consequently, roman type is the best suited for continuous text. Italic and oblique typefaces are variations of the roman style.

Italic typefaces are a structural redesign of the typeface's roman letterforms. These condensed, angled typefaces are the most difficult of the three to read, but they are suited for limited use within a sentence. Setting an entire paragraph in italic is comparable to setting it in boldface type. Readers would struggle and tire with such a type block.

Italicized type is suitable for one or two lines of type, as a subhead, heading, or caption. In limited doses, it is extremely effective. Type artists use italics to separate one type line from another. On a business card, for example, the name set in roman is visually distinct from the title set in italics—without a type size change. (See chapter 5.)

Oblique typefaces are a slanting of the original roman and more closely resemble the original roman shape. This visual similarity makes them easier to read in a lengthy block, but less effective than their italic counterparts for specialized use or emphasis within a sentence.

Reading Patterns and Readability. A good type artist respects the studied reading patterns and mechanics of reading. English-language readers read from left to right and from top to bottom, more specifically, from the upper-left corner to the lower-right corner of the page. While that is no surprise, it is a reading characteristic that the type artist should work with, not against. For example, after reading a short, wide column, the reader exits the paragraph on the right side. If the next design element on the page is positioned there, the reader moves to it easily. A tall thin paragraph is an excellent way to move the reader vertically downward to the next page stop. Working with the reader's natural inclinations eases the task of moving the reader through a document.

Stock and Readability. The term *stock* refers to printing paper. A designer, for example, chooses an appropriate stock for a client's brochure. The printer uses that stock for the job when the brochure goes to press. A stock's color and *finish* (surface texture) directly affects the legibility and readability of printed type. A stock's finish can be bumpy, smooth, or rough. Stock finish and color add to the emotional and cognitive response the viewer has to a printed brochure or page.

In a type family, the roman style is the most legible and easiest to read.

> Roman is upright.
>
> *Italic is restructured.*
>
> *Oblique leans.*

William Addison Dwiggins
Type Designer

Changing type style controls emphasis without changing size.

English-language readers move from the upper-left to lower-right corner.

High contrast between type color and stock color improves readability.

Stock texture should influence typeface selection.

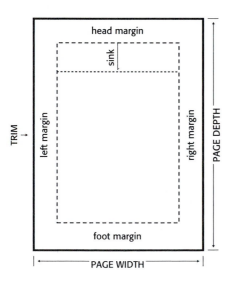

A stock's finish affects typographic quality.

PAGE GUIDELINES AND MEASUREMENTS

When choosing stock color, the type artist should maintain a strong contrast between type color and stock color. Printing black type on dark gray paper compromises the readability of the page because the reader has a difficult time distinguishing the letters' edges. They blend with the color of the stock. This is particularly important as it relates to target audience. Some readers can tolerate more work for their reading than others.

When choosing stock finish, the type artist should keep in mind that there is a link between stroke weight and stock finish. As the roughness of a stock's finish increases, so too must the type weight to compensate. The finish determines the quality of the printing surface. If the finish (printing surface) is rough, a lightweight typeface might break apart. The thin strokes cannot make a bold enough mark to visually compete on the bumpy surface. A smooth finish provides a flat printing surface, which enables a good reproduction of the type. In this case, the finish does not compete with the delicate stroke weights of the printed typeface. The typographic page appears as the type artist intended.

Working with type on a page is a form of communication. How the reader interacts with that page and how the stock affects the type elements on the page should influence the type artist's decisions.

PAGES AND THEIR COMPONENTS are measured using a combination of inches or millimeters, picas, and points. The term *page* is applied to an entire document, such as an 8½-by-11-inch flyer. The front side of the page is called the *recto;* and the back side the *verso.* If the document opens like a book with two facing pages, it is a *spread.* The left page is the *verso.* The right page is the *recto.* Page width and depth are measured in inches or millimeters.

The *margin* is the white space surrounding all items that print; it extends to the finished edge of the page, called the *trim.* Margins on a single page are identified by location—top (or head), bottom (or foot), left, and right. On a spread (fig. 3-1), they are identified as the *head margin* (top), *foot margin* (bottom), *fore-edge margin* (outside), and *back margin* (inside). The back margin is also referred to as the *gutter margin,* but the *gutter* also describes the white space between columns on a page.

Drawing horizontal and vertical lines along the outermost page elements forms a rectangular shape. This area, the *type page,* includes all elements that print—type, illustrations, photographs. Within the type page, the *text page* refers to the primary text area, excluding all smaller

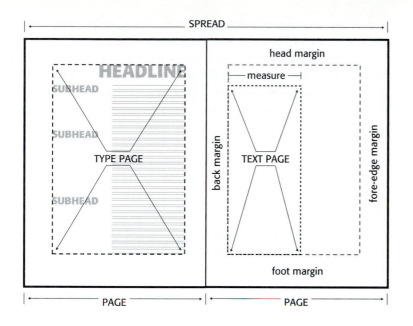

FIGURE 3-1: *Spread elements*

type elements such as captions, running heads, and page numbers, as well as graphics.

It is easier to use picas and points for measuring the width and depth of type blocks since typefaces are measured in points. A *pica* equals 12 points (1 pica = 12 points). There are 6 picas to one inch (6 picas = 1 inch). Using the same measurement system enables the type artist to see relationships between measurements more easily.

The area anywhere on the page that does not print is called *white space*. The white space from the top edge of the type page to the topmost ascender of the nearest type block is called the *sink* or *sinkage*. On a multiple-page document, the sink on the first page identifies the starting point. If a lengthy document includes chapters or similar major sections, a sink is an effective method for drawing attention to a new section. Points and picas are used to measure white space—the distance between type blocks, for example.

BEFORE TYPE APPEARS on the page, the type artist receives the document's copy. The *copy* is the material the type artist will typeset. With a book, the copy is the typewritten manuscript. For almost everything

PAGE TYPOGRAPHY
PRELIMINARIES

AaBbCcDdEeFfGgH
AaBbCcDdEeFfGg

Adobe Garamond (top)
Souvenir (bottom)

Magic!

MAGIC

MAGIC

Magic!

Investments

Investments

Investments

Typefaces create a visual environment within which the reader interprets the typeset message.

else—advertisements, newsletters, brochures, or annual reports—the copy is the handwritten or typewritten words to typeset.

Reading the copy is the first step to selecting type for a page. Reading introduces the type artist to the subject matter (product, service, event), to the tone of the material (lighthearted, serious, authoritative), to the context (continuous, discontinuous, technical), to the target audience (grade-school children, retirees, vacationers), and to the format (newsletter, flyer, annual report). This information prepares the type artist for the many type decisions that follow.

For example, the typeface Garamond is an elegant typeface, but its small x-height might make reading difficult for some target audiences. The typeface Souvenir is a readable typeface, but its informal style might be inappropriate for some subject matter. The impact of a message is strengthened or weakened by the appearance of the messenger—the typeface. Knowing what is being said enables the type artist to make appropriate type choices.

The broadest determinant for categorizing copy content is formality. Are the written words informally or formally presented? Is it a flyer about a Saturday-afternoon magic show for five-year-olds or a handout about tax investment services for corporate executives? The tone of the words, the subject matter, and the target audience in this example are dramatically different. The magicians in a magic show want to emphasize fun, excitement, and pizzazz! The tax investment professionals want to emphasize trust, stability, and expertise. The reader evaluates the quality of the service or product based upon the typeset message, because that might be the only item the reader has to appraise this previously unknown organization or service. If the typefaces for these flyers were reversed accidentally, the readers might conclude that the magic show will be low key and the expertise of the tax professionals suspect.

The second step when preparing copy for typesetting is identifying the different kinds of type blocks required for the material. What is the headline? Are there any subheads? Do the visuals have captions? Is the text copy lengthy or short? What emotional impressions does the text project or did the client request? Even subjective terms, such as stately, classic, or strong, are useful when looking through the available typeface library.

Although it is not part of the page decisions directly, it is helpful to note whether the text copy has any special requirements that would limit the type family selection. For example, if it is technical text filled with figures and symbols, an expert collection or a special pi font is

useful. If the text contains many foreign words that require italicizing, it is good to note that also. If the text copy is several pages in length, noting the need for a typeface suitable for continuous text is beneficial. The more the type artist knows about the copy, the better the typeset result.

BEFORE PAGE-LAYOUT APPLICATIONS were available for use with personal computers, placing type on a page required illustration board, a T square, rubber cement (or wax), type books, a type gauge, scratch paper, and a good head for math. Type was set by professional typesetters who spent the day (hurriedly) setting type according to a designer's written instructions. Before the typesetter received it, however, the designer had counted each letter and space to find out how many characters the text contained; consulted the type book to find out how many characters of the chosen typeface would fit in a single pica; multiplied the number of characters in a pica times the type measure (in picas) required for the layout; and divided the number of characters per type measure into the total number of characters. All this was done to find out how many lines the text block required (fig. 3-2) and, consequently, whether or not it would fit in the allotted space. The wise designer did all these calculations while executing the layout (before the client saw it) to make sure everything fit—in something larger than 4-point type.

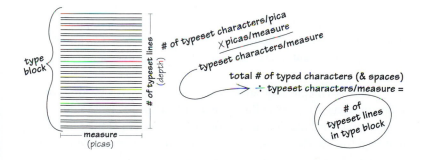

FIGURE 3-2: *Copyfitting formula*

Few designers long to return to those days of mathematical gymnastics, because the emphasis was on fitting the type into the allotted space. Readability, legibility, and typographic quality sometimes took a backseat to getting it on the page. Computer page-layout applications enable today's type artists to place all the type on the page immediately. Making it fit is achieved by manipulating the type attributes (typeface,

Electronic copyfitting emphasizes the interaction of typographic elements rather than type fitting.

size, leading, and style, to name a few). True, these were the factors the designers previously controlled too, but there were times when the type foundry was closing in 45 minutes and if it was not called in immediately, the client could forget about receiving the finished art at noon the next day. Sometimes the crisis of the moment got the better of the typographic quality.

Now the type artist has the opportunity to make the type choices within the context of the advertisement. The type artist can set the copy in all faces and sizes and can evaluate the results in relation to the other page elements. This is better. The designers, or type artists, have gained the ability to compare different type solutions without buying them from the type foundry. What they also gained is the title *typesetter.* The designer no longer goes home while the foundry's night shift sets the type. Each and every comma, period, and question mark is the sole responsibility of the type artist (who now must know how to type). All the typographic nuances designers should have known, but did not learn in art school, were deposited back in their laps (and the lap of everyone else using type on the computer). Now there is a new cadre of typesetters who spend the day (hurriedly) setting type according to their own instructions, and they do not close until it is done.

PAGE TYPOGRAPHY DECISIONS

When the type is poorly chosen, what the words say linguiſtically and what the letters imply visually are disharmonious, dishoneſt, out of tune.

——————————— Bringhurst
Elements of Typographic Style

Page type elements create visual distinctions between type levels while maintaining the visual unity of the page.

TYPE ELEMENTS ON A PAGE are a blend of written words (content) and visual graphics (typeface). The availability of extended type families provides the type artist with a range of stylistically unified typefaces for headlines, subheads, captions, text, and other type elements. Using a single type family automatically unifies the design style of all type blocks.

There is a hierarchical structure between page type blocks. The different levels of type (headline, subhead, text) are assigned a different typographic attribute to visually prioritize the weight of their message and establish the visual hierarchy. Type level treatment should remain consistent throughout the page or document.

The point of this visual hierarchy is not to identify each type block so distinctly that it no longer belongs to the total page. If the subheads are more prominent than the headline, the message makes no sense. Readers are attracted to the subheads before they read the headline. A page is a single unit, just as a chorus, composed of many vocalists, sings as one unit. The sopranos, altos, tenors, and basses add depth, harmony, and texture, but their voices unite for a single vocal presentation. The typographic elements on a page blend with and support one another for

a unified visual presentation. The headline starts it off, the subheads chime in, and the text fills in behind them for body and depth of meaning. The visual distinctions identifying one type block from another should not break the entire page into isolated soloists. If all type blocks project with equal volume, they disrupt the logical blending of elements. As a result, the reader sees chaos and confusion, not a complete, harmonious presentation.

AFTER READING THE COPY and understanding its intent and special needs, the type artist decides what type family or families will satisfy the type requirements of the page. The type selection should project the mood, image, or emotional feeling required by the copy. If more than one type family is used, choosing the display face is more important initially. Having identified all levels of type blocks required by the text, the type artist needs a type family with enough styles to meet those requirements. Also, the type family should complement the mood and style of any illustration in the document.

It is easy to make a distinction between what is a legible typeface and what is not. Deciding what typeface suits the content and emotion of the page involves more than legibility. Besides the obvious style differences of decorative typefaces that suggest scenes from King Arthur's court or script typefaces that elicit thoughts of quill pens or unique period typefaces reminiscent of manual typewriter type, a type artist frequently makes style distinctions based on more subtle design differences.

The projected mood or emotions of a typeface should match the copy it sets.

Deciding to use a serif typeface or a sans serif typeface is a frequent question. Typefaces with serifs project a more formal appearance. The serif finishes the stroke, just like the top hat on a tuxedo-clad Fred Astaire. Functionally, a serif typeface is easier to read. The serifs form a definite top and bottom, which establishes a horizontal line for the reader to follow across the paragraph. The reader's eye is locked into this typographic channel and moves easily from left to right and back again. In addition, the serifs keep the letters a fixed distance apart. This isolates each letter's shape and enhances legibility.

In broad terms, serif typefaces project a formal appearance. Sans serif typefaces create an informal atmosphere.

Sans serif typefaces have an informal appearance. The finishing touches are missing. Without a serif to hold the reader on each type line, the type artist manipulates the leading to isolate the lines and to form a typographic channel.

There are many exceptions to this general observation of serif and sans serif typefaces. The typeface ITC American Typewriter has serifs,

AaBbCcDdEeFfGg
abcdefghijklmnopqrstuv
wxyz 1234567890 .,?!&

ITC American Typewriter

AaBbCcDdEeFfGgH
abcdefghijklmnopqrstuv
wxyz 1234567890 .,?!&

Optima

AaBbCcDdEeFfGg
abcdefghijklmnopqrstuv
wxyz 1234567890 .,?!&

Caslon Swash Italic/Roman

AaBbCcDdEeFfGg
abcdefghijklmnopqrstuv
wxyz 1234567890 .,?!&

Caxton

One or two type families provide all the text block differentiation needed for a single document.

Two sans serif or two serif type families in a document do not provide enough design contrast to warrant using both.

but the monoweight strokes and the cupped rounded serifs make this anything but formal. This typeface typifies a quick trip to the fast-food restaurant, not dinner out with Mr. Astaire. The typeface Optima is a sans serif typeface, but its variable stroke weights and graceful splayed stroke ends give it an elegance that American Typewriter cannot touch. Even considering the exceptions, the broad generalizations provide a place to start.

Combining Type Families. Combining type families enables type artists to use unique typefaces as attention-getting headlines and perhaps as subheads and then to use an easy-to-read typeface to deliver the bulk of the message. Choosing more than two type families in a document places too many competing visual styles on the page. (This does not include the company logotype or a newsletter's nameplate.) Too many type families destroy the visual continuity of the message and the page design. The book *Looking Good in Print* (Parker 1993) characterized the overuse of typefaces in a single document as "the 'ransom note' school of typography." With too many typefaces, the reader is asked repeatedly to identify letters in different shapes, proportions, and styles. All this visual retooling forces the reader to get reacquainted with the visual landscape. This detracts from the purpose of the type—to be read. Using a single type family for a document, on the other hand, provides a built-in design unity while still offering the ability to distinguish one level of typography from another. Typeface weight, style, size, and white space are all visually effective ways to differentiate message levels.

Pairing a serif type family for the text type and a sans serif type family for the display type is an effective traditional usage for two type families. The serif typeface works well for the text copy, because serifs aid readability. A sans serif typeface works well for headlines, subheads, and captions by providing design contrast. Because each of these uses employ short, discontinuous type blocks, the readability issue is not a major concern.

Another combination of typefaces to use is a distinctive, decorative typeface for the headline and a clean, legible type family for everything else. This enables the type artist to introduce a unique typeface to establish the proper visual context while maintaining an easy-to-read document with a large type family.

A type artist should base the selection of each type family on how they work together. For example, choosing two serif typefaces for a single document is confusing. If the type artist wants a serif typeface for

the text as well as the display type, then choosing a single large type family serves both purposes. Two serif typefaces are too similar in design to make a strong visual distinction within the hierarchy. The same reasoning discourages selecting two sans serif typefaces. A serif paired with a sans serif typeface creates a visual contrast that enables the reader to distinguish the type hierarchy easily.

Determining which two type families to pair in a document depends upon their structural similarities. The type artist should compare structural widths, stroke weights, and x-heights. A narrow sans serif typeface with a short x-height, such as Kino, is not complementary to a wide serif typeface with a tall x-height, such as Memphis. Either of the serif typefaces Utopia or ITC Fenice (fig. 3-3) is better suited as a companion typeface for Kino.

AaBbCcDdEeFFGg AaBbCcDdEeFfGg

FIGURE 3-3: *Kino and ITC Fenice are structurally similar*

There are exceptions to the rule. Some decorative typefaces are so distinctive, so unusual, that sans serif or serif is not their major distinguishing feature. The typeface Machine, for example, is a strong, decorative sans serif typeface straight from the football field with a substantial stroke weight. The strength of this typeface contrasts almost any typeface, sans serif or serif. The objective here is to find a typeface that is structurally similar, condensed, and not too light so it will not be overpowered by the heavyweight Machine. The consistent stroke weight and narrow set width of ITC Officina Sans can stand up to Machine and compete well on the same visual playing field.

Similar choices are made when selecting a script typeface, such as Pepita, for a headline and then pairing it with the graceful Optima. The more a type artist successfully pairs typefaces together, the easier (and more fun) type selection becomes.

Many type families are so visually distinct that they establish the correct emotional link with the reader all by themselves. Typefaces, such as Caxton, Garamond, Caslon, Perpetua, Bembo (the list is endless) are so well designed that using one of them alone is a visual delight. Good typography does not necessitate an endless supply of typefaces (but do not turn any down). It does require a selective palette that includes the timeless beauty of a Perpetua or a Garamond, over a faddish, soon-to-be-dated newcomer. The seasoned typefaces, such as Bodoni, have been

AaBbCcDdEeFfGgH
abcdefghijklmnopqrstuv
wxyz 1234567890 .,?!&

Bembo

Structurally and proportionally similar typefaces make good partners on a page.

AaBbCcDdEeFfGg
abcdefghijklmnopqrstuv
wxyz 1234567890 .,?!&

Pepita/Optima

ABCDEFGHIJKLMNO
abcdefghijklmnopqrstuv
wxyz 1234567890 .,?!&

Machine/ITC Officina Sans

One type family can provide all the visual contrasts and aesthetic enhancements a document needs.

AaBbCcDdEeFfGgH
abcdefghijklmnopqrstuv
wxyz 1234567890 .,?!&

Perpetua

refined over the years almost to visual perfection. Smart type artists know to reap the benefits of the talented type designers that came before them.

VISUAL PAGE HIERARCHY recognizes the unique role each type block plays in a typographic message. The headline (the town crier, the attention getter) is at one end of the spectrum and the text (the fine print, the details) is at the other end. The subheads are visually between those two extremes. By position, the subheads are closer in content to the text than the headline. They should have a stronger typographic tie with the text, but not so much so that they pale in comparison to the headline. A quick scan by the reader should include the content of both the headline and the subheads.

Subheads divide the text into *site*-size pieces. A lengthy expanse of text does not look daunting when it appears as three smaller subcomponents of a whole. Subheads also provide a break, a pause in reading, before continuing into the next text section. The surrounding white space, if properly proportioned, indicates that a section ends (more white space) and a new one begins (less white space). Setting type on a page is a visual balancing act. If the type artist remembers the roles of the distinct type levels, it is not difficult to assign correct visual markers.

The display typeface of the headline triggers an emotional response, or establishes a context for the page in the eyes of the reader. If the headline is to be the first page element the reader sees, it must be strong enough to get the reader's attention. If a graphic is the attention getter for the page, then the headline is the first typographic element the reader sees. In both instances, the headline complements the visual—either in style or in subject. For example, a typeface reminiscent of the Old West (fig. 3-4) establishes a context and is aptly placed with photographs of stagecoaches and saloons. A well-chosen headline typeface prepares the reader for what is to come.

HEADLINES AND SUBHEADS

Subheads divide lengthy text into *site*-size pieces.

Headlines set the initial tone of the page.

ITC American Typewriter prepares the reader for an article on typing speeds and techniques.

FIGURE 3-4: *Proper type selection establishes a mood*

Headings are phrases, snippets of thought, not lengthy sentences or statements. If a headline or subhead requires more than one line, the type artist should divide it according to logical pauses between word groupings. They should never be hyphenated. Dividing a heading logically (by isolating related word groupings) helps the reader understand its meaning. Letting the software divide the heading according to the line's length can emphasize unimportant words or present a puzzling message. Both occurrences confuse the reader. Delivery of a heading needs proper pacing and enunciation.

If there are insufficient words to warrant splitting the heading into two lines, the following techniques can reduce the amount of horizontal space a heading requires: decrease the type size, decrease the type weight, increase the type measure, switch from all uppercase letters to uppercase and lowercase letters (fig. 3-5), or select a typeface with a narrower set width.

Headlines and subheads are written concisely and not hyphenated.

The typeface Kino projects the height and sleek appearance of the subject matter.

| RENOVATION REKINDLES ECONOMIC GROWTH | Renovation Rekindles Economic Growth |

0 3 6 9
PICAS

0 3 6 9
PICAS

FIGURE 3-5: *Uppercase and lowercase letters require different horizontal space*

Distinctive typeface design styles, such as decorated letters, inline type, or typefaces with exaggerated features, are well suited for the role of attention getter (as headlines), but are inappropriate for text type. These virtuoso styles are graphic elements unto themselves. They would not shrink from view or bow to the message as a text typeface must do. The fact that they are harder to read is not problematic, since a headline contains so few words. The extra effort needed to read headlines is outweighed by the mood, image, or emotion they establish on the page.

The last word of the headline determines the reader's location after reading it. (This is not usually an issue with subheads because they have shorter measures.) The headline should lead or attract the reader to the next page element. The headline may function as the attention-getting element on a page, but it is not a soloist in this visual presentation. It too must hand off to another typographic or graphic element, so the message can continue.

Headlines can support extreme type styles.

A well-placed headline leads the reader to the next page element.

FIGURE 3-6: *Graphic and text elements create a visual path for the reader's eye to follow*

A good type artist sees a type block as individual words (What does it say?); as a graphic (What shape is it?); as a guideline (Where does it take the reader?); and as a design style (What emotion does it project?). Type as a visual element has many important roles for the type artist to orchestrate.

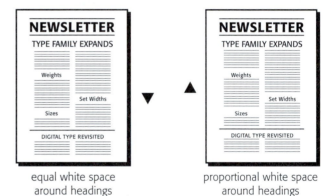

equal white space around headings

proportional white space around headings

FIGURE 3-7: *Properly placed white space guides the reader from a heading into its corresponding text*

Properly proportioned white space links the heading to its text.

The amount of white space around a headline or subhead also helps to identify the text block it introduces. By placing more white space before a heading than after, the reader associates the subhead with the text block that follows. Floating a subhead evenly between two text blocks stops the reader's momentum. There is no clue as to what happens next (fig. 3-7). By placing more white space after the first text block and in front of the subhead, the reader understands that the first section

ended. The white space suggests a pause—exit the text section, coast a bit. After reading the subhead, the small amount of white space that follows serves as a short entrance ramp into the next information highway (text block).

A triangular cap on a column of text provides an optical transition from the heading above into the wider text block below. If a headline is not as wide as the type artist wants, it should be divided differently. Headings should never be justified. Headlines and subheads are short bits of type. Justifying so few words destroys the rhythm of the letter-spacing and pokes white holes in the heading.

Setting an entire word in capital letters can emphasize its message, if used selectively. Excessive use of uppercase type, however, has the opposite effect. The impact of the capitalized word is lost when all the words are capitalized. The same principle holds true in other venues. For example, if cats were cloaked in feathers rather than fur, the lone feather dangling from a tabby's lips would not automatically link him to the empty bird cage. Type artists should not overuse capitals (remember the feathered cat).

With an unavoidable lengthy headline, the type artist could set one word in all caps and the rest of the headline in upper- and lowercase letters (fig. 3-8). This serves as an effective transition between the headline and the text that follows.

Multiple-line headings benefit from a short top and a long bottom line.

Letter case controls headline emphasis when selectively applied.

FIGURE 3-8: *Letter case controls emphasis in lone headlines*

One purpose of a subhead is to call attention to a subsection of text. Starting a subhead at the end of a column or at the bottom of a page without sufficient text lines following it deemphasizes the subhead. An isolated subhead is meaningless. For a single-line subhead, at least two text lines should follow it, providing the block of text lines is taller than the subhead. If it is not, more lines are needed. For a multiline

At least two or more lines of text follow a subhead.

subhead, the depth of the text lines should be more than the depth of the subhead. Just as placing even white space before and after a subhead strands it from the text it introduces, marooning a subhead at the bottom of a column or page results in a similar problem. The relationship between subhead and text is weakened with such placings.

When designing the type hierarchy for a book, a book designer uses different levels of headings to subdivide the text. A *run-in sidebar* is the lowest-level subhead. It is set in italics, followed by a period, and positioned on the first line of a paragraph with an indent. The same principle (with a twist) is employed with the embedded subhead, but it creates a more prominent division in the text.

When subheads are not designated by the copywriter for lengthy text, the type artist can use the first few words of a paragraph (or a short first sentence) as an *embedded subhead.* With this technique, the type artist increases the point size and changes the typeface style of the first few words of the paragraph. This style and size change calls attention to a new subsection without adding words or using much more vertical space. An embedded subhead needs additional white space in front of it, but does not require a line indention. This subhead technique positions the subhead closer in content to the text than a traditional subhead. Consequently, its typographic treatment is closer to that of the text. If the copy's length requires a stronger subhead, a skilled type artist can manipulate type attributes to emphasize the embedded subhead without tearing it from its text foundation.

Not all copy lends itself to this treatment. If the wording does not cooperate, the type artist can insert an ornament in between two sections of type to provide the reader with a well-deserved reading pause. As with everything else, this technique must be applied consistently throughout the document.

CAPTIONS IN A DOCUMENT are used with photographs, illustrations, or diagrams to identify or clarify the graphic. Unlike a subhead, a caption's role as a visual is a minor one, but for content and clarification, it is an important one. Its proper placement links it to the graphic it identifies and clarifies. If the type artist leaves it off, pairs it with the wrong graphic, or positions it too far away from the graphic, its usefulness is compromised. With appropriate identification in the caption, such as the words *Figure 3,* the type artist can reference the graphic in the text and notify the reader that a visual accompanies that passage.

An embedded subhead serves as a subhead and the first words of the paragraph.

Seafaring captains tell the tallest tales about the Portland Head Light built in 1791 at the mouth of

Seafaring captains tell the tallest tales about the Portland Head Light built in 1791 at the mouth of the

Embedded subhead with type style link to text (above) and type style link to headline (below)

CAPTIONS

A caption is the same size as the text or slightly smaller.

Since a caption is discontinuous text, its readability is not as critical as the main text. Nevertheless, it should not be hard to read. Some type artists distinguish the words *Figure 3* with same size bold or italic type as the rest of the caption in order to separate it, but not isolate it, from the caption. The type artist also could set the word *FIGURE* in all caps to distinguish it from the lowercase caption text.

Limiting the number of lines required by a caption makes it easier to position with other page elements. If the caption requires two or more lines, the type artist should divide it logically, just as a headline or subhead. Although a caption is discontinuous text, there is a logic to its content. Dividing it incorrectly destroys that logic.

Correct placement of captions determines whether or not the reader sees them. If the caption is too close to the graphic, it crowds the graphic and is difficult to notice and read. If the caption is too far away from the graphic, the reader might not understand its purpose.

When positioned below a graphic, aligning the left end of the caption with the left edge of the graphic creates a visual link between the two. Captions should not exceed the width of the graphic.

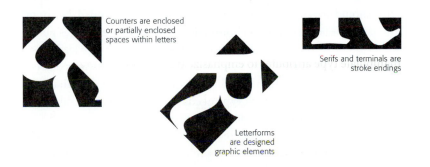

Counters are enclosed or partially enclosed spaces within letters

Serifs and terminals are stroke endings

Letterforms are designed graphic elements

FIGURE 3-9: *Placement visually links captions to graphics*

When positioned alongside a graphic, the caption should align flush along the graphic's adjacent edge for a cleaner visual placement. (See "Type Alignment" later in this chapter.) Aligning the caption's cap line with the top edge of the graphic or the baseline of the caption's last line with the bottom edge of the graphic is effective also.

TEXT TYPE REPRESENTS the largest amount of characters in a document. It requires the greatest attention to detail. For typography on the page level, the type artist determines type style and type measure.

A caption is short and easy to read.

Captions require proper placement to function.

TEXT

Properly set, legible text typefaces render readable text.

The amount of reader contact with the text determines the role readability plays in text style and measure choices.

Extreme style characteristics are unsuitable for continuous text typefaces.

A 66-character measure is recommended for continuous text.

(Leading for type style and measure is discussed in chapter 4.) Each type attribute affects readability, although some more significantly than others.

The type of reading, continuous (extended reader contact) or discontinuous (limited reader contact), determines the importance of type style selection and type measure. For example, when selecting type for small, isolated entries in a sales catalogue, the importance of the type style and measure for readability lessens. Since the reader uses the text type only to read four or five product-description lines, it is not critical how the eye responds to the type style and measure over an extended time period. The reader's contact with the text is limited. On the other hand, when selecting text for an annual report that contains lengthy paragraphs of detailed, technical information, the more time the report recipients spend reading, the more informed (and perhaps more supportive) they become. In this situation, eliminating reading fatigue is critically important.

Type Style. In selecting text type for continuous reading, readability is of paramount importance. If the readability is too low, the reader tires and stops reading. When choosing continuous text type, the type artist should avoid extremes. Extremely condensed, extended, heavy, or thin faces are not suitable for continuous reading. Style extremes push letters into unfamiliar proportions and configurations. Since legibility depends on ease of recognition, too much style enhancement is detrimental to letter shape. Both serif and sans serif typefaces are suitable for continuous text, but sans serif type needs special handling to aid the reader's horizontal eye movement. (See chapter 4.)

Type Measure. During the reading process the reader's eye moves from left to right in a series of small jumps, called *saccades.* Each saccade encompasses approximately 12 characters (letters and spaces), but it can be greater for some readers. A comfortable measure enables the eye to make five or six saccades before beginning another line. The ideal line length of text for continuous reading contains 66 characters or 10 to 12 individual words.

The length of a measure is directly related to readability. If the measure is too long, the increased number of saccades tires the eye, causing the reader's attention to wander. Once the eye reaches the end of a long measure, it must make the long trek back to the left side and start again. The instance of *doubling* (rereading the same line) increases as the measure lengthens. Doubling both tires and annoys the reader. An annoyed reader quickly finds a reason to do something else.

A measure that is too short breaks the rhythm of saccades. The eye is constantly returning to the left side to resume reading. It is similar to listening to a reader who pauses after reading every three or four words. While length of line, or measure, is less important for discontinuous text blocks, the ease with which the reader finds the next line's starting point is always important. If the reader gets lost or distracted after the first line, the content of the rest of the text block is inconsequential.

For a single-column page of text for continuous reading, the type artist should allocate a measure between 60 and 75 characters. (Count characters and spaces by twos for faster results. Place the pen tip after each pair.) For a multiple-column page, a measure between 40 and 50 characters is acceptable. (See chapter 4.)

Interrelationship of Type Style and Measure. All type decisions are interrelated. A highly legible typeface enhances readability to some degree, just as an illegible typeface does not improve when set on a 66-character measure.

If a text block exceeds the ideal measure and extends to 78 characters (for reasons beyond the type artist's control), using a serif typeface for the text alleviates some of the problems caused by the overage. In this same situation, using a typeface with a larger *x*-height improves readability and keeps the reader from tiring. A type artist delivers more of the message by putting the reader's needs first.

THE POSITIONING OF TYPE LINES within a type block or paragraph is called *type alignment.* There are four alignment styles: flush left, flush right, centered, and justified. Of the four, flush left and justified are more commonly used in continuous text. Flush left is the easier of the two to read, but not by a significant margin. Flush right and centered, on the other hand, are more commonly used for discontinuous reading, such as small text entries, headlines, subheads, and captions.

Flush left alignment positions the left end of each type line along a common left edge. Since the type lines are different lengths, the right edge of the type block is uneven or *ragged.* Flush left alignment is more informal and contemporary. This alignment style is suitable for continuous and discontinuous text (fig. 3-10).

Justified alignment positions the beginning and end of each type line along a common left and right edge, respectively. Each side of the type block is flush and every line is the same length. Since each line contains a different number of characters, the software places additional white space between all words and letters to achieve the exact measure.

Single-column character count

Multiple-column character count

Type style and measure are interrelated attributes— changing one requires reevaluating the other.

TYPE ALIGNMENT

Flush left and justified type alignment are suitable for continuous text.

Justified type is more formal and projects an authoritative, factual air. This alignment style is suitable for continuous text, when set properly.

Flush left Justified

Centered Flush right

flush left text alignment justified text alignment

FIGURE 3-10: *Popular continuous text alignment examples*

Centered and flush right type alignment are suitable for discontinuous text.

Centered alignment positions the midpoint of each type line along a common midline. The type block is symmetrical with both edges ragged. This alignment style is suitable for discontinuous text (fig. 3-11).

Flush right alignment positions the right end of each type line along a common right edge. The left edge of the type block is ragged. This alignment style is suitable for discontinuous text.

centered text alignment flush right text alignment

FIGURE 3-11: *Discontinuous text alignment examples*

Interrelationship of Type Alignment and Readability. Type alignment directly affects readability by determining where each line stops and starts. During the process of reading, the eye moves to the right across a line of type. At the end of that line, it returns to the left end of the next line and resumes reading. Readability of continuous text is enhanced if this back-and-forth motion is uninterrupted. With discontinuous text (headlines, subheads, and captions, for example) the back-and-forth rhythm might occur only once or, in a single-line headline,

not at all. For that reason, discontinuous text alignment is not a major concern.

With flush left type alignment, the eye returns to the same edge with each line change. The common starting point simplifies the task of starting over. There is no question in the reader's mind concerning where the line continues, no pause for logistical reasons. This alignment style is suitable for all kinds of type blocks, both continuous and discontinuous.

With flush right type alignment, on the other hand, the eye returns to a different location with each new line. The reader briefly interrupts the reading rhythm (and train of thought) to locate where the words resume. (This is similar to finding one's dinner plate in a different location after each forkful.) Since a headline might be only two or three lines long, the starting-point issue is inconsequential. For a subhead or headline, the design benefits of a flush right heading outweigh the minor decrease in readability.

With justified type alignment, the eye moves between common points on both the left and right edge. The consistency of edges might sound perfect, but the internal spacing changes necessary to make that alignment possible also adversely affect readability if handled poorly. (See chapter 4.) For continuous text, justified type (handled well) is easy to read and creates a shaped text block that adds other design options.

Centered type alignment is suitable for discontinuous text only. It has all the problems of flush right type, doubled. The starting and ending points vary from line to line. (In this scenario, the dinner plate moves constantly during the meal.) This is not to say that centered type is not perfectly suited to headlines and subheads, because it is. A centered heading is an effective attention-getting device, since it breaks the overall page format. For continuous text, however, it is a headache, both figuratively and literally.

Flush left eye movement

Flush right eye movement

Justified eye movement

Centered eye movement

White Space

A DISCUSSION OF PAGE TYPOGRAPHY is incomplete without mentioning the use of white space to aid reading. If white space is used correctly, it works to organize, emphasize, and balance page elements. The first decision regarding white space involves page margins. Margins surround the page elements isolating them for a common purpose. They invite a reader into a document. A well-sized margin gives the reader a place to hold the document without obliterating an important page element.

Adequate page margins welcome the reader into the page.

Insufficient page margins chase away readers by demonstrating that there is too much material on the page.

Margins—External White Space. Margins vary in width according to location and to the document's purpose. On a single-sided page, a large head margin and sink draws attention to a headline and identifies the document's starting point. A large left margin can emphasize small subheads and balance lengthy, adjacent text blocks. The foot margin should be slightly larger than the smaller of the two side margins to balance page contents visually. The optical center of a page is above the measurable horizontal center line. A larger foot margin balances that optical point. Any margin decision made when the page is empty requires review as the page elements appear. A large graphic on the left side might need a wider right margin for balance.

Many page-layout applications provide margin controls along with the initial document size controls. These can be seen only as temporary decisions, since the page is blank. Remember to reevaluate the margins as the page evolves. It is not imperative that all type elements align along the left or right margin. It is easy to feel that they should when the margin guidelines are on a page, but that is not so. If a page element stops short of the margin, it creates white space that can emphasize the edge of a type block or balance a block on the other side of the page. Type artists should use external margins as guidelines to prevent elements from crowding the outside edge of the page, not as magnets that draw everything up to them.

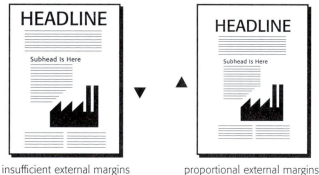

insufficient external margins proportional external margins

FIGURE 3-12: *External margins invite viewers into the page*

A common mistake made by novice type artists is underestimating the visual importance of adequately sized margins. A page with only a sliver of white space around its edge looks like a document that has outgrown its borders (fig. 3-12). Such a monumental quantity of text requires a sizable time commitment to read. Rather than block off next

week to read the document, the reader places it aside in a pile labeled "To Read Later." It is more aptly named "To Ignore" because that is what happens. After several weeks the document joins other poorly designed documents in the wastebasket. No one is required to read anything they receive. Most people exercise that option daily.

Internal White Space. White space in and around page elements is the internal white space of a document. This white space is smaller than the margins because its purpose is subordinate to that of the margins. The purpose of internal white space is to set off type blocks or smaller type elements for emphasis, to establish visual links between separate type blocks, such as a subhead and text, and to provide a temporary resting spot for the reader, when a reading pause is warranted. Large areas of internal white space make large holes in a page and destroy the visual unity established by the margins. Excess internal white space should be brought to and lost in the margins.

Additional white space before or around a type block isolates and emphasizes it.

Limited white space between page elements visually links them.

BEFORE LEAVING THIS LEVEL of typography, the type artist should answer two fundamental questions: Is type selection and placement appropriate for the purpose of the page? and, Is the page hierarchy clear and logically structured?

When readers first look at the page, they should immediately have a sense of the page's intent. If the page is an advertisement, it should look like one. If the page is the front page of a newsletter, it should not look like an advertisement. A newsletter should use type appropriate for that purpose. An advertisement should use advertisement-appropriate type. Readability, legibility, placement, type style, alignment, measure, and use of white space all come together to create a unique page. A conflict between how the page looks and what the page says is apparent to the reader and casts doubt on the veracity of the information.

During its development, a type artist must look at the page as a whole. The details of typographic decision-making should produce a page appropriate for its original intent. The details of type can create a quagmire for the overwhelmed type artist. Climbing out of the alphabet soup to review how the entire page is developing is a necessary skill for a type artist to perfect.

After identifying the purpose of the page, the reader scans the headings for a snapshot of its content. A logical page hierarchy creates an accurate snapshot. With a clear arrangement of headings, the reader understands what information is primary—the headline—and what information is secondary, clarifying information—the subheads. The

PAGE TYPOGRAPHY EVALUATION

Periodically reviewing the page's overall appearance keeps its development on the right course.

Effective page hierarchy is clear and logically structured.

typographic attributes for the headline and subheads establish a visual priority. At the same time, they prioritize the content of those headings. The reader understands the topic (the headline) and what aspects (the subheads) of the topic are discussed. Suitable typographic treatment establishes the headline as the primary heading. Type treatment for the subheads should be visually related and appropriate for secondary headings. The same logic follows throughout the rest of the type elements on the page or in the document.

This is not to say that the arrangement of page elements should be obvious and, as a result, boring. An intriguing, aesthetically pleasing, unique page structure is more appealing to a reader than a commonplace one. An easy-to-navigate page structure is not inherently dull. A reader entering a page is comparable to a shopper opening a door. If the door opens to a crowded hallway filled with placard-waving, clamoring hucksters, the shopper might reconsider entering the chaotic scene. On the other hand, if the door opens to a brightly lit hallway lined with tastefully designed store fronts and welcoming merchants, the shopper continues ahead eagerly.

Elements on a page create a visual terrain through which the reader proceeds. If the typographic terrain is strewn with discordant typefaces crowded into seemingly insufficient space, the reader will decide to go elsewhere. A type artist should take a break from working on the store fronts to stand in the doorway and check the hallway.

<p style="text-align:center">❧</p>

PAGE TYPOGRAPHY INVOLVES decisions on the broadest visual level. The type artist compares groups of words united by function to other word groups with a different function. A type artist might ask, Does the headline work well with the subheads or does it overshadow them? or, Do the subheads provide a smooth transition into the text? Page typography has aesthetic and functional qualities that the type artist controls to deliver a single message. Properly chosen typefaces create a mood; they elicit an emotional response compatible with the message's intent. Properly set type moves the reader's eye between and through type blocks with a minimum of effort. Both typeface style and typographic quality support and enhance the message. It is unwise to rush past these larger decisions on the way to the detailed nuances of paragraph and sentence typography. The finest typeset text goes unread if the reader fails to notice the page itself.

Effective typographic design does not end with the reader noticing the page. It is important to catch the reader's eye, yet even eye-catching design must give way to the importance of communicating the desired information. The use of type in tandem with other page elements must hold the reader's attention and then get out of the way of the message. Page elements establish and maintain the connection between message and reader. This, then, is the test for typographic design. Does the message get through? Does the design connect writer to reader? Type artists need to know how to use type to create visually exciting, functionally successful pages for their target audiences. The page and its elements create the map for the reader's eye to follow—all the way to understanding the message.

FIGURE 3-13: *Typographs add graphic elements to the page*

SETTING
TYPE
IN A
PARAGRAPH

Paragraph typography as defined in this text refers to the use of type characters, white space, typefaces, and type attributes within a typeset paragraph. A discussion of paragraph typography focuses on the effective use of these components to create an even page texture for improved readability. The word *text* in typography originates from the word *texture*. Texture appeals to a viewer's sense of touch. A *tactile texture* is a three-dimensional surface that a person can touch, feel, and experience. An ocean-side beach has a tactile texture. Swimmers and sunbathers feel the sand, the shells, the pebbles, and seaweed as they stroll along the shore. Their feet leave pockmarks in the sand that sculpt the surface and alter its texture.

A *visual texture* is a two-dimensional, visual illusion of a three-dimensional tactile surface. It suggests the desired tactile qualities that viewers cannot feel with their fingers. An artist creates a visual texture on a piece of paper or on a canvas using shapes, colors, proportion, and values to replicate a believable visual frame of reference. When painting the image of a linen napkin as part of a still life, a painter uses small marks of color to create the napkin's textural illusion. To create the illusion of linen, the painter employs short, thin strandlike marks to represent the woven fibers. Applying broad, fat strokes of color to represent the napkin's surface would destroy the illusion of fine linen by ignoring the size relationship of the textural elements to the whole.

TYPOGRAPHIC TEXTURE IS an even, light gray visual texture created by placing type on a page. The type artist controls texture quality through type size, type weight, vertical spacing, and horizontal spacing for every letter, word, and paragraph on the page. Typographic texture is unobtrusive. Its uniformity enables the reader's eye to skim its surface and concentrate on the text's message without distraction from unrelated textural disturbances. Well-executed typographic texture eases reading and facilitates reading speed.

Type size and type weight determine the visual impact of each texture element. An extrabold typeface creates a darker texture than a light typeface from the same type family. A larger type size makes the individual texture elements more noticeable to the reader's eye. It is hard for readers to see a paragraph as an even overall texture when staring at the largest lowercase *a* they have ever seen.

Vertical and horizontal spacing determine the amount of white space between type lines, letters, and words. *Vertical spacing* concerns the distance between baselines of type within a paragraph (*leading*). Evenly spaced lines of type, along with appropriately sized type and measure, create an easy-to-read paragraph. Too much leading in a paragraph isolates each line and destroys the paragraph's visual cohesion. Insufficient leading creates a dense forest of letters that lead the reader's eye in all directions—diagonally, vertically, and horizontally.

Horizontal spacing concerns the distance between letters within words (*letterspacing*) and words within the measure (*word spacing*). Too much letterspacing in a word destroys the visual cohesion that links letters together as a recognizable word shape. Uneven letterspacing forms subgroupings within a word that destroy the word's integrity. Instead of the word *ransom,* the reader sees *ran* and *som.* (Who ran? Isn't *some* spelled with an *e*?) Uneven letterspacing can ruin the logic of a sentence or word. Type size and weight decisions are easy to make. Spacing decisions require a more practiced eye to evaluate the subtle distinctions that enhance or impede reading on this level.

PARAGRAPHS AND THEIR COMPONENTS are measured using picas, points, ems, ens, leads, and units. Type artists use points to measure typefaces and leading. Leading is measured from the baseline of one type line to the baseline above or below it. The leading includes two items: the typeface size and the remaining white space that separates one line of letters from the next line of letters. Typeface size and leading are written as a level fraction—10/12. The number *10* represents the

TYPOGRAPHY AND TEXTURE

ran som

Incorrect letterspacing changes one word into two.

PARAGRAPH GUIDELINES AND MEASUREMENTS

typeface size (10 points) and the number *12* represents the leading size (12 points). The amount of white space between lines of 10-point type set on 12-point leading is 2 points (12 – 10 = 2).

The distance between paragraphs is measured in points also. Keeping the spacing unit of measure consistent enables the type artist to see proportional relationships of inter- and intraparagraph vertical spacing. Proportional relationships are an important concern when working with type.

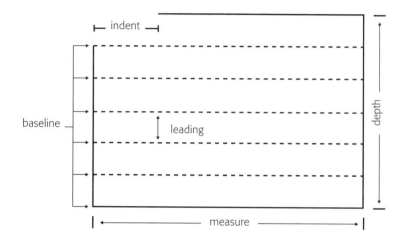

FIGURE 4-1: *Paragraph elements*

A type artist uses picas to measure paragraph width (*measure*) and paragraph depth. Once the character count is established, it is easier to refer to the measure in picas. (See chapter 3.) The type artist indicates the typeface, weight, type size, leading, and measure in the following manner: Centaur Regular 10/12 × 22. The word *Centaur* denotes the typeface; *Regular* indicates the weight; *10* is the type size in points; *12* is the leading in points; and *22* is the measure in picas.

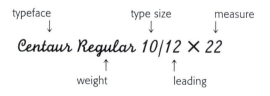

FIGURE 4-2: *Paragraph type notation*

Indenting the first line of a paragraph is done with ems, ens, and leads. These three units of measure are important in typography because they are proportional to the paragraph's typeface size. A pica, for example, is a preset unit of measure. A black square with sides of 1 pica looks large alongside the word *pica* set in 8-point type (fig. 4-3). The same 1-pica black square looks small alongside the word *pica* set in 24-point type. The type size tripled, but the square stayed the same. Picas, inches, feet, and miles are all preset units of measure.

1 inch = 6 picas
12 points = 1 pica

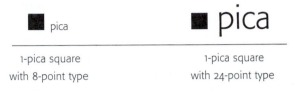

1-pica square
with 8-point type

1-pica square
with 24-point type

FIGURE 4-3: *Picas are preset measurement units*

An *em* is a unit of measure equal to the size of the typeface. Type artists use ems to indent lines, to determine the length of a dash (the em dash), and to add a space (an em space) between words. If the type artist uses an em dash to set off a parenthetical phrase in a sentence of 11-point type, the em dash is 11 points in length. If an em space is between the word and its definition in an 8-point dictionary entry, the em space is 8 points in length. In foundry type, em quads (or *mutton*) were used for spacing type. The *em quad* was a square (quad) with sides equal to 1 em.

Since typeface size determines em size, the em is a proportional unit of measure. Continuing with the previous example (fig. 4-3) with the pica square and the typeset word, placing a black 8-point em quad alongside the words *em quad* set in 8-point type looks proportionally the same as a black 24-point em quad alongside the words *em quad* set in 24-point type (fig. 4-4). The type size tripled, but the proportional relationship stayed the same.

 em quad

■ em quad

8-point em quad
with 8-point type

24-point em quad
with 24-point type

FIGURE 4-4: *Ems are proportional measurement units*

An *en* is a unit of measure equal to half the size of the typeface. An 8-point en is 4 points in length. In foundry type, an *en quad* (or *nut*) was the width of an en, but the height of the em. Ens are used for indents, dashes, and word spaces. Type artists also can use a lead as a proportional measurement for indents. The *lead* is equal to the distance from baseline to baseline in a paragraph. Using ems, ens, and leads provides proportional units of measure for working with type.

The horizontal spacing of letters and words is not as clearly specified as spacing for indents and leading. Spacing the letters in a word is an optical placement rather than a measurable calculation. Letters come in all different shapes and sizes. A concave side here and a convex side there creates measuring problems. Fortunately for the digital type artist, the type designer determines the amount of space surrounding each character in the typeface and determines the space between particularly troublesome letter pairs, such as *Yo, Va,* and others. Spacing instructions are included in the kerning-pair information and in the hints for PST-1 fonts, for example.

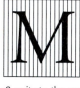

18 units to the em

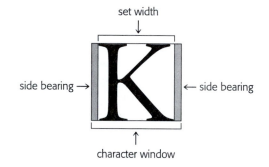

FIGURE 4-5: *Character window*

When designing a typeface, the type designer determines the width of the actual letter, the *set width,* and the amount of white space, the *side bearing,* on either side of it. Together, the side bearings and the set width make the *character window*—the amount of horizontal space allocated on the page for a particular letter. All character windows are proportional to the set width of the letter and are subdivided into incremental measurements called *units.* Unit size is determined by the application. A well-known page layout application uses 100 units to an em, or 1 unit equals $^1/_{100}$ em. In this application, a unit for a 24-point typeface

equals 0.24 points. A unit, like an em, is a proportional measurement. A type artist uses units when kerning letter pairs or tracking words.

WITH THE RESPONSIBILITY for typesetting moving from the typesetter in a foundry to the type artist in a company, all typesetting instructions stay in-house. They might even stay on the same person's desk. *Proofreaders' marks,* or *proofmarks,* are standardized marks used by type artists for communicating typographic instructions or changes on typeset copy. Proofreading, like typesetting, has evolved with technology. The pros and cons of this evolution can be debated, but it does not change the fact that more and more typographic work is done in its entirety by fewer and fewer pairs of eyes and hands. Type artists rely on spell checkers, grammar checkers, proofreaders' methods, and personal techniques to catch errors that their tired eyes no longer see. On the paragraph level, proofing involves checking the texture of the page—type size, weight, word spacing, leading, hyphenation ladders, knotholes, widows, orphans—and the uniform implementation of paragraph attributes—indents, alignment, and space between paragraphs.

Proofreaders' marks, unlike copyeditors' marks, are designed for typeset copy. Since typeset copy uses space measured in points, corrections do not fit between the lines at the point of insertion, as copyeditors' marks do. Proofmarks are abbreviations, codes, and symbols that indicate lengthy instructions in minimal space. Type artists use these marks to communicate with themselves as well. Marking a proof to improve typographic quality is the type artist's responsibility. In addition, some type artists are designers also. Proofmarks can indicate type and design changes before anyone else sees the document.

PROOFMARKS COME IN PAIRS. There is a *text mark,* located within the text, and a *margin mark,* located in the margin alongside the edited line. Every mark within the text has a corresponding mark in the margin—*always.* The text mark locates the problem. The margin mark indicates its solution. The margin mark functions also as a flag to catch the type artist's eye. It is easy to miss a small mark buried in typeset text, but not a mark sitting alone in the margin.

There are four categories of proofmarks—additions, deletions, substitutions, and relocations. Type artists and proofreaders make proofmarks with a fine-tipped ballpoint pen with colored ink—red, green, purple, anything but blue or black. The most-used text mark is the *caret.* It indicates an insertion of space, punctuation, letter, and word

PARAGRAPH PROOFREADERS' MARKS

Type artists use proofreaders' marks to attain typographic quality without altering the author's style and content.

USING PROOFREADERS' MARKS

The word *caret* derives from Classical Latin, meaning *it is missing.*

into or between lines. The caret intersects a type line from below, with a few logical exceptions, or it intersects a paragraph from the side. A sideways caret identifies an insertion point between lines when adjusting line and paragraph spacing (leading). The margin instructions are written alongside the caret.

To indicate an insertion within a line, the type artist positions the tip of the caret where the missing item belongs, making sure not to cover any letter or word. In extremely tight type (or to prevent confusion), the type artist can extend one side of the caret to pinpoint an insertion. The insertion is written in the margin to the left or right of the caretted line. If a line requires more than one proofmark, the type artist positions the margin marks in the same order, left to right, as the text marks. A vertical slash between each margin mark separates the insertions to avoid confusion. Keeping insertions in the correct order is important for a properly edited document. The type artist can use the left, right, or both margins for margin marks, as long as the order of text and margin marks is identical. Some margin marks are circled. This draws attention to a small mark, such as a period, or indicates instructions or queries. Margin marks representing words or letters to insert into the text are not circled. In both instances, legible, case-sensitive writing is a must; script handwriting is preferred for letter-case clarity.

A vertical or horizontal strike-through indicates a deletion or a substitution. To delete or replace a single character within a word, the vertical strike is more visible. To delete or replace two or more characters or a word (or words), the horizontal strike is suitable. It is important not to obliterate a character completely when striking it, because the type artist needs to identify the character to delete. An extrafine ballpoint pen makes this easier.

The fundamental purpose of proofmarks is to mark typeset copy clearly with a minimum of clutter. A lengthy note clutters more than clarifies. In other situations, replacing an entire word with a new one is clearer than surgically inserting and transposing characters.

The brown dog jumpd over the lazy red fox and sent the entire chicken house ito a frenzy Never before had the fox cme so clo e to its chosen pr ey; and nev r before had the dog so poorly bungled his obj as barnyard protector.

Proofreaders' marks come in pairs. Each text mark has a corresponding margin mark.

PARAGRAPH TYPOGRAPHY PRELIMINARIES

WITHIN PARAGRAPH TYPOGRAPHY, working to improve page texture is a feature of typographic quality. It is fairly easy to get the type on the page. Refining it to do the job well distinguishes the work of a skilled type artist. There are several thoughts to keep in mind while working with paragraph typography.

All typographic page decisions are interconnected; changing one requires reviewing them all. The resizing of one type block might

require a proportional resizing of another. Changing one feature, such as stroke weight, changes the relationship of that type block to all other type blocks on the page at that time. There is no point agonizing over the exact point size for a subhead, if the text is not present. If any or all components change, all typographic decisions require review.

A quick way to remember the interrelationship between type elements is by making type attribute selections, such as font, size, leading, and tracking, from a single dialog box. Applications with sophisticated type controls usually have one major type dialog box that lists all type attributes. When a type artist selects a new type size, it is easy to remember to adjust the leading for this change because the leading attribute is listed nearby. A quick scan of the dialog box enables the type artist to compare attributes easily and make all the necessary adjustments. These same attributes are available in single-purpose dialog boxes, but their isolated display does not remind the type artist of other attributes that may be affected by their change.

The type size and letterspacing appropriate for the 8½-by-11-inch flyer is different from the size and spacing needed for a video presentation. Type is used in so many different visual arenas, yet the type artist designs them from the same viewing distance—artist to monitor. It is useful to stop and think how and where the reader will see the type. The type artist should preview a type sample at its intended viewing distance and in its final form, if possible. The time spent printing a quick sample for preview is beneficial if it avoids an after-hours revision.

Another technique that emphasizes the interaction of type attributes concerns how type artists evaluate their work. When evaluating type elements on a page, it is helpful to describe a type problem in terms of multiple solutions. For example, if the headline—24-point, medium-weight display type—on a document is not satisfactory, the type artist should not describe the headline in terms of a single attribute. Instead of saying that it is not *big* enough or *bold* enough (descriptions with predetermined solutions), the type artist might describe the headline more accurately as *not attracting enough attention.* This opens the door to a variety of solutions. Perhaps isolating the headline with additional white space, changing typefaces, reducing the size of the surrounding copy, using a larger sink, indenting the copy below it, or italicizing the headline would attract more attention to it. By describing the inadequacy of the visual effect, the type artist sees creative, alternative solutions more easily.

Type decisions work within the context of the page.

Viewing distance affects all type decisions.

Describing a type problem in terms of a single solution limits ideas for the problem's resolution.

PARAGRAPH TYPOGRAPHY DECISIONS

THE DECISIONS MADE within a paragraph concern the elements that control the paragraph's texture. These are the type size, leading, letterspacing, word spacing, hyphenation, and intraparagraph spacing (space between paragraphs). While the units of measure used to adjust texture are small, the end result is obvious to the reader. The importance of these adjustments cannot be overlooked by the type artist.

TYPE SIZE

BEFORE THE ADOPTION of the American point system by the American Type Founders' Association in 1886, typographers specified type sizes by names, such as *Agate, Minion, English,* and *Nonpareil.* These names, although not standard throughout the industry, did indicate an approximate size for those accustomed to using them. After 1886, the standard unit of measure made size comparisons more reliable and more accurate. Typographers measured the body of the metal foundry type in points. The letters of the font were a little smaller than the body itself, but all bodies for a single type font were the same size and easy to measure.

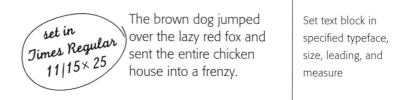

FIGURE 4-6: *Paragraph-wide proofmark*

Once typesetting moved away from reproducing letters as impressions from metal type bodies, the tangible, measurable object vanished. Typographers were left to measure the letters themselves. Disembodied typefaces were reproduced from photographic film and later from digital descriptions. A typographer needs the entire font to measure the size of a digital type font. The distance (in points) from the lowest point in the type font to the highest point in the type font is the type's size. Taking this measurement is possible when the *entire* font sits on a common baseline. Precise font size comparisons require baseline samples from each font.

More frequently, however, type artists compare type sizes using incomplete font samples—a line, a word, or a paragraph—never

knowing if the lowest and highest points in the font are present. When comparing incomplete samples, the type sample of a smaller point size can look larger than the type sample with the larger point size. A type artist can be certain that 16-point type is smaller than 18-point type only when comparing the same typeface.

When categorizing type size, the terms *display* (type 14 points and above) and *text* (type below 14 points) are categories based on generalizations. Display type is for headlines and subheads. (Actual display or titling fonts are designed as 18-point fonts with stroke weights and proportions for larger uses.) Text type is for text copy. These categories provide only a starting point for type size selection, not rigid size ranges.

FIGURE 4-7: *Adobe Garamond, Clearface, and Caxton type samples set in the same point size*

A reader's perception of type size is influenced by the structural proportions of a typeface. A typeface's *x*-height and counter size are easier to compare on the page, than the actual, measurable type size. The *x*-height of a typeface represents the torso, or central mass, of each letter. Ascenders and descenders project from it, like arms and legs from a human torso. These appendages do not have the visual weight (or may not be in sufficient quantity) to change the viewer's perception of the typeface's overall size. In the English alphabet only 14 of the 26 letters and 5 of the 6 vowels do not have ascenders or descenders. A typeface whose *x*-height represents more of its measurable height appears larger compared with a typeface whose *x*-height represents less of its measurable height (fig. 4-7). It is easier to compare *x*-heights when only a word or a line of lowercase type is available.

Leawood | Garamond
LEAWOOD | GARAMOND

FIGURE 4-8: *Leawood and Garamond type case comparison*

Typeface structure influences the viewer's perception of type size.

A large *x*-height makes a typeface look larger.

For example, an 18-point typeface, such as Adobe Garamond, has a short *x*-height (in comparison to its point size). The elongated ascenders and descenders of this face add to its delicate appearance. Using human colloquial terminology, Adobe Garamond is "small-boned." As a comparison, an 18-point sample of ITC Leawood appears larger than the 18-point Adobe Garamond (fig. 4-8). Leawood has a larger *x*-height to point-size ratio. More of its central mass is visible. Leawood is one of the "large-boned" types. (Human-anatomy terminology is abundant in typography. When a typeface has a large *x*-height, it is said to have a *large eye*.)

When comparing uppercase samples from these typefaces, the size difference is not as noticeable (fig. 4-8). The cap height of each typeface is proportionally similar. When setting these two faces in a paragraph (uppercase and lowercase letters), the amount of vertical space each line requires is identical because they are the same point size. It is the overall perception of their sizes on a letter-by-letter basis that differs.

Leawood | Caxton
AaBbCcDdEeFf | AaBbCcDdEeFf

FIGURE 4-9: *Leawood and Caxton comparison*

Open counters make typefaces look larger.

The counter size within a typeface also affects the viewer's perception of type size. Using 18-point samples from ITC Leawood and Caxton is a case in point (fig. 4-9). Both typefaces have comparable *x*-heights. Caxton, however, is a more condensed typeface than Leawood. The counter in the Caxton lowercase *o* is egg-shaped. Leawood's counter is more circular. Because of this structural difference, Leawood appears larger than Caxton. As a side note, since the counter-size difference is achieved through character width, the Leawood sample requires more horizontal space than the Caxton sample. These comparisons demonstrate that a type artist cannot rely on point size to determine the visual size relationship between two typefaces. The type artist's eye makes the final decision.

Consistent type size within type levels prevents confusion.

There is nothing more unsettling than reading a document and all of a sudden realizing that something changed. Once a reader commits to reading several paragraphs of text, he or she becomes familiar with the rhythm created by their type attributes—type size, letterspacing,

CHAPTER FOUR

leading, and measure. Good or bad, the reader is cognizant of the reading rhythm. If one of those attributes suddenly changes—the type size, for example—the reader notices it and the reading rhythm falters. Some readers stop completely until they determine what changed. Then, not only is the reading rhythm interrupted (stopped), but also the delivery of the message.

Some would argue that most people do not notice such nuances. Readers might not know what happened, but they notice that something happened. People see many things without focusing on them. For example, after a viewer watches several news stories on television, the anchor (who is wearing a navy business suit with a dapper handkerchief in the breast pocket) announces a station break. Once the anchor returns, the viewer realizes something changed. Several news items later, the viewer blurts out, "That's what it is; the handkerchief's gone!" If quizzed, the reader might not recall the stories since the break. The subtle change of the visual landscape was noticed by the viewer, and it broke his concentration. Readers must ignore common external distractions when they read. A type artist should not include reader distractions within a document. Changing type sizes between type levels (making the headline bigger than the subhead, the subhead bigger than the text) is good typography. Changing sizes within type levels is not.

Eric Gill wrote in his *Essay on Typography,* "Mere weight and heaviness of letter ceases to be effective in assisting the comprehension of the reader when every poster plays the same shouting game." Gill's reference to the "shouting game" played by posters overusing heavy type also applies to type size. If all type elements on the page are large, the reader receives loud messages from all text blocks. It is impossible for the reader to see page hierarchy through the visual noise. Using type sizes that are too large for the viewing distance is a common mistake made by novice type artists. Reducing the type size for such a paragraph makes the type more welcoming and improves readability. It is difficult to listen when a speaker shouts. (Any adjustment of size requires a review of measure and leading.)

CHOOSING LEADING FOLLOWS specifying type size. Poorly chosen leading can ruin the readability of a well-chosen, legible type font. Leading is the vertical distance (measured in points) between baselines in a type block (fig. 4-10). This distance includes the type size and the additional white space between the lowest point in the first type line and the highest point in the second type line. Increasing or decreasing the

Type size is chosen for reading comfort.

Measure and leading should be checked after a type size change.

LEADING

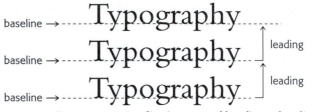

FIGURE 4-10: *Leading is measured baseline to baseline*

leading controls the position of the first type line in relation to the second. Leading affects page texture by determining the amount of white space between lines of type on the page. The amount of leading lightens or darkens page texture.

The term *leading* originated from the days of foundry type when actual strips of lead separated the lines of individual sorts. The height of the lead strip (in points) was the size of the white space between the lines of type on the page. Use of this term continued in other typesetting methods; but after type lost its metal body, measuring type size and leading changed. With digital type technology, the vertical baseline-to-baseline measurement became the leading, or *line spacing*. Leading now includes the type size (ascent plus descent) as well as the white space between the lines (fig. 4-11). There are three categories of leading—solid, positive, and negative (fig. 4-12). It is easier to describe these categories by the amount of white space between the type lines.

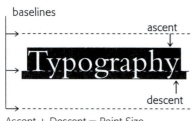

Ascent + Descent = Point Size

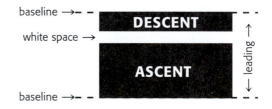

FIGURE 4-11: *Ascent + Descent + White Space = Leading*

Solid Leading. The term *solid* describes a type block without extra white space between the type lines. The distance from baseline to baseline is the same as the type size. An example of type set solid is 12/12 (12 over 12). Type size is identical to leading. In a set-solid paragraph of continuous text, the descent of the first type line sits atop the ascent of the second type line. If a descender from above is adjacent to an

ascender below, the two butt against one another. They do not overlap. Such unfortunate placement creates a hard-to-ignore detour for the reader.

For discontinuous text, a reader's need and the length of the information influence leading decisions. For example, a dictionary entry is a good example of discontinuous text. Readers head for the dictionary when they want a definition, a measurement, an abbreviation—a short burst of data. Using more or less leading for a dictionary entry will not determine whether or not the reader finishes reading the definition. The readers' need for the information and the length of time required to get it override the usual provisions of reading. Set solid works well in this situation, with entries separated by bolded words or indentions.

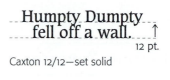

Caxton 12/12—set solid

Caxton 12/16—positive leading

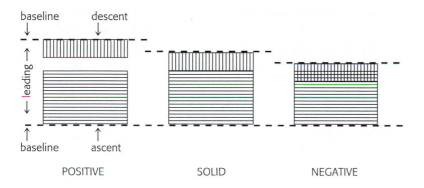

FIGURE 4-12: *Leading categories*

Positive Leading. The term *positive* leading describes type lines separated by white space. The white space keeps the descent of the first line from butting against the ascent of the second line (fig. 4-12). An example of positive leading is 12/16 (12 over 16). Type size is smaller than leading. The amount of white space equals 4 points. With sufficient positive leading, descenders and ascenders cannot form an exit ramp from the first type line into the second.

Positive leading is recommended for continuous text. It isolates lines from one another. With significant text quantity, it is impossible to avoid (to catch all instances of) butting descenders and ascenders. Positive leading separates all ascenders and descenders, so horizontal eye movement is encouraged over vertical movement.

Negative Leading. The term *negative* leading describes an overlapping of the first line's descent and the second line's ascent (fig. 4-12). The

Caxton 12/10—negative leading

Caxton 12/10—negative leading using all capitals

distance from baseline to baseline is less than the type size. An example of negative leading is 12/10 (12 over 10). The leading is smaller than the type size. With negative leading, adjacent descenders and ascenders can overlap, causing an unsightly blotch in the typographic texture.

LEADING FUNCTION

WHITE SPACE BETWEEN LINES of type isolates the lines from one another and facilitates the reader's horizontal eye movement. Easy-to-read text does not force the reader to make procedural decisions, such as, Which way do I go? Up? Down? Right? and does not annoy the reader with frequent distractions, such as, What is that ascender doing in this line? Insufficient white space eliminates the white guidelines that clearly mark the reader's path. Without them, the reader consciously works to stay on the line and to ignore the ascenders and descenders crowding in from adjacent lines. These guidelines serve as guardrails to separate one line of text traffic from another. Doubling and *line skipping* (reading the first half of a sentence with the second half of another) occur more frequently with insufficient leading. In addition, page texture is too dark and often blotchy. Dark page texture signals an over-crowded page and a slow-reading-zone ahead.

Too much white space between type lines also impedes reading. Excessive leading destroys the paragraph's visual cohesion. The reader sees the lines as separate entries without a line-to-line connection. The effortless downward hop from line to line while reading becomes a perilous leap that breaks the reader's rhythm.

Reading a line of text is similar to driving a car along a tree-lined road. If the trees are too close to the road's edge, the driver worries that the car might hit one of them unintentionally. A driver might lean toward the driver's-side door in an unconscious effort to avoid hitting the trees. In this scenario, only a portion of the driver's attention focuses on driving; the rest of it worries about the trees. If the trees are six feet from the road's edge, the driver can concentrate on driving safely. Type artists should provide their readers with distraction-free reading that leaves them attentive to the scope and depth of the document's message.

DETERMINING LEADING SIZE

LEADING SIZE IS DETERMINED by a combination of four major factors—type size, type measure, type style, and letter case. Not all of these factors affect leading equally. In some situations one overshadows all the rest. A type artist, however, should consider all four typographic factors initially. Suitable leading size comes from balancing the visual requirements of these factors with the approval of the type artist's eye.

This does not mean that everything flies out the window if the type artist does not *like* it. Evaluating type has nothing to do with likes and dislikes. An experienced type artist can see if the type in the paragraph *works,* based on type texture, line and paragraph integrity, typeface style, measure, type size, and previous experience. Experience includes creating an abundance of effective typographic documents as well as studying the typographic documents of other, more experienced, type artists. Good work is not done in a vacuum. A good eye for type is sustained and nurtured by a diet of good typography.

Type Size and Leading. Type size is the distance from the topmost point to the bottommost point in a font. Since structure affects the perceived size of a typeface, a type artist cannot base leading decisions solely on point size. For text type (uppercase and lowercase type), the amount of white space between the type lines optically balances the perceived size of the type. A quick squint at a page can show the type artist whether the paragraph consists of multiple horizontal bands or just a sea of unstructured gray.

Many sophisticated type applications provide an autoleading feature. This computes an amount of positive leading as a percentage, 120% for example, of type size. A paragraph of 12-point Adobe Garamond receives the same amount of autoleading—in this case, 14.4 points—as the same paragraph set in 12-point ITC Leawood. Leawood's large *x*-height, however, makes it appear larger than Adobe Garamond. Using the same amount of leading for each ignores the typefaces' optical size (the only size determinant the reader has). With so much of Leawood's type size devoted to *x*-height, the ascenders and descenders are not long enough to create a sufficient white zone above and below each type line. The white space included in the leading measurement is responsible for improving readability. Increasing the leading from the autoleading's 14.4 points (2.4 points of white space) to 16 points provides the needed space between lines. Adobe Garamond uses less of its 12 points for the *x*-height, so its ascenders and descenders are longer in comparison. Garamond has built-in white space to add to that of the leading. As a result, the 2.4 points of white space from autoleading is sufficient for Adobe Garamond.

In continuous text or any text block requiring positive leading, 2 points of white space (type size + 2 points = leading size) is a good place to start. While autoleading creates positive leading, it does not say how much. Increasing or decreasing the leading from autoleading is impossible until the type artist does the math. Starting with a 2-point

Type size (measurable or perceived) affects the amount of white space needed between uppercase and lowercase type lines.

add-on to the type size is a more accurate starting point from which to begin adjusting.

With text type, the rule of thumb to follow is this: As typeface size increases, so should leading. Switching the type in a leaded paragraph to a typeface with a large *x*-height also requires an increase in leading. With display type sizes in headings, the reverse is true. The larger the headline, the smaller the leading and the resulting white space. The reason for this is simple: As display type size increases, it appears closer to the viewer. In a hand-held document, a proportional increase in leading becomes magnified at such a close distance (18 inches). When increasing the type size of headings, a type artist should leave the leading size at its original setting and evaluate the result. Most times, only the heading size needs to increase.

Type Measure and Leading. A reader makes a significant time commitment when deciding to read an annual report, a novel, a newsletter, or any lengthy document. The leading works with the measure to maintain a comfortable reading rhythm during that time. Any significant shortening or lengthening of the measure requires a leading adjustment. A longer measure means a longer journey back to the start of the next line. Adding more leading more clearly marks the path to the left edge of the page. As the measure increases, so too must the leading. When the measure decreases from the optimum measure, the leading might decrease, but at a slower rate. Leading increases more rapidly than it decreases in response to measure adjustments.

Type Style and Leading. Type style encompasses different type attributes. The attributes that influence leading are serifs, set width, and stroke weight. A serif provides a visible foundation along the baseline. Since each letter stroke has one, the collective effect is a visible horizontal band for each type line. When the serif is missing, the vertical strokes in the letters become more visually dominant. In continuous text, sans serif type requires more leading than serif type. The extra white space isolates each line and creates the horizontal banding (inherent in serif type) that makes reading easier.

Condensed typefaces (typefaces with a narrow set width) have a strong vertical appearance. As with sans serif typefaces, condensed faces require extra leading in order to prevent vertical eye movement between lines. In a lengthy document, if readers must consciously work to stay on the type line, they will tire and eventually stop reading. This is a lesser concern in discontinuous text, because a single-line subhead, for

In continuous text, a significant increase or decrease of measure requires a corresponding increase and possible decrease in leading.

In continuous text, sans serif type requires more leading.

Condensed typefaces and typefaces with heavier stroke weights require more leading.

example, is separated from its surrounding by a size increase or style change.

Paragraphs set in text faces with heavier strokes benefit by increased leading. The additional white lightens the overall paragraph texture. While bold or semibold type styles are not suitable for continuous text, the humanist typefaces, such as Stempel Schneidler, have medium-to-heavyweight strokes that darken paragraph texture. Lightening this texture by increasing the leading makes the paragraph more welcoming and easier to read.

eq # > Humpty Dumpty sat on a wall, Humpty Dumpty had a great fall. All of the King's horses and All the King's men,	Equal leading for all lines
Humpty Dumpty sat on a wall, Humpty Dumpty had a great fall. *reduce #* > All of the King's horses and…	Reduce leading (general)
add 2 pts > Humpty Dumpty sat on a wall, Humpty Dumpty had a great fall. All of the King's horses and…	Add leading (specific)
ld in > Humpty Dumpty sat on a wall, Humpty Dumpty had a great fall. All of the King's horses and…	Add leading (general)
Humpty Dumpty sat on a wall, Humpty Dumpty had a great fall. *ʃ #* > All of the King's horses and…	Delete line space

FIGURE 4-13: *Leading proofmarks*

Type set in all capitals has built-in leading.

TIMES SET IN ALL CAPS.

18/20 Times

TIMES SET IN ALL CAPS.

18/16 Times

LETTERSPACING AND WORD SPACING

Letter Case and Leading. Setting type in all lowercase or all upper-case letters influences the visual effect of leading. Initial capitals and lowercase letters, whether used in a heading or in continuous text, occupy space above and below the baseline. The actual white space between type lines is restricted to the space between the descent and ascent of adjacent lines. Type set in all uppercase letters, in the majority of typefaces, remains above the baseline. The space allocated for the descent is unoccupied. As a result, a two-line, set-solid heading in all caps has white space between the lines. The descent of the first line serves that purpose.

For example, 18-point Times has an ascent of 14 points and a descent of 4 points. With a type block set 18/20, the white space would normally be 2 points. If the type block was set in uppercase letters exclusively, the 4-point descent is unoccupied. The white space separating the type lines increases from 2 points to 6 points. To bring these lines closer together and return to the intended white space size, the type artist uses negative leading. Decreasing the amount of leading, from 18/20 to 18/16, the 14-point, ascent-only type lines now have 2 points of white space between them.

It is unusual for a type artist to know a typeface's ascent and descent measurement without access to specialized font utility software. More than likely, the uppercase type lines just look too far apart. It may take a bit of trial-and-error until the right distance is achieved, but negative leading is just what the "type-doctor" ordered.

Negative leading can work with lowercase letters if the first line does not contain descenders or if the ascenders and descenders of both lines interlock, like a well-planned jigsaw puzzle. Both techniques are suitable for headlines only.

TYPE ARTISTS USE LEADING to place white space vertically between type lines to attain good typographic texture. They use letterspacing and word spacing to place white space horizontally between letters and words for the same goal. Unlike leading, letterspacing is not measurable in points. Letterspacing has always been described in vague, subjective terms that placed the designer somewhat at the mercy of the typesetter's skills—which has not been necessarily bad. Designers specified letterspacing (and some page-layout applications still do) in the following terms: *loose, normal, tight,* and *tight but not touching.* In the days of foundry type, the letter face fit on its metal body in such a way that created white space on either side. Normal letterspacing occurred when

the individual sorts butted against one another. The kern and the ligature remedied letterspacing for the most troublesome combinations. For word spacing, the typesetter inserted spacers made for that font.

With the liberation of letter face from the metal type body, the typesetter could position letters on top of each other if the designer requested it. This ability, first possible with phototypesetting, initiated a new era of typographic design, exemplified by the work in the 1960s and 1970s of designers such as Herb Lubalin, Milton Glaser, and others. The development of digital typography provided for the same infinite placement of letters along a baseline. Even after digital type artists apply global letterspacing to a text block, they can adjust the spacing between any two letters until it is optically correct. Once again, the type artist's eye is the most valued tool.

Individual adjustment of letter pairs, called *kerning*, is more prevalent in display type, where the larger type and space size accentuate letterspacing problems. Kerning follows the laws of *optical letterspacing* (visually balancing space shapes around and within letters in a single word or group of words). Measuring the distance between letters does not work, because the visual impact of the counter also influences letterspacing decisions. For example, in the word *You*, optical letterspacing requires the negative space between the *Y* and the *o* to appear equal to the space between the *o* and the *u*, while recognizing that the counter of the *o* and the *u* affects the space between the *Y* and the *o* also. The type artist's eye is the only tool capable of such delicate balancing.

No complicated plan of measuring negative space can substitute for a practiced eye. Experienced typographers recommend visualizing the space between letters filled with drops of ink. Once the space on either side of the same letter holds the same number of drops (in the mind's eye), the spaces are balanced. While this method is not foolproof, it is a place to start. The point of this mental exercise is to force the type artist to see the space, rather than the letter. Seeing space shapes is a prerequisite to balancing them.

When Jan Tschichold (1902–74) supervised typographic design at Penguin Books in the 1940s, he became so frustrated editing spacing for capital letters that he had a rubber stamp made. It said, "Equalize Letter Spacing According to Their Optical Value." He then stamped those instructions on every instance of incorrect letterspacing he found. (The stamping [or slamming] motion of applying stamp to paper probably helped dissipate his continued frustration.) Tschichold said, "the rhythm of a well-formed word can never be based on equal linear

Optical letterspacing balances the space between and within letters in a word.

① You (no kerning)

② You (tighten *Y* and *o*)

③ You (open *o* and *u*)

distances between letters.… This unmeasurable space must always be of equal size. But only the eye can measure it, not the ruler" (Tschichold 1965). This statement still holds true.

Letterspacing directly affects readability by controlling word shapes. If the type artist sets letterspacing too small or too large, the word shape distorts from its familiar contour. With insufficient letterspacing, letters touch one another and create new letterforms not included in the alphabet's customary 26. Dark blotches appear in the paragraph, which distracts the viewer with odd patterns. At the other extreme, an overabundance of letterspacing causes the reader to question whether the space is between two letters or two words. The reader's puzzlement triggers multiple questions, which breaks reader concentration, destroys sentence readability, and jeopardizes reader comprehension and patience.

Letterspacing and word spacing directly affect readability and page texture.

(kern)	**Peruvian Proofreader**	Kern letters (close)
ls	**Achieves Profitability!**	Add letterspacing
eq #//	The perfect Peruvian proofreader	Use equal word space
#	parlayed his perfectionist perusals	Insert word space
less #	and his penchant for pencil pushing	Reduce space
	in to a profitable profession.	Close up word space

FIGURE 4-14: *Letterspacing and word spacing proofmarks*

Word spacing directly affects page texture and readability by smoothing the breaks between words to carry the reader's eye easily through the sentence. If the type artist sets word spacing too large, white "rivers" form vertically and diagonally between adjacent type lines. These rivers carry the reader along a meandering white current through the type and away from the logic of its content. This destroys the page's even texture and distracts the reader with patchy gray text.

Setting Letterspacing and Word Spacing. It is impossible to discuss letterspacing separately from word spacing. One is proportional to the

CHAPTER FOUR

other. The space between letters in a paragraph must be smaller than the spaces between the words. If these spaces are equal, the reader faces a page filled with evenly spaced letters that hold no clue as to internal groupings. If the letterspacing is enough to separate the letters comfortably, but the word spacing is extreme, the reader sees a page filled with words with no clue as to line cohesion. Letterspacing and word spacing are the glue holding together the letters and words in a readable, evenly textured paragraph.

Letterspacing and word spacing are proportional.

Type designers include letterspacing instructions in their typefaces by designing side bearings for each letter. (See "Paragraph Guidelines and Measurements" earlier in this chapter.) This designer-approved spacing is customized for the design attributes of the face—stroke weights, set width, counter, and such. Word spacing is designer-set also with the inclusion of a *spaceband* (the amount of space [approximately ¼ em] left between letters after a single press of the spacebar) for each font. This term is a carryover from linecasting machines in which expandable metal wedges (the spacebands) served as word spaces between the matrixes in a single line of justified type.

The side bearings provide appropriately sized letterspacing for most text paragraphs, if three factors are present. First, the application must be able to interpret, or read, the spacing information included in the font. Some graphics applications, for example, cannot access the typographic specifications included in a typeface. With type-savvy graphic applications, setting type is a type-tweaker's delight because all the type controls are there. With type-clumsy applications, setting type is disappointing, frustrating, and far too time consuming.

Second, the spacing information must be programmed into the typeface. With the release of some type formats as open formats, all interested comers are invited to design their own typeface. While the ability to create John Doe Condensed has an appeal for some, the words *You get what you pay for* come to mind. A typeface distributed by a time- and market-tested type manufacturer, while more expensive than some, will include more instructions that improve typographic quality. It is better to have one well-designed, more expensive font than a hundred cheap fonts of inferior quality.

Third, the type artist's hardware must interpret accurately the information included in the typeface. For example, the results of printing PostScript fonts on a QuickDraw printer are not identical to those from a PostScript printer. PostScript-interpreter software (Adobe Type Manager) in the computer improves QuickDraw output quality, but the

best results come from PostScript-reading hardware. When all three factors are satisfied, the type artist can benefit from the type designer's knowledge.

Alignment and Spacing. The type alignments, flush left, flush right, and centered, enable the type artist to maintain even letterspacing and word spacing throughout a paragraph or page. These are the space-friendly formats. The amount of space between letters and the space-bands between words and sentences are consistently maintained. There are no alignment requirements causing the application to override or adjust spacing sizes. With flush left, easy-to-find line-starts combine with uniform letterspacing and word spacing to create an easy-to-read paragraph—with other readability-enhancing attributes assisting also.

The justified alignment forces the application to ignore the designer's spacing preferences and asks the type artist to set an acceptable spacing range. The application increases or decreases letterspacing and word spacing within the range (line-by-line) to justify the text. The goal is to keep the range narrow enough so the reader does not notice the spacing differences between lines, yet wide enough so the application can achieve the desired alignment. If the spacing range appears too narrow for the needs of the text, increasing the measure or reducing the type size can solve the problem by creating more spaces to adjust.

In a page-layout application, there are three settings for word spacing ranges for justified type. Together, these settings form an acceptable range with a specific preference when possible. One setting is for the desired or optimum spacing. (Use this if possible.) The second setting defines the minimum spacing. (Do not go any smaller than this.) The third setting defines the maximum spacing. (Do not go any larger than this.) With the desired spacing, the application's default setting uses the type designer's specifications. One popular application assigns word spacing in percentages, with the desired spacing as 100%. (Graphic designers should recognize this as the size of the original—what the type designer provided.) A rule of thumb for optimum word spacing is ¼ of an em (M/4). This is equivalent to the width of a lowercase *t*. Since the em is a proportional unit of measure, this spacing is suitable for any size type. Minimum word spacing for justified text is ⅕of an em (M/5). Maximum word spacing for justified text is ⅓ of an em (M/3).

With 100% representing M/4, a mathematically inclined type artist can start with a sample point size, such as 12 points, determine M/5, M/4, and M/3 (2.4, 3.0, and 4.0 points, respectively), and then work backwards to find the minimum and maximum percentages (80% and 133%,

Justified text adjusts letter and word spacing on a line-by-line basis and is not consistent throughout the paragraph.

Recommended word spacing range for justified text:

minimum—M/5
optimum—M/4
maximum—M/3

respectively). Because the em is proportional, these percentages work for any size type.

Since letterspacing is proportional to word spacing, the logical approach to letterspacing is to follow the same proportions as word spacing. Assuming the desired or optimum setting is the designer's preferred spacing, a type artist sets a proportional range with the equivalent of an 80% minimum and a 133% maximum. Previewing printed samples of different spacing ranges at this time saves the type artist hours of adjustment later. (See "Paragraph Typography Evaluation" later in this chapter.)

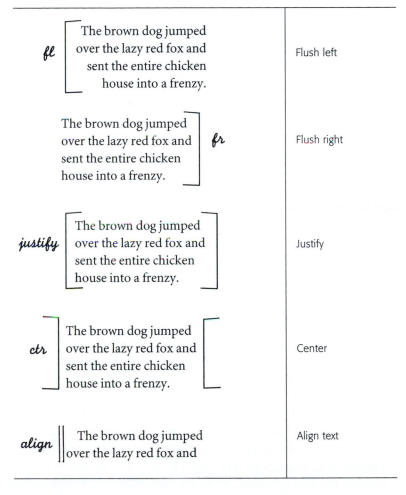

FIGURE 4-15: *Paragraph-alignment proofmarks*

When setting justified foundry type, the distribution of excess horizontal white space was limited primarily to the spaces between words and sentences and secondarily to the spaces between words and select punctuation marks. In those foundry-set texts, larger word spaces are apparent. The result of this was consistent letterspacing from line to line, but the type was prone to white rivers, particularly due to extra space after each sentence. The changing visual landscape for each line was restricted to word spacing. Consequently words maintained their visual integrity and distinct word shape.

Type artists today can still limit excess white space distribution to word spaces by setting all three letterspacing measurements to the desired or optimum spacing. The type artist then makes line-by-line adjustments as needed, eliminating any texture problems. Longer measures are better suited for this justification technique.

Type Style and Spacing. The type attributes of serifs, set widths, and stroke weight influence horizontal spacing decisions. Fortunately, a well-designed digital typeface has a character window sized for its style characteristics. If all the software and hardware requirements are met, the type artist has only a few key spots to check in text type—not each and every word pair. (Chapter 5 identifies the kerning needs of individual typeface characters.) Display-size type for headlines and sub-heads requires more careful visual scrutiny and more frequent kerning due to its size.

Serifs provide a line with built-in letterspacers. The letters cannot get too close to one another without touching. Sans serif typefaces are more challenging because the arms-length separation provided by the serifs is gone. Sans serif type relies on sufficient letterspacing to keep letters apart and to prevent oddly shaped mergers from forming. The type artist should carefully check a sample of sans serif type before using it for lengthy text.

Horizontal spacing is proportional to a letter's set width and stroke weight. Using the type designer's preset spacing is the best and easiest option, but if this is overridden (with justified alignment) or unavailable (with unhinted type), the type artist sets the spacing. Condensed typefaces require less letterspacing than extended typefaces. Reversed type (white type on a black background) benefits by additional spacing. Typefaces with heavy stroke weights cannot be too tightly positioned on the line, or the word shape turns into a word blob. Inserting more space between the letters prevents this. Conversely, a thin-weight font needs a bit more glue to hold it together; narrower spacing assists here.

Digital type provides the type artist with a direct link to the type designer. Buying high-quality digital type provides the designer's expertise, and a type-savvy application enables the type artist to tap into this wellspring.

Type Usage and Spacing. Much of the work a type artist does is viewed at a hand-held distance of 18 inches. All typographic decisions are easily made on screen and then finalized with a quick printout. This viewing distance is not absolute. Some type artists work with type for video presentations, billboards, signage, and other larger or smaller final uses. Type for signage and video presentations needs tighter spacing on screen. Otherwise, the horizontal spaces between the letters and words appear exaggerated in their final form. Conversely, type that will be reduced after it leaves the type artist's screen needs more letter and word spacing to prevent letters from touching in their reduced versions.

Letter Case and Spacing. Words set in all capital letters are effective as headlines, subheads, titles, and captions. The character window for capital letters is proportioned for use with lowercase letters. All caps set from a font suited for text type requires additional letterspacing to balance the larger letters with larger counters. A typeface with a display or titling font (all capital letters) in the proper weight (regular, semi-bold, or bold) has a character window suited for all-cap usage. That does not eliminate the need for page-proof scrutiny. Isolated letter pairs might need kerning. Punctuation in an all-cap sequence requires a visual check for kerning also.

Ligatures are a hallmark of classic typographic quality. The *f-i* and *f-l* ligatures are a standard feature of a digital typeface. The *f-f-i*, *f-f-l*, and *f-f* ligatures are more commonplace with the introduction of more expert collections. Ligatures have preset spacing, because the letters are designed as a single sort. Use of the designer-specified letterspacing and word spacing is recommended when using ligatures. Justified type needs sufficient maneuvering room to make ligatures blend into the text.

ISOLATED INSTANCES OF *kerning* (optically adjusting the letterspacing between two letters) and *tracking* (uniformly increasing or decreasing the amount of letterspacing within a group of letters—word, headline, acronym) might remain after the document-wide spacing settings are applied. Well-set letterspacing and word spacing controls should eliminate the need for kerning in text type. Kerning text drives the type artist crazy and does not produce a significant improvement in readability. Headlines, primarily, and subheads, depending on their size, are the

KERNING AND TRACKING

focus of kerning. The type artist works in an enlarged view (at least 400%) while kerning. A printer or imagesetter capable of reproducing these minute spacing adjustments is a must for high-quality typographic output.

Hyphenation

Hyphenation is another feature type artists use to control typographic texture. It affects letterspacing and word spacing in justified text (by adding or removing letters from a line) and affects the rag range in unjustified text. *Line-end hyphenation* (hyphenating a word at the end of a line) is suitable in text material, but unsuitable for headlines, subheads, pull quotes, and other examples of display typography. With hyphenation turned off, the application can break lines only after words.

In rag text using line-end hyphenation, the type artist sets a hyphenation zone to control the smoothness of the rag. The *hyphenation zone* is a distance measured in from the extreme right edge that determines when hyphenation can occur. Once a word enters this zone, the application begins hyphenating as needed. The longer the zone, the greater the distance between right-side line endings, or the *rag range*. To create a smoother rag, the type artist narrows the hyphenation zone.

The hyphenation zone determines when word breaks can occur.

Type-savvy applications offer automatic hyphenation. With this feature, the type artist continues to enter text while the application breaks the word at preprogrammed hyphenation points. While this increases keyboarding speed, the type artist should check all hyphenated lines on the proof.

A text paragraph should contain no more than three consecutive end-of-line hyphens.

There are several guidelines to follow when hyphenating text. The first rule is the anti-ladder rule. It states that no more than three hyphens should be used consecutively in a paragraph. Abandoning that precept produces a ladder of hyphens along the right edge of a paragraph that mars typographic quality. Some typographers prefer no more than two consecutive line-end hyphens, since a hyphen disturbs the smooth line of the paragraph's right edge; that can be too limiting, however. Some applications enable the type artist to set the number of consecutive hyphens—a handy feature. The second rule is the two-three rule. It states that a hyphenated word should leave a minimum of two characters before the hyphen (on the first line) and bring a minimum of three characters to the next line.

Line-end hyphenations leave a minimum of two characters on the first line and bring down a minimum of three characters to the next.

Some typographers prefer to hang the punctuation. Hanging the punctuation is not as gruesome as it sounds and is possible only with justified type. When hung, the punctuation, such as quotation marks, is positioned beyond the limit of the left or right margin. This smooths

the margins by eliminating the chinking caused by quotation marks, hyphens, commas, and periods. The mark's small size makes its presence beyond the margin unobtrusive.

ꝺ After awaking late, the White Rab⸗bit rushed to dress.	Delete line-end hyphen and close up word
although the dic⸗tionary set thumb⸗nails on edge; ther⸗mometers were dis⸗turbed and simple. *break up*	Too many consecutive hyphens

FIGURE 4-16: *Hyphenation proofmarks*

Another guideline that minimizes message disruption is a variation of an old rule—always hyphenate by syllables. The rule is true, but it does not go far enough. Words should be divided by syllables, but when there are several syllable breaks available, the updated rule—hyphenate by pronunciation—improves readability. For example, the word *encyclopedia* has five syllables—en·cy·clo·pe·dia. Breaking the word after the second syllable (ency·clopedia) is confusing. At the end of a long measure, the reader reunites the two syllable segments after a two- or three-second delay. The sound the reader forms after seeing the segment *ency* does not flow smoothly into the remaining segment *clopedia*. If the type artist divided the word in accordance with its pronunciation—encyclo·pedia—the reader forms the correct sound that flawlessly matches the second segment. Hyphenating by pronunciation maintains the smooth flow of words.

The same goal of creating a smooth flow of words holds true when hyphenating the end of a right-hand (*recto*) page or at the end of a column. If the reader must turn a page or scale a lengthy column before reuniting the two parts of a hyphenated word, the type artist should reconsider hyphenation.

Other common situations requiring hyphenation guidance involve closed compound words, such as *dragonfly;* hyphenated compound words, such as *double-talk;* and words with prefixes, such as *displeased.*

Hyphenating words according to syllables and pronunciation smoothes the flow of words.

Hyphenating words at the end of a page or at the end of a long column impedes word flow.

Line-end hyphenation belongs between compound words and hyphenated words.

A type artist should always divide a closed compound between the two words, such as *dragon·fly,* and a hyphenated compound word at the site of the existing hyphen. Adding a hyphen to a hyphenated word confuses the reader. Hyphenating a word after the prefix is the preferred location.

Indents and Tabs

Indents and tabs position text at precise locations. The type artist sets indents for an entire document or a single paragraph. The application applies the indent automatically as the type artist works. Tabs, on the other hand, are used for a single line or several consecutive lines. The type artist sets the tabs first and then presses the Tab key to activate each tab. In the days of manual typewriters, spacing over with the spacebar worked well because all spacebands and character windows were sized identically. With proportionally spaced type, spacing over is not reliable and is time consuming to fix.

Indents and tabs align proportionally spaced type more accurately than the spacebar.

Common indents are *indent left* (starting the left side of a text block in from the margin at a specified distance), *indent right* (ending the right side of a text block in from the margin at a specified distance), *indent first* (starting the first line of a paragraph in from the left margin at a specified distance), and *hanging indent* (starting the first line of a paragraph at the margin and indenting left the remainder of the lines). Using indents for relocating a paragraph's edge is preferable to moving and resizing a single paragraph in a multiparagraph document. Indents are more accurate and easier to apply to multiple paragraphs.

Common tabs are *left-aligned tabs* (text lines aligned along the left edge at a specified point), *right-aligned tabs* (text lines aligned along the right edge at a specified point), *centered tabs* (text lines centered at a specified point), and *decimal tabs* (decimal numbers aligned vertically at the decimal point). Tabs are more flexible than indents, but just as reliable. They are not restricted to the sides of the text block.

First-Line Indents. First-line indents call attention to the beginning of a new paragraph and provide a small respite for the eye. After a heading, however, the first-line indent is unnecessary because the heading heralded the beginning of the paragraph. If the type artist does not place additional white space between the paragraphs on the page, then the first line of the remaining paragraphs is indented. If the type artist places additional space between paragraphs, the first-line indent is redundant and should be eliminated.

A first-line indent does not follow a subhead or headline.

The type artist determines the length of the indent according to the size of the measure and size of the margin. A minimum first-line indent is 1 em or 1 lead. Both the em and the lead are suitable indents

because they are proportional measurements and have a visual relation-ship to the rest of the text. If a paragraph is set 11/14, the indent can be either 11 points (the em) or 14 points (the lead). Increasing the indent is acceptable with a wide margin or long measure. In that case, using 1½ or 2 ems or 2 leads is preferable. There is the rare occasion when a more sizable indent works well, but it is a rare case. The problem with longer indents is the large unusual white shape created between paragraphs. It is distracting to the reader.

Hanging indents effectively call attention to a new paragraph by jutting into the margin away from the left edge. These indents are pre-ceded by additional paragraph space that lightens the texture and em-phasizes the indent. Without it, the paragraphs form a single, formi-dable, mega-paragraph that chases away readers. Initial caps are a decorative technique, coupled with first-line indents or hanging indents, that call attention and add graphic emphasis to the beginning of a new section of text. (See chapter 7.) While these initial flourishes can en-hance a document, they are not suitable for all documents. The job of the type artist is to enhance readability, not design a typographic mine field. Knowing when to stop is an underrated, essential design skill.

A first-line indent or space between paragraphs identifies a new paragraph. They always work alone.

A 1-em or 1-lead first-line indent is the minimum for paragraphs.

A 1½-em, 2-em, or 2-lead first-line indent is suitable for wide margins and long measures.

☐ ⌃The brown dog jumped over the lazy red fox and	Indent 1 em
◪ ⌃The brown dog jumped over the lazy red fox and	Indent 1 en
☐◪ ⌃The brown dog jumped over the lazy red fox and	Indent 1½ em
2 ⌃The brown dog jumped over the lazy red fox and	Indent 2 ems

FIGURE 4-17: *Indention proofmarks*

Setting Block Quotes. The term *block quote* refers to a quote in running text that exceeds four lines. It is easy for the reader to lose track of the speaker with a quote of that length. Consequently, separating the quote from the text by a typographic change helps the reader recognize

<div style="margin-left:2em">

Quotations in excess of four lines are indented, prefaced by additional white space, and not quoted.

</div>

the speaker change. Reducing both the type and leading size by 1 point alerts the reader to the shared relationship of the words. Inserting 2 or 3 points of additional white space before and after the block breaks the leading pattern of the text and further supports this subgroup union. (See "Intraparagraph Spacing" later in this chapter.) The block quote has neither a first-line indent nor quotation marks.

If the typographic changes are insufficient, the type artist can use a left and right indent for the block quote. The use of the indent is not required, but is helpful if the decrease in type point size, coupled with the decrease in leading, creates a readability problem for the existing measure. The type artist should set the indents in proportion to the first-line indent. For example, with a 2-em first-line indent, a 1- or 2-em block-quote indent makes visual sense. A quote of four lines or less is quoted and included in the running text without typographic changes.

Using Tabs. Type artists use tabs to organize and to tidy visually a collection of statistics, measurements, facts, and figures, in columns. It is difficult for readers to compare statistics when they are racing about the page trying to find them. Tabs position these items into subgroupings that encourage comparison. Many type artists cringe after hearing the word *tab* due to prior bad experiences. Tab-savvy type artists avoid trouble by using indents whenever possible.

Indents should replace tabs whenever possible.

[⌐The brown dog jumped over the lazy red fox and	Move left to location indicated
] The brown dog jumped over the lazy red fox and	Move right to location indicated

FIGURE 4-18: *Line-placement proofmarks*

Tabs are appropriate when there are multiple alignment points along the same line. To set three adjacent columns of figures, for example, set all the figures first—row by row, abutting one another. With all the material in place, the type artist selects the lines of figures as a single entity, sets the correct tabs, and then (working from left to right) positions the insertion point and hits the Tab key. Adjustments to column placement can commence after all three columns are aligned. To

break up	The fox for the one day ; the dog for the one bone dinner and the entire	Fix knothole
widow	The brown dog jumped over the lazy red fox and sent the entire chicken house into a fren-zy.	Fix widow
break	The brown dog jumped over the lazy red fox and sent the entire chicken	Take down to next line
move up	The brown dog jumped over the lazy red fox and sent the entire chicken	Take back to previous line
¶	"I am late!" "No, you are not!"	New paragraph
no ¶	house into a frenzy. Later that day the farmer	Run in
run in	The brown dog jumped over the lazy red	Run in

FIGURE 4-19: *Line-manipulation proofmarks*

adjust the columns, the type artist selects all the figures again and drag-edits the tab markers.

A PARAGRAPH NEEDS a good beginning—in the form of an indent, additional white space, or an initial cap, to name a few—to draw the reader into the text. Frequently, paragraphs straddle more than one page. The reader starts the paragraph on one page and ends on another. If the type artist could choose, all paragraphs would break in the middle, leaving an ample text block to end the first page and start the

WIDOWS
AND ORPHANS

second page. Since this is not possible, the type artist tries to maintain the visual integrity of both pages by controlling where the split occurs.

The terms *widow* and *orphan* refer to partial paragraphs residing on a page. The term *widow* refers to the last line of a paragraph positioned at the top of the next page or column. It also refers to a short word (less than four letters) or the tail end of a hyphenated word as the last line of a paragraph. The widowed line (or word) goes forward to the next page (or line) alone. The term *orphan* refers to the first line of a paragraph positioned at the end of a page or column. The orphaned line is left behind while the rest of the paragraph goes forward to the next page.

In both cases, an insufficient number of paragraph lines weakens the top or bottom edge of a page. The orphan is the least offensive of the two. How to fix a widow depends upon its length. It could be easier to bring it back to the previous page if it is short. Fixing a widowed word follows the same guidelines as fixing hyphenation problems. (See "Hyphenation" earlier in this chapter.)

(See "Hyphenation" earlier in this chapter.)

Intraparagraph Spacing

A PAGE OF TEXT TYPE is frequently, and thankfully, punctuated with type treatments (headlines, subheads, block quotes, and pull quotes, to name a few) as well as illustrations, photographs, or additional white space. These type treatments help the reader by subdividing and organizing the text. They can contribute to page chaos, however, if handled incorrectly. On a multicolumned page, the baselines of the text in the first column should align with the baselines of the other columns. If the page contained nothing but columns of 10/13 text, baseline alignment between columns would be assured. With the addition of subheads, block quotes, pull quotes, and illustrations into columns of text, baseline alignment between columns becomes a challenge.

Size is the key to inserting headings and graphics into a text column while maintaining baseline alignment. The amount of space used by the insertion should be a factor of the leading. For example, if the type artist places a subhead in the middle of a 10/13 continuous-text column, the subhead's total leading should be 13 points (13×1), or 26 points (13×2), or 39 points (13×3), and so forth (a factor of 13). If the subhead is two lines set 12/13 in a semibold typeface, the subhead is larger and bolder, but it still maintains the 13-point leading for a total insertion size of 26 points (a factor of 13, that is, 13×2). Because the subhead's leading is a factor of the text leading, the adjacent text baselines realign once they pass the subhead.

A paragraph's last line should not be a whole word of less than four letters or the last half of a hyphenated word of any length.

Baseline-to-baseline alignment should be maintained horizontally through adjacent columns of text.

Many times a text insertion is not a factor of the leading. In those instances, the type artist adds additional white space before and after the insertion to make its total size a factor of the leading. If the type artist inserts a two-line subhead 13/15 into the same 10/13 text column example (fig. 4-20), the insertion measures 30 points (15 + 15 = 30) vertically. The insertion is 9 points short of the nearest leading factor— 39 points. The type artist must distribute a total of 9 points of white space before and after the subhead. Placing more of the 9-point white space in front of the subhead positions it closer to the text it introduces, which aids reader comprehension. Although the subhead's baselines will not match adjacent baselines, the text beneath the subhead will align correctly to adjacent text baselines.

Leawood type set in 10-point type with 13-point leading. Leawood type set in 10-point type with 13-point leading for text.	Leawood set in 10-point type and 13-point leading. **Type 13/15** **Type 13/15** Leawood set in 10-point type and 13-point leading for text.	Leawood set in 10-point type and 13-point leading. **Type 13/15** **Type 13/15** Leawood set in 10-point type and 13-point leading.

Leawood 10/13 (left); Leawood 10/13 • 13/15 subhead (center);
Leawood 10/13 • 13/15 subhead • 6-points white space above subhead
• 3-points white space below subhead (right)

FIGURE 4-20: *Align baselines between adjacent paragraphs*

Inserting photographs or illustrations into multicolumn pages follows the same principle as typographic insertions. The total insertion size must be a factor of the leading. With graphic insertions of varying heights, the amount of white space varies in size also. If the amount of space around the graphics is too noticeable, the type artist can hide the difference by placing the graphic at the top or bottom of the column. Resizing the graphic is also an option.

With lengthy documents, such as annual reports or newsletters, it is important to establish a baseline-alignment system initially that is easy to maintain as the page numbers increase. For example, many type

artists prefer using paragraph indents instead of extra white space between paragraphs because it maintains the leading rhythm while still identifying new paragraphs.

PARAGRAPH TYPOGRAPHY EVALUATION

SMALL CAPS the elements are all on the page, it is time to customize. The work is not over by any means. In house-building terms, the house is framed, roofed, and drywalled; now it is time for the carpenters and painters to do the trim and custom work. The type artist's custom work at the paragraph level includes four areas of concern: software spell checking, baseline alignment, consistency, and typographic texture.

The software spelling checker is the broadest means to check spelling, and it catches only the most obvious errors. It catches the extra letter *t* in the word *litttle* or the additional letter *i* in the word *siilly*. With proportionally sized letters, it is easy to overlook an additional letter or a missing letter when spell checking manually (by eye). There is no reason to spell check manually for this kind of error, because the software can do it faster. It is the *compliment* and *complement* errors that await the type artist on the sentence level of typography.

With major spelling errors eliminated, the type artist prints out a proof copy for paragraph-level corrections. It is a waste to use good paper for this because an experienced type artist will cover it with colored ink while editing. Some type artists use a specific paper color for this stage—light yellow, for example—to identify the printout as a proof.

With proof in hand, a good way to check for baseline alignment is to turn the page sideways (similar to holding a cafeteria tray) and tilt upward the page side closest to the type artist. At this angle it is easy to look along the type lines to check baseline alignment. Any insertion (subhead, photograph, and others) breaks the alignment, but baseline alignment should resume beyond the insertion. If an alignment problem appears, the type artist draws a colored-ink line along the baseline of both offending lines, extends them parallel to one another into the gutter, and writes *align* (circled) above it. If an adjacent text block uses smaller type than its neighbor, baselines should come into alignment every three or four lines.

Consistency on the paragraph level concerns uniform treatment of like paragraph elements, such as type size, indentions, alignment, and leading. If the paragraph alignment was to be justified, the type artist checks each and every paragraph for uniformity. The type artist should compare all like paragraph elements individually to confirm consistent treatment.

Baseline alignment proofmark

Typographic texture on the paragraph level also concerns letter-spacing and word spacing, knotholes, and hyphenation. Texture is checked with the page turned upside down. By breaking the eye's ability to read the document, it is much easier to see any white rivers or dark blotches in the text. The type artist can circle a white river, add proof-readers' marks for spacing problems (fig. 4-14), circle a hyphen ladder (more than three consecutive hyphens), check the two-three hyphen-ation rule, and circle any knotholes.

A *knothole* is an unfortunate placement of two or more identical words (fig. 4-19) directly below one another in adjacent type lines. Two identical short words directly below one another is not a problem and should be overlooked, but two identical long words will attract reader attention. It is acceptable for two consecutive lines to start with the same word (depending upon length), but three start to look like a list.

&

Proofmarks are succinct and easy to understand with practice. They indicate a particular remedy without cluttering the page with a lengthy message. A written message can cause more confusion if not worded correctly. With the multitude of items to check on the para-graph level, it is wise to make a prioritized checklist to follow. Trying to catch everything in one look-through is impossible and confusing. Working from the largest infraction to the smallest is a useful order to follow, but an experienced type artist will customize the checklist order to satisfy the specifications of the document or individual work style.

SETTING
TYPE
IN A
SENTENCE

When the prolific American type designer Frederic Goudy started his impressive list of type designs in 1901, the United States railway system serviced almost 200,000 miles of line. Train travel was the primary mode of long-distance travel. Well-appointed trains barreled along well-maintained tracks. Passengers marveled at miles of rugged landscape as the train's wheels glided swiftly along smooth, parallel rails supported by wooden crossties. When the rail lines were maintained properly, the ride was smooth and the mechanics of train travel went unnoticed by the passengers. However, if a rail broke or the track bed eroded or a cow decided to chew while camped in the middle of the track, the train's progress slowed or stopped, and the passengers' ride was bumpy, bone jarring, or delayed.

In much the same way, lines of type on a page guide a reader's eye past a landscape of printed information. A reader's eye flows smoothly from word to word, just as a train glides smoothly past each crosstie. When type lines are constructed properly, reading is smooth, comprehension is high, and type-line mechanics go unnoticed by the reader. Type quality at the sentence level can accelerate or impede the reader's progress through a paragraph. A wayward cow on the tracks will stop the train, just as an errant period in the middle of a sentence will cause the reader to stop and ponder its purpose.

Sentence typography is the use of type font characters (letters, figures, punctuation marks, diacritics, joined characters, symbols) and type styles within a sentence to improve reader comprehension. The tools of sentence typography enhance the delivery of the message by giving the words visual clarity and by eliminating visual clutter. On this level, the type artist's role is not to change the writing style or content of the author's words, but to make them easier to discern. The type artist's responsibility is similar to that of an audio technician on a sound stage. The technician adjusts the controls to improve sound quality, so the listener hears the singer's voice or the orator's words clearly without distracting static or booming background noise. These behind-the-scenes professionals enhance, not create, sound quality. The type artist manipulates type controls to improve typographic quality, so the reader reads and comprehends the author's words without distraction.

A well-set sentence displays a high quality of typographic form, just as well-written prose displays a high quality of literary form. The experienced writer uses language more adeptly than the novice. The more experienced type artist uses font characters more proficiently than the novice. For example, just as the word *there* indicates a place and the word *their* indicates possession, a hyphen (-) indicates non-inclusive numbers, as in a telephone number, and an en dash (–) indicates inclusive numbers, as in a range of time.

In the previous *there/their* example, the change in type style from roman to italic identifies the two modifiers as terms for discussion, rather than terms in context. The visual change is subtle enough for the words to remain part of the continuing sentence, but obvious enough to distinguish the term for special consideration. Without the type style change, the reader might misunderstand the author's intent. Hopefully, a second read-through would eliminate the reader's confusion; but good sentence typography should eliminate reader confusion and sentence rereads.

Sentence guidelines and measurements focus on the positioning of characters horizontally along the baseline and vertically within the point size. Horizontally, the type artist uses incremental spaces to separate characters and improve readability. The em and en are the foundations of this measuring system.

Not all applications provide a full range of space inserts. Some possible options and their sizes are a thick space (M/3), a middle space (M/4), a thin space (M/5 or M/6), and a hair space (M/12 approximately).

TYPOGRAPHY AND TYPOGRAPHIC FORM

SENTENCE GUIDELINES AND MEASUREMENTS

The width of some spaces and characters is equal to the width of other characters. For example, a figure dash is the width of a standard figure or numeral in the typeface. The lowercase *t* is the equivalent of M/4 (almost).

Varying space sizes enable the type artist to adjust letter position when a full spaceband is too much, for example. When setting personal initials, such as in *F. D. Roosevelt,* a spaceband should follow each period. There are times when the space between the *F* and the *D* appears too large, because some typefaces allocate a larger character window to a period than others. In those instances, the type artist might use a thin space (M/5 or M/6) in place of a full spaceband (usually M/4). The smaller space pulls the two letters together and eliminates the oversized, texture-disturbing gap.

Kerning and tracking are other forms of horizontal space manipulation. They add or delete space, in the form of units, between character pairs or, in the case of tracking, between several selected letters. The application sets the unit size: $\frac{1}{100}$ of an em (M/100) is a common kern unit. Inserting horizontal space of any size enables the type artist to position letters or words comfortably along the baseline to enhance readability. Sentence kerning, however, is a sinkhole for the type artist's time. Fixing the most egregious errors is more important than improving something that works adequately as is. Setting the global word and letterspacing correctly in a dialog box eliminates 95% of the kerning problems when using a high-quality typeface.

The placement of characters within the point size determines how characters align horizontally. The vertical location of a character determines whether or not the character aligns with or flows easily into the adjacent characters. The guidelines within the point size—the mean line, cap line, and baseline, for example—are the points of reference for vertical placement (fig. 2-1). For example, an en dash (–) sits closer to the baseline than the figure dash (–). The bullet (•) is centered higher than the midpoint (·) within the point size. The type artist relies on an accurate, easy-to-carry measuring tool when evaluating sentence spatial relationships—the human eye.

SENTENCE PROOFREADERS' MARKS

THE FIRST PRINT OF ANY DOCUMENT emerging from a printer (of any resolution) is a *page proof.* No matter how pristine the letterforms (attributable to a clean printer with abundant toner) or how complete the document (getting all the copy on the page is not the primary goal here), a page proof is a work in progress, a draft—it contains errors. A

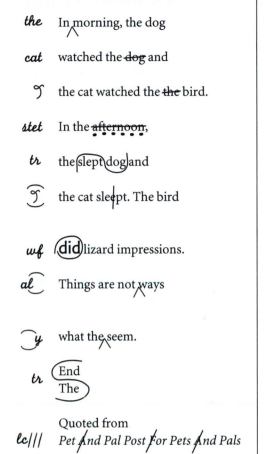

the	In morning, the dog	Insert word(s)
cat	watched the ~~dog~~ and	Substitute word(s)
ℐ	the cat watched the ~~the~~ bird.	Delete word
stet	In the ~~afternoon,~~	Let it stand
tr	the ⌒slept dog⌒and	Transpose words
ℐ	the cat sle¢pt. The bird	Delete letter and close up
wf	⊘did⊘lizard impressions.	Set in correct font
al	Things are not ⋀ways	Add to beginning of word
y	what the⋀seem.	Add to end of word
tr	⟮End⟯ ⟮The⟯	Transpose lines
lc///	Quoted from Pet /And Pal Post /For Pets /And Pals	Set in lowercase three times

FIGURE 5-1: *Deletion, relocation, insertion, and substitution proofmarks*

The word *stet* (let it stand) comes from the Latin *stare* (to stand). A stetted word should remain in its original form.

reproduction proof (a document ready to be reproduced for distribution) is only pronounced as such after it is scrupulously checked for spelling errors, typographical errors, content-omission errors, consistency errors, printer errors, and all others. Before the document passes through the human error-checker, it is merely a page proof.

Proofmarks on the sentence level are made with surgical precision. Here the type artist uses all categories of proofmarks (fig. 5-1) to fix spelling, add or delete spaces, transpose words, insert or substitute characters and ligatures, standardize character usage, check type style,

and check kerning. The type artist slowly proofreads each text block and carefully inserts text proofmarks to identify the error and neatly positions margin proofmarks to correct the error.

In a heavily edited document, the clutter of margin marks can become confusing. To minimize clutter and conserve space, type artists position a slash (/) after a margin mark to indicate the number of consecutive times they identified the mistake. Each slash indicates a single correction. For example, the letters *lc* followed by three slashes indicates three letter case changes in a row (fig. 5-1).

A prioritized checklist for proofing reduces confusion and overlooked mistakes as the type artist stares at the same week-old document. Checking for consistent typographic treatment throughout a lengthy document also is easier with a checklist. (See "Sentence Typography Evaluation" later in this chapter.)

SENTENCE TYPOGRAPHY PRELIMINARIES

Sentence typography employs consistency to communicate effectively.

One way to become proficient at setting typographically correct sentences is to read (and analyze) well-set type. Publications with lengthy preparation times, such as books and magazines, are good sources. Newspapers have short preparation times, and so follow a different set of typographic rules. Text set with small caps, text figures, and ligatures are easily identified signs of type likely to be well set.

There are typographic style guidelines for every situation imaginable. For the novice, it is overwhelming at first. The first typographic style rule to remember is consistency. Even in error, it is better to be consistently incorrect than to set the same word differently (in the same document), hoping to get it right at least once. To avoid confusion, it is wise to start with a few rules for common situations. The rule *Put one space after a sentence and a colon* is a logical starter rule. Once those rules become second nature, the type artist incorporates more in the repertoire. Keeping a well-marked source book handy (such as this one) is wise as well. It is impossible to remember everything, but type artists should know where to find what they forgot. Many publishers and corporations adopt style manuals, such as the *Chicago Manual of Style,* as their final word on type usage.

Type artists need access to all font characters when setting sentences correctly. An expert collection for several often-used typefaces, and perhaps a specialized pi font, provides the tools of the trade for well-set sentences. Standard digital type fonts offer 256 font characters, including a couple of *f*-ligatures, diphthongs, symbols, punctuation marks, and diacritic marks. They do not provide the text figures, small

caps, superior and inferior figures, case fractions, additional *f*-ligatures, titling fonts, alternate letters, and expanded punctuation marks that make typesetting a true art form.

THE REMAINDER OF THIS CHAPTER deals with typographic form as it applies to sentences and the characters within them. It notes distinctions between continuous and discontinuous text usage as well. Each section explains appropriate font characters and appropriate punctuation placement for common text situations. Font characters are listed by frequency of use, not in alphabetical order. (The index lists the individual marks alphabetically.) Text samples, usage rules, and proofmark pairs are included in each section. The arrowheads (▲) and (▼) denote text samples set correctly or incorrectly, respectively.

UPPERCASE, MAJUSCULES, OR CAPITAL LETTERS, as they are known in diverse situations and different times in history, call attention to themselves and their positions on the page. Uppercase letters are more formal, more stately than the lowercase letters. It is the alphabet dressed up in its finest. Type artists use capital letters to identify the beginning of a new sentence, proper names, book titles, personal initials and acronyms, or two-letter state abbreviations. (See "Titling Caps and Small Caps" in chapter 6.) Personal acronyms, such as *FDR* and *JFK,* use full caps without periods or spaces. In discontinuous text, setting words in capital letters emphasizes or draws attention to them. In continuous text, as a technique for emphasis, they are excessive. They jar the reader, give undo emphasis, and disrupt the smooth flow of the words.

▲ Franklin Delano Roosevelt (FDR) was born in Hyde Park, New York.

caps//ᴅ Franklin delano roosevelt (FR) was born in Hyde Park, New York.

IN 1501 THE NOTED VENETIAN TYPOGRAPHER Aldus Manutius developed italic letterforms for typesetting books. This condensed typeface increased the number of characters per page, decreased the book's length, and kept printing costs lower. (Initially, italic lowercase letters were used with roman capitals. The design of italic capitals came later.) Italic type gets its name from Italy, its country of origin. It is reminiscent of cursive letterforms with calligraphic terminals and strokes.

In the early years of the twentieth century when writers and journalists wrote about train travel in the United States, they used manual typewriters (invented by C. L. Sholes in 1868). As their fingers pounded

SENTENCE TYPOGRAPHY DECISIONS

CAPITAL LETTERS

- Start sentences and proper nouns with a capital letter.
- Use capital letters for personal initials and two-letter geographic acronyms.

ITALIC TYPE

- Italicize the space before an italicized word to improve word spacing.
- Do not underline a word when italic type is available.
- Italicize the names of books and periodicals.

the keys, the typists underlined publication titles (books, periodicals, and newspapers) because italic letterforms were unavailable on their keyboards. Typists also underlined words to emphasize them.

Contemporary type artists should use italics in those situations previously handled by underlining. Underlining is not acceptable typographic form in continuous text because the line beneath the word collides with the letter's descenders, creating a texture blot—<u>really</u>. Mixing italic type within running roman text calls attention to individual letters without marring the sentence's texture. Similarly, boldface type also alters the sentence's even texture. Italicized words should enhance the reader's understanding of the content. Italicizing a book title, for example, identifies those words as part of a single unit, the title. Italics as emphasis should be applied with a light touch. Too many italicized words diminish their impact and create textural chaos. Conversely, within italicized text, the type artist sets roman a word or words that otherwise would be italicized, such as a book title, in roman text.

bf	The premiere Parisian proofreader	Set in boldface
ital	was not persuaded that	Set in italic
rom	the Peruvian's predominance	Set roman
bf + ital	as a precise proofreader was	Set in bold italic
lc	properly and Positively proven	Set in lowercase
lc	to the PERUVIAN's peers.	Set all in lowercase
caps	The end (probably)	Set all in caps

FIGURE 5-2: *Letter case and style proofmarks*

A lone italicized word within a roman sentence creates word-spacing problems. As the italicized letters lean to the right, they lean away from the roman word on their left. This visually increases the word space before the italicized word. At the same time, these letters lean closer to the roman word on their right. To decrease the word

spacing preceding an italicized word, the type artist italicizes the space before the word, along with the word. In some instances, this is sufficient. With other letter combinations, kerning the word space tighter is necessary. If the italicized word is crowding its neighbor to the right, the type artist must kern additional word space between the words.

▲ *The Perfect Puppy,* published by W. H. Freeman and Company, helps families choose a puppy based on breed behavioral characteristics.
▼ Although technically categorized as a Golden Retriever, our model of the breed <u>never</u> returns what she finds.
▲ … our model of the breed *never* returns what she finds.
ital … our model of the breed <u>never</u> returns what she finds.

The use of different type styles changes over time, as the 1936 quote from Eric Gill's *Essay on Typography* illustrates. Arthur Eric Rowton Gill (1882–1940) was a noted British type designer, sculptor, wood engraver, and an outspoken social critic of his time—among other things.

THE DEVELOPMENT OF PUNCTUATION for text started as far back as 260 B.C., when Aristophanes of Alexandria placed dots between select words to indicate pauses and stops. Since word spaces were not standard until A.D. 600, these dots suggested a relationship between sections of words. In the fourth century A.D., the Romans adapted the use of dots by placing them between all words. Later, when spaces separated words, the dot remained as the equivalent of the current period, comma, and colon. The dot's vertical position within the *x*-height determined which of these functions it served (Firmage 1993). Aligned at the top of the letters, the dot indicated the end of a sentence. Aligned on the baseline, it functioned as a comma. It is believed that the full system of punctuation marks was not complete until after printing with movable type was invented in the mid–fifteenth century. The foundation for the current system of punctuation is credited to the typographer Aldus Manutius (1450–1515).

Punctuation makes the written message clearer and facilitates its delivery. Distinguishing a question from a statement of fact is important for the reader's overall understanding. A hyphen at the end of a line, for example, differentiates the word *damage* from the two words *dam* and *age.* The hyphen's absence here changes the meaning of the sentence considerably.

The common practice of using italics to emphasise single words might be abandoned in favour of the use of the ordinary lower-case with spaces between the letters (l e t t e r - s p a c e d). The proper use of italics is for quotations & foot-notes, & for books in which it is or seems desirable to use a lighter & less formal style of letter.

——————————Gill
Essay on Typography

PUNCTUATION

- All complete text sentences end with a punctuation mark.
- Headlines and subheads do not need a terminal punctuation mark.
- Set punctuation in the style of the word it follows.
- Punctuation following isolated bold words may remain roman to match the rest of the sentence.
- Punctuation point size in text matches the text type size.
- Punctuation size in display type can be reduced in point size.

A terminating punctuation mark follows a complete sentence. Headlines, subheads, and captions (heading type set apart from other text as a separate type block) do not require a period, however, even if they are complete sentences. If the heading is a question or exclamation, the appropriate mark should follow.

When several punctuation marks are adjacent, each mark's location is important. Frequent questions occur with double or single quotation marks, parentheses, and brackets (see the individual sections later in this chapter).

Type Design and Punctuation. Although punctuation marks are small, they are designed for use with only one typeface. A period in one typeface is a perfect circle, while in another it is an oval or diamond shape. Punctuation clarifies the message and complements the design structure of the typeface. Although small, some punctuation marks require kerning. They cannot crowd or touch the words they clarify. Even a small mark can disturb a paragraph's texture. Question marks and exclamation points are likely to require kerning.

Type Style and Punctuation. Punctuation style—italic, bold, roman—blends the mark into the surrounding text. When type styles change, the mark maintains the style of the preceding word. There are some notable exceptions concerning parentheses and brackets (see "Parentheses and Square Brackets" later in this chapter). When using bold type within a regular-weight sentence (to identify a vocabulary word in a textbook, for example), an exception is made as well. The bolded comma might cause confusion, because the comma is part of the mechanics of the sentence, not part of the vocabulary word.

▼ A Golden Retriever is bred to **retrieve;** a house cat, based on personal observation, is bred to sleep.
▲ A Golden Retriever is bred to **retrieve**; a house cat,…
▲ In human terms, the word *retrieve* means to return or to bring back. In dog terms, it means *gotcha!*

The type artist italicizes small punctuation marks (such as commas, periods, and semicolons) that follow italicized words. It improves the letterspacing. A type artist would italicize an exclamation point or question mark (following an italicized word) only if the mark belonged to the word. This clarifies the message.

Type Size and Punctuation. Punctuation marks in text are the same point size as the body copy. In display type, however, a type artist

Period styles
from book and regular types

▲ Correct typographic form
▼ Incorrect typographic form

can reduce the point size to maintain the mark's proper visual relation-ship to the words. The decrease in punctuation size is proportional to the display type's point size. The larger the type, the larger the reduction in point size. When using a large initial cap, or versal, in a quoted sen-tence, for example, the typesetter can set the opening quotation marks to match the size of the initial cap, the text, or a suitable size in between. The closing quotes would match the text size, because they fall within the text block.

An experienced type artist establishes a personal style for some of the discretionary typographic rules. Consistent application of these distinguishes the work of one type artist from that of another. There is only one rule to follow: Apply type rules consistently within a single document.

PERIODS BELONG AT THE END of a sentence, after personal initials, after an abbreviation, and after figures and letters enumerating elements in a vertical list. The typist with a manual typewriter placed two spaces after a sentence-ending period. With monospaced type, the extra white space distinguished sentence breaks by visually overpowering the sentence's generous letterspacing. With proportionally spaced type, a single space between sentences is correct and two spaces is a puzzling excess. One space follows a colon within a sentence as well.

▲ The dog stood guard. The cat prowled. The bird did nothing.
▼ The dog stood guard. The cat prowled. The bird did nothing.
less # The week's shopping list included: ˄dog food, cat food, and bird food˄ ⊙

Within a sequence of personal initials (F. D. Roosevelt), a space follows each period. A thin space is preferred if the spaceband appears excessive. Some typographers prefer to drop the space between per-sonal initials, but this emphasizes them and weakens their link to the last name. Some spacing is recommended.

▲ The speaker, E. M. Gottschall, was scheduled in the green room.
▼ The speaker, E.M. Gottschall, was scheduled in the green room.
#/⊙ The speaker, E˄M˄Gottschall, was scheduled in the green room.

When a parenthetical statement is a complete sentence and not positioned within a larger sentence, no space separates the period and the closing parenthesis.

Apply type rules consistently within a document.

PERIODS AND COMMAS
— . , —

* One space separates typeset sentences.
* A period follows complete sentences and personal initials.
* Use a period after enumerating figures or letters in a vertical list.

* Commas separate elements in an address or location.
* Commas separate items in a series.

Comma styles
from book and regular types

SEMICOLONS
AND COLONS

— ; : —

* Semicolons join sentences
 that can stand alone.
* Semicolons link elements
 in a run-in series when
 complex punctuation is used.

* A single space follows a
 colon.
* Colons set off elements in a
 run-in list.
* Colons set off a vertical list
 after the words *follows* or
 following.

Commas separate items in a series, offset a direct quote as dialogue, precede conjunctions in compound sentences, and separate elements in an address or location. A single space follows a comma used in text. The design of the comma varies in appearance from a circle with a downward-curving tail to a diagonal line angled into the letterform at the bottom.

▲ The voracious dog lives at 23 First Street, Middletown, Ohio 45042, in a large, well-chewed mansion.
▲ We will visit London, England, during our summer vacation.
 We will visit London‸England‸during our summer vacation. ‸∖//

SEMICOLONS AND COLONS ARE similar in appearance, but have different functions. A semicolon joins two related independent clauses that could be written and punctuated as separate sentences. Also, a semicolon links elements in a series when complex punctuation is within one or more of the individual elements. In this situation, the semicolon shows a hierarchy of punctuation that helps to clarify the meaning for the reader. A single space follows a semicolon.

A colon, on the other hand, sets off elements in a run-in list (within the text) or comes after the words *follows* or *following* before a vertical list. A single space follows a colon.

▲ Eating for the dog was an avocation. She practiced (a) nutritional eating (dog food served in a dog bowl at the beginning of the day); (b) recreational eating (shoes, children's toys, and crayons partially consumed, mostly chewed, strictly for sport); and (c) stealth eating (the successful capture and consumption of a bar of bath soap without leaving incriminating evidence—soap crumbs, wet feet, or bubble breath).

 She practiced (a) nutritional eating (dog food served in a dog bowl at
;/ the beginning of the day)‸(b) recreational eating....

▲ The week's shopping list included the following:
 1. dog food
 2. cat food
 3. bird food
:/ The week's shopping list included the following‸

THE EXCLAMATION POINT AND the question mark clarify the author's intent and indicate how to place emphasis when reading the sentence. These marks differentiate between an imperative shout *Watch out!* and a puzzled inquiry *Watch out?* Both marks can appear at the end of the sentence or within it according to the sentence's meaning. If the question or exclamation is not a direct quote, it is not set off by a comma.

▲ Why isn't the cat hungry for his dinner? she speculated silently.
▲ "Is the bird cage empty?" she shouted in a staccato screech.
 "Is the bird cage empty" she shouted in a staccato screech. *?* (*set*)

Both exclamation points and question marks require careful proofing. They create kerning problems with certain letters—the lowercase letter *f,* for instance. Often an all-cap headline requires kerning when followed by either mark. Display-size type always exaggerates letterspacing problems, and the use of the exclamation and question marks are prime candidates. When used with other punctuation, such as quotation marks, parentheses, and brackets, the exclamation and question marks are positioned according to the meaning of the statement. (See chapter 6 for special small cap punctuation.)

▲ "He's in here, dear!" a falsetto voice fluttered in from the foyer. Fortunately for our feathered flapper, his stark sanctuary was the result of scrupulous scrubbing rather than sumptuous snacking.
 "He's in here, dear" a falsetto voice fluttered in from the foyer. *!* (*set*)

THE DASH CATEGORY ENCOMPASSES marks of varying lengths from the hyphen, the shortest, to the three-em dash, the longest. Because dashes vary in length, their effect on paragraph texture and their spacing requirements differ also. Each dash has a different function, ranging from offsetting a break in thought to separating groups of numerals. A type artist checks the horizontal spacing around each dash in the text. Some require a whole space on either side, and others require gentle kerning. In all cases, the dash should not mar the texture either by opening a large white hole or by colliding with adjacent letterforms.

Learning that there are at least five dashes from which to choose can confuse and daunt the novice type artist; when to set them also can be confusing. Many typeface packages provide three—the hyphen, the en dash, and the em dash. These three are good starter dashes. The expert collections can add at least four more. An easy way to remember

EXCLAMATION POINTS AND QUESTION MARKS
— ! ? —

+ An exclamation point indicates an interjection or exclamation.
+ Exclamation points are not limited to end-of-sentence usage.
+ An exclamation point requires kerning with all caps and some lowercase letters.

+ A question mark indicates an interrogative.
+ Question marks are not limited to end-of-sentence usage.
+ A question mark requires kerning with all caps and some lowercase letters.

DASHES

+ Check dashes for kerning.
+ Equate dash length to reading-pause length.

[–] **En dash**
　　Option + hyphen

[–] **Figure dash**
　　Option + hyphen (expert)

[—] **¾ em dash**
　　equal sign (expert)

[—] **Em dash**
　　Shift + Option + hyphen

Macintosh typeface keystrokes
for typesetting dashes

— - —

* Hyphens divide words at line breaks.
* Hyphens create compound modifiers.
* Hyphens link noninclusive numbers.
* Do not hyphenate more than two or three consecutive lines.

▬　▬　▬

Hyphen styles set on same baseline:
Adobe Garamond (left), Adobe
Caslon (center), and Centaur (right)

which dash goes where (or at least to provide the means to make an educated guess) is to equate the length of the dash with the length of the pause the author intended in the text.

For example, when reading the hyphenated word *up-to-date,* the reader hears these words as a single word. No pause is required. When hyphenating a word at the end of a line, the reader knows the word is not complete, and a pause is not suggested. Some readers unconsciously hold their breath until the last portion of the word comes into view.

An em dash in text, on the other hand, sets off a break in thought—an aside or an explanatory comment. This dash replaces a colon in some situations. In the previous sentence, the length of the dash suggests a long pause before the words *an aside.* Equating the length of dash with the length of pause keeps dash choices less devil-may-care and more matter-of-fact.

Hyphen. The hyphen evolved from a varied ancestry. Some of the hyphen's precursors slanted up on the right side; some paralleled the baseline; some were slanted and doubled (like an equals sign), so they were not confused with commas (Bringhurst 1992). Today's hyphen is ¼ em in length, or (approximately) the width of the lowercase letter *t.* In some typefaces, such as Adobe Garamond, the hyphen slants up on the right side, but the majority of hyphens are parallel to the baseline. The type artist employs a hyphen for line breaks when an entire word does not fit in the measure; for hyphenating words, such as a compound word; and between noninclusive numbers, such as a telephone number or a social security number.

Line-end hyphenation should not disrupt the word flow. Incorrectly hyphenating a line creates confusion and causes doubling. It also can change a sentence's meaning by forming new or questionable words. A line-end hyphen remains with the first part of the hyphenated word. Proper line-end hyphenation dictates leaving a minimum of two characters on the first line and bringing down a minimum of three characters to the next line. (See chapter 4 for additional hyphenation information.) In headings, line-end hyphens are too noticeable, creating clutter and confusion. In text, the type artist does not hyphenate personal names, unless their number makes this rule impractical or if the name includes a hyphen of its own.

Hyphens in compound words or noninclusive numbers at times need kerning to even the space on either side. The type artist should check punctuation marks for possible kerning when checking a page proof for typographical form. When hyphenating a compound word set

in all caps, an en dash can replace a hyphen for a better visual balance between characters.

- ▲ The shaggy-haired dog is nearing cat-chasing retirement.
- ▲ The phone number at the kennel is 555-1234.
- ▲ The student's social security number is 123-45-6789.
- =/ The shaggy�row haired dog is nearing cat͎chasing retirement. =/

En Dash. The en dash is ½ em in length, or the width of the letter *n*. It has several specific uses: between inclusive numbers to indicate a duration for times of day or a range of page numbers or ages; replacing the word *to* for vote tallies and scores; joining hyphenated modifiers; or replacing an em dash for a break in thought. (See "Em Dash".) The type artist sets inclusive numbers in running text with the word pairs *between/and* or *from/to*. The en dash is acceptable in running text when inclusive numbers are abundant. The type artist should not mix word pairs with the en dash. (See "Figure Dash" later in this chapter.)

- ▲ The baseball scores were 3–2, 2–4, and 3–6.
- ▼ The baseball scores were 3-2, 2-4, and 3-6.
- ▼ The office hours are from 9:00 A.M. – 3:00 P.M.
 The baseball scores were 3⁄2, 2͎4, and 3–6. N͟ //

En dashes also link two hyphenated modifiers before a noun. It alerts the reader that both modifiers describe the same noun. Without the en dash it is difficult to distinguish the nouns from the modifiers in the crush of words.

In a similar situation, if two words are modifying a noun and one or both are open compounds, an en dash separates the two. This holds the lengthy modifiers together and defines each one's place in front of the noun. Finally, if an open compound requires a prefix, an en dash is used instead of the usual hyphen.

- ▲ The rat-tailed–lop-eared dog won first place.
- ▲ The dog was a Shetland Sheepdog–Cocker Spaniel mix.
- ▲ The new breed of dog is reminiscent of a mini–Shetland Sheepdog.

Em Dash. The em dash is the length of an em and comparable to the width of the letter *m*. Typists use two hyphens (--) for this mark. An em dash sets off a phrase due to a break in thought.

— – —

- ◆ An en dash joins inclusive numbers.
- ◆ An en dash indicates a duration.
- ◆ An en dash links open compounds modifying a noun.
- ◆ An en dash replaces the words *between/and* and *from/to*.

▲ Correct typographic form
▼ Incorrect typographic form

— — —

The em dash does not need additional space on either side. It often needs subtle kerning to prevent it from touching the letters it separates. Some type artists prefer an en dash bracketed by a single space in place of the em dash (fig. 5-3). They think the dash's length and the amount of attention it draws disrupts uniform paragraph texture and creates awkward line breaks. (Line breaks occur after an em dash, not before it.) Still others prefer the threequartersem dash with kerning on either side. Whatever choice is made, consistency dictates its implementation.

▲ After the carnivorous curmudgeon careened through the caravan of caramel-colored camels—although hardly a violation of law—he was incarcerated.

▼ After the carnivorous curmudgeon careened through the caravan of caramel-colored camels--although hardly a violation of law--he was incarcerated.

M̲ After … the caravan of caramel-colored camels⊸although hardly a violation of law⊸he was incarcerated. M̲

Type artists use multiple em dashes for specific circumstances. Since the em dash fits tightly between letters, consecutive em dashes form a continuous line. Two-em dashes represent missing letters within a word. This mark indicates that the letters are not known or, for an author, have not been determined. In bibliographies, three-em dashes followed by a period represent the repetition of the previous author's name. In text, the three-em dash, bracketed with a single space, represents the omission of an entire word. Neither mark replaces the ellipsis in quoted material.

em dash—length · ¾ em dash—length · en dash – length

FIGURE 5-3: *Proper horizontal spacing makes three dashes interchangeable for some functions*

Figure Dash. The figure dash is the width of a standard numeral and sits higher from the baseline than the en dash. It is longer than a hyphen and shorter than an en dash. Some type artists prefer this between numerals because it makes a smoother visual transition in an inclusive-number sequence. It is certainly an option to consider, but the final decision is a matter of personal preference.

— - —

26–34 26–34 | 26–34 26–34

FIGURE 5-4: *Titling figures and text figures with en dash (left) and figure dash (right)*

• The figure dash replaces an en dash with figures according to the type artist's preference.
• A figure dash is shorter and sits higher from the baseline than the en dash.

The higher vertical position of the figure dash is more suited to titling figures, since they are confined to the ascent. The lower vertical position of the en dash is suited to text figures, since they have ascenders and descenders. The length of the en dash is a bit long for the text figures, but some type artists might not view that as bothersome. Both dashes should be checked for kerning and consistency. (See "Numbers in Text" in chapter 6.)

▲ The groups of children were divided by age as follows: 1-4, 5-10, 11-14, and 15-19. (Titling figures with figure dash)
▲ The groups of children were divided by age as follows: 1-4, 5-10, 11-14, and 15-19. (Text figures with figure dash)
 … divided by age as follows: 1‚4, 5-10, 11-14, and 15-19. —/*figure*

Threequartersem Dash. The threequartersem dash is ¾ em in length. It can replace an em dash to set off a phrase as a break in thought. It is shorter than an em dash and longer than an en dash. For those still unhappy about using either an em or an en dash in this situation, the threequartersem dash is the logical solution (fig. 5-3). It does not disrupt texture, as does the em dash, and it does not introduce extra spaces, as does the en dash. The threequartersem dash needs generous kerning on either side, but a full space is too much. A thin space here may satisfy the discriminating eye.

— — —

• A threequartersem dash replaces an em dash with kerning on either side.

▲ The dog is two years old—although he looks older.
 The dog is two years old⊂although he looks older. *3/4M*

THE APOSTROPHE IS A FAMILIAR MARK that indicates possession or the absence of a letter or figure. A typesetter's apostrophe (hereafter called an *apostrophe*) looks like a flying comma. It is positioned above the letters and curves toward the letter it follows. Some typefaces slant, rather than curve, their commas and apostrophes. The apostrophe, positioned before or after the letter *s*, indicates possession. In a contraction, such as *couldn't*, it replaces the missing letter *o*. When indicating a

**APOSTROPHES
AND PRIMES**
— ' ' —

• An apostrophe indicates possession.
• An apostrophe replaces a letter or figure.

- A prime is the linear unit-of-measure symbol for feet.

year, such as *1986* as *'86,* the apostrophe represents the missing figures *19.* If a period or a comma follows a plural possessive, the punctuation mark follows the apostrophe.

The typewriter's apostrophe (hereafter called a *prime*) is incorrect as an apostrophe. A prime is a short vertical stroke positioned along the cap line. It does not curve toward the letter that precedes it. A prime is a symbol for *feet* when it is used as a linear unit of measure. It is appropriate in tables, charts, and technical or informal writing. (See "Abbreviations and Symbols" in chapter 6.)

▲ The dog was the Joneses', although he followed me home.
 The dog's bowl wasn't empty. ˅/tr
▲ The board measures 6' in length.
▼ The board measures 6' in length.

QUOTATION MARKS AND DOUBLE PRIMES
— " " ' ' " —

- Double quotation marks indicate quoted material.
- A single quotation mark indicates a quote within a quote.

- A double prime is the linear unit-of-measure symbol for inches.

QUOTATION MARKS, BOTH SINGLE AND DOUBLE, come in pairs. They indicate words attributed to a specific speaker that are run into the text. A quote long enough to be set as a block (more than four lines) does not use quotation marks. (See chapter 4.)

Double quotes are used more frequently than single quotes, because the latter indicates quoted material *within* quoted material. The mark used for quotations is similar in structure to a comma. It is a wide stroke that curves (or slants) and tapers into a finer stroke. Opening quotes have the wider stroke at the bottom of the mark. Closing quotes have the wider stroke at the top of the mark. Both curve or slant toward the copy they enclose.

It is important to place other punctuation marks correctly when using quotation marks. Commas and periods are included within the closing quotes, since the statement is ending. Colons and semicolons are placed outside the closing quotes, since the sentence is continuing. Question marks and exclamation points are positioned inside or outside the closing quotes depending upon their use in the sentence. If the quoted statement is a question, the question mark belongs within the quotation marks. If the quoted statement is part of a larger question, the question mark belongs outside the quotation marks. The same considerations apply to exclamation-point placement.

Typesetter's quotation marks (hereafter called *quotation marks*) and quotation marks from a typewriter (hereafter called *double prime*) are interchanged incorrectly in typeset copy, as with the apostrophe and prime mix-up. A double prime is two short vertical strokes positioned

along the cap line. It does not curve to enclose the quoted material. A double prime is a symbol for *inches* when used as a linear unit of measure. (Use a dimension sign [×] when setting dimensions, not a lowercase *x* from the typeface.) The double prime is appropriate in tables, charts, and in technical or informal writing. (See chapter 6.)

▲ The dog stated, "Woof! Woof!" The cat asked, "Meow?" The bird said nothing.

▼ The dog stated, "Woof! Woof!" The cat asked, "Meow"? The bird said nothing.

The dog stated, 'Woof! Woof!' The cat asked, "Meow? The bird said *tr* nothing.

▲ The rooms were: 12'7" × 10'6"; 11'5" × 12'3"; and 10'4" × 9'6".

▼ The rooms were: 12'7" × 10'6"; 11'5" × 12'3"; and 10'4" × 9'6".

(prime) The rooms were: 12'7" × 10'6"; 11'5" × 12'3"; and 10'4" × 9'6". *(dbl prime)*

THE VIRGULE AND THE SOLIDUS are diagonal lines that separate different kinds of information. These marks are identical except for their angle. The type artist does not italicize these marks, because it would distort their distinguishing angle.

The virgule ['vər-(ˌ)gyü(ə)l], or *slash,* is the more upstanding of the two. It separates alternative words, such as *and/or;* calendar years, such as *1986/87* (dropping the apostrophe); alternative spellings of a single word; and numbers in a level fraction, such as *2/3.*

The solidus ['sä-lə-dəs], or *fraction bar,* leans farther to the right than its almost-twin, the virgule. The solidus is the key mark for constructing a piece fraction with superior and inferior figures. With its increased angle, the numerator and the denominator tuck securely above and below the solidus, making a compact, single-unit fraction. The solidus is essential when the expert collection does not include the necessary case fraction for a job, such as $^{15}/_{64}$. In many Macintosh typefaces, the solidus is available with the Shift-Option-1 keystroke.

▲ The academic year of 1990/91 was an eventful one.

▼ The academic year of 1990/91 was an eventful one.

▲ The dog eats $^5/_6$ can of food in the morning, $^7/_{10}$ can in the afternoon, and $^2/_∞$ can for a bedtime snack.

The academic year of 1990/91 was an eventful one. / *(virgule)*

The dog eats $^5/_6$ can of food in the morning,... / *(solidus)*

PARENTHESES AND SQUARE BRACKETS
— () [] —

- Parentheses separate major breaks in sentence content for clarification.
- Parentheses set off the definition of a foreign word.
- Parentheses set off figures or letters to itemize text elements.

- Square brackets isolate editorial insertions in quoted material.
- Square brackets enclose a phonetic pronunciation.
- Square brackets are used as parentheses within parentheses.

[[{ ([•]) }]]

Bracket hierarchy for brackets within brackets

PARENTHESES AND SQUARE BRACKETS set apart material in text. Both marks are used frequently, but not exclusively, in pairs. The choice of mark depends upon the content of the separated material.

Parentheses isolate a word or words that break the continuity of the sentence in a major way. The information could clarify a word in the sentence, for example, but it might confuse the meaning of the entire sentence if not set apart. A minor break in continuity would use a comma. (See "Foreign Terms and Definitions" in chapter 6 for additional uses.)

Type artists use parenthesis pairs to isolate figures or letters when denoting a list or prioritized elements within text. In this instance, the parentheses physically and visually isolate letters or figures that are outside the sentence's context. They organize material within the sentence and eliminate the need for a list as a separate text block.

Square brackets isolate editorial comments or insertions in quoted material. They indicate a special communiqué from the author or editor. For example, the term *sic* used in quoted material indicates an error in spelling or usage in the original material. Since this is an editorial comment about the material, it is set off in square brackets. The Latin term *sic* (this is the way it was) is italicized, although the brackets are not.

A type artist also uses square brackets to isolate the phonetic pronunciation of an unusual or technical word presumably unknown to the reader. This functions as editorial assistance. Square brackets replace parentheses when a parenthetical element is within a parenthetical element. As with single and double quotation marks, square brackets within parentheses indicate a hierarchical structure of marks. Other marks, such as angle brackets (⟨ ⟩) and braces ({ }) are also available for structuring text material once the formerly mentioned marks have been employed.

▲ The week's shopping list included: dog food (large chunks [with bits of cheese] in a bag) and cat food (small cans).

⊱ / ⊰ (*sq bracket*) The week's shopping list included: dog food ⁁large chunks ⁁with bits ⊰ (*sq bracket*) / ⊱ of cheese⁁in a bag⁁and cat food (small cans).

Technically, parentheses and brackets require special handling. The roman version is preferred in text, even if the contents or the surrounding letterforms are italicized. Inserting a parenthetical phrase or an editor's remark interrupts the text intentionally. Italicizing these punctuation marks deemphasizes this break and changes the author's intent.

Additionally, parentheses and brackets do not italicize well. They are odd-looking marks that do not enhance the text's typographic form.

Since these marks curve or angle around letters, they are an obvious place to check for kerning problems. While a word space is not suitable here, kerning is necessary, particularly with italicized contents.

Typographers of the sixteenth and seventeenth centuries used parentheses and square brackets as today's type artists use italic and boldface type—for emphasis (Firmage 1993). Placing type within these marks called attention to it and gave it added punch. Unlike the use of parentheses and brackets today, these marks were not seen as a technique to segregate the enclosed words for a clarifying or modifying role.

AN ELLIPSIS IS A SEQUENCE of three periods that indicates the omission of a word or words from quoted material. It also can indicate the trailing off of a thought. Digital type fonts provide an ellipsis as a single character, so the type artist need not create one.

Since this mark indicates the absence of a word or words, it is spaced as a word. When used within a quote, the type artist leaves a single space before and after the ellipsis. When used at the end of a quote (indicating that the rest of the sentence was eliminated), the type artist places a period immediately after the last word and positions the ellipsis immediately after the period. This is correct if the remainder of the quote is grammatically complete. The type artist eliminates the spaces before and after the ellipsis when another punctuation mark, such as a comma, is used. The location of the ellipsis—before or after the mark—depends on the location of what was eliminated.

The following quote is from Lewis Carroll's *Through The Looking-Glass* (1872):

Alice was too much puzzled to say anything, so after a minute Humpty Dumpty began again. "They've a temper, some of them—particularly verbs, they're the proudest—adjectives you can do anything with, but not verbs—however, I can manage the whole lot!"

▲ Alice was too much puzzled…, so after a minute Humpty Dumpty began again. "They've a temper, some of them … adjectives you can do anything with, but not verbs.…"

⊙⊙⊙ Alice was too much puzzled to say anything, so after a minute
 Ƨ Humpty Dumpty began again. "They've a temper, some of them⫟
⊙⊙⊙ particularly verbs, they're the proudest—adjectives you can do
⊙ ⊙⊙⊙ anything with, but not verbs—however, I can manage the whole lot!"

ELLIPSES
— … —

* An ellipsis replaces words intentionally omitted from quoted material.
* An ellipsis in the middle of a sentence is proceeded and followed by a space.

LIGATURES

— fi fl —

- Use the search-and-replace feature of software to insert ligatures.
- Ligatures are characteristic of good typographic form.

fi→fi

fl→fl

ffi ﬆ ﬅ

Adobe Garamond ligatures

fi→fi→fi

fl→fl→fl

ff→ff→ff

ﬅ ﬆ ﬆ

Adobe Caslon ligatures

fi fl ff fi fl ff

Optima (left) and Palatino (right)

[fi] Shift + Option + 5

[fl] Shift + Option + 6

Macintosh typeface keystrokes for typesetting ligatures

A LIGATURE IS TWO OR MORE CHARACTERS designed and set as a single letterform. Gutenberg originally designed ligatures as a means to control letterspacing when justifying type and to duplicate handwritten text more accurately. Ligatures fell victim to mechanized typesetting at the beginning of the twentieth century. They disappeared from fonts. With the advent of phototypesetting, they started reappearing and are becoming increasingly available in digital type.

Common ligatures involve the lowercase letter *f*. The *f* likes to take up more horizontal space than other letterforms. It is similar to siblings sitting on a couch. Even though each child has enough room for comfort, they continue to encroach on the other's space (*Mom!...*). Because of this expansionist attitude, the *f* is always crashing into the lowercase *i* and *l*. There are problems also with other *f*s.

In foundry type, the *f* actually extended beyond its metal body and overlapped the metal body of adjacent sorts (see chapter 1). Without the correct *f-i* ligature, for example, the typographer would cut off the *i*'s dot to make room for the *f*'s overlap (the *kern*). A carefully designed *f-i* ligature not only removed the dot of the *i*, but aligned its stem to the *f*'s crossbar and terminal. While the letter *f* gives the English language the most problems, due to the frequency of the *f-i* occurence, other languages require other ligatures. Danish, for example, requires a ligature for the letters *f* and *j*.

Ligatures characterize good typography. They are not used simply to solve border skirmishes. They are also designed to add a flourish to certain letter combinations. Adobe Garamond, for example, has a ligature for the letters *c* and *t* (ﬅ). The italic version of that typeface has a ligature for the letters *s* and *t* (ﬆ).

When setting type, the type artist saves ligatures for the end—after the spell checker. A spell checker does not appreciate fine typography and most flag these words every time. The word *find* is *Wnd* to the spell checker. After the spell checker pronounces the obvious errors corrected, the type artist uses the application's search-and-replace feature to insert the correct ligatures. (See "Sentence Typography Evaluation" later in this chapter for ligature-insertion techniques.)

Not all typefaces come with ligatures; others are designed not to need them. The majority of sans serif typefaces do not require ligatures—Optima, for example. (The letter *f* stays on its side of the couch.) Palatino is a serif typeface that works well without ligatures. A ligature has preset letterspacing. Type set with additional letterspacing cannot use them because the ligature letters stand out on the line with their

tighter letterspacing. Type artists should use the designer-specified letterspacing (or very close to it) when they use ligatures. This produces consistent document-wide letterspacing. If a job does not warrant the typographic care that ligatures need, the type artist should choose a typeface that does not require them.

THE AMPERSAND IS ONE OF the most popular typographic abbreviations in handwritten usage. Early ampersand sightings reach back to A.D. 79 (Haley 1994). The ampersand evolved from the Latin word *et* (et per se and) and became a ligature of the two letters *e* and *t*— *&*. The word *ampersand* evolved from a consolidation and distortion of the Latin meaning. In the past, the use of the ampersand and the knowledge of its derivation was so widespread, that typographers abbreviated the word *et cetera* using the ligature— *&c.* The ampersands that retain their visual link to this letter heritage blend better with other characters in the same typeface. The simplified ampersand (&) of some typefaces does not have the grace of the original ligature.

The ampersand has limited use in good typographic text today, although this was not always the case. In *An Essay on Typography* (1936), Eric Gill (1882–1940) stated, "The absurd rule that the ampersand (&) should only be used in 'business titles' must be rescinded, & there are many other contractions which a sane typography should encourage." True to his beliefs, Gill used ampersands (along with the word *and*) and contractions (such as the contraction *sh'ld* for the word *should*) liberally in his book.

He felt these variables enhanced readability by controlling the number of words on a line—preferably 12. Gill also advocated equal word spacing in text to improve readability, preferring it over variable word spacing resulting from justified text. According to Gill, typographers who preferred justified text were more concerned with looking at the page than reading what was on it. Gill's opinion on ampersand use did not sway the day. Jan Tschichold (1902–74) recommended ampersands for use in company names only when joining two surnames; a style, if adopted, that can add an elegant flourish to continuous text.

Within the context of text typography, the ampersand is an informal shorthand suitable for personal notes. For discontinuous text, the ampersand is an expressive typographic embellishment for company names and headlines. The range of available ampersands (Slimbach's Poetica has 58) makes choosing an ampersand a design decision unto itself. Roman ampersands appear subdued alongside their chic italic

AMPERSANDS
— & —

• Use ampersands with headlines and company names.
• Ampersands are too informal for text typography.

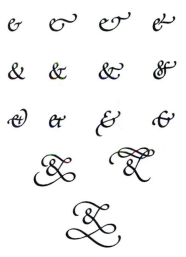

Poetica ampersand sampler (15 out of 58)

& *&*

Adobe Garamond ampersands:
regular (left) and italic (right)

counterparts. Type artists should not hesitate to mix an italicized ampersand with roman letterforms for an eye-catching headline. It can produce exciting results. This is one of the rare times when mixing type styles can enhance the typographic quality of a headline, rather than detract from it. (See "The Graphic Ampersand" in chapter 8.)

▲ The accounting house of Scrooge *&* Marley was a creation of Charles Dickens.

The accounting house of Scrooge ~~and~~ Marley was … *& ⌾ampersand⌾*

ORNAMENTS AND DINGBATS

— ⚲ ☎ —

* Ornaments are designed for one typeface family.
* Carefully size ornaments so they do not overwhelm the text.

* Dingbats are informal, keystroke graphics.
* Carefully size dingbats so they do not overwhelm the text.

Adobe Caslon Ornaments

Adobe Garamond Ornaments

Minion Ornaments

Utopia Ornaments

IT IS FITTING TO END THIS SECTION with a discussion of those elements that can add beauty to a page of type or blemish it. A type artist uses members of a typeface family to communicate the author's message, just as an orator chooses the vocabulary for a persuasive oration. A commanding control of vocabulary distinguishes a rousing address from a disjointed harangue. Selective usage of ornaments and dingbats enhances the flow of text. Overuse creates a jumble of visual characters all shouting for attention. (See chapter 7.)

The difference between ornaments and dingbats is simple. *Ornaments* are visual elements (leaves, fleurons, moons, and others) designed to accompany a specific typeface. The typeface designer applied the design qualities of a typeface—stroke, tone, and structure—to these visual elements. A Minion ornament is distinct from a Utopia ornament. Ornaments serve as typographic flourishes or functional typographic elements. They send subtle typographic signals to the reader. Their careful use is a sign of good typography. *Dingbats* are designed as separate pictorial elements and have a decorative function. Dingbats are small pictures designed for use with a variety of typefaces. There are dingbat fonts, offering a host of hands, check marks, stars, pencils, scissors, telephones, and others, for type adornment.

Ornaments first appeared when metal type originated in the fifteenth century. They were heavy black shapes, as were the typefaces they enhanced. In an effort to replicate the handwork of the scribes, ornaments served as replacements for the typographic flourishes scribes added to their letters and texts (Haley 1989). While ornaments could never replace the illustrated initial letters that adorned those manuscripts, they were an attempt to bridge the gap between the individual qualities each scribe invested in his handwork and the mechanized, standardized letterforms of the newly invented movable metal type.

Ornaments, like other functional characters, clarify the text. Type artists use ornaments to divide text into sections when subheads are not available or appropriate. In a six-page report, for example, the author might make four different points in support of a single position. Sub-heads might separate these points too much, causing the reader to interpret a single position as four separate positions. An ornament suggests a slight pause, rather than the start of a new section. Consequently, the reader views the report as a position paper with four arguments supporting one position. A small ornament (✤) between sections and then a larger one (❦) at the end provides the reader with pleasant typographic "signal-ry" along a written path.

Dingbats are fun; they are informal. A dingbat is a miniature graphic that adds information to the text. As a result, it can change the text's content. Selecting the right dingbat face for a typeface requires the same concern as selecting two typefaces for a single document. A poor choice turns serious text into a cartoon.

Some dingbats are more aggressively graphic than others. A *pointer* (the hand with an extended forefinger) draws attention to an item in a list, but also adds an illustrative style to the text that frames the content. In a list of surgical procedures for emergency lifesaving techniques, a cartoon-style pointer is inappropriate. In a list of daycare activities for three-year-olds, it is not. With a typeface such as Tekton, dingbats provide the spark and flash that complements the informal, spontaneous quality of this typeface. An arrow or wide check mark is right at home on a page of this informal typeface. Dingbats, like ornaments, require a light touch for maximum impact.

A type artist can use ornaments instead of bullets to highlight elements in a list. A small ornament (◆) blends better with its typeface than a regular *bullet* (•). In some instance, the bullet is too large and overpowers the text. In those cases, a *midpoint* (·) is a suitable replacement. A midpoint is the little brother of the bullet. It eliminates the need to change the bullet's point size to get a smaller one, and the midpoint's vertical placement is more suited to lowercase letters. In many Macintosh typefaces, the midpoint is the Shift-Option-9 keystroke.

Some typeface ornaments include elements that appear more closely allied with dingbats than ornaments. Adobe Caslon, for example, has an hourglass, pointers, and connectable border sections that cross-over into dingbats. Their style, however, maintains the emotional quality of the typeface, so that while illustrative in nature, they still remain typeface specific.

Pointer samples

➜ Tekton

✗ with

✓ Zapf

✏ dingbats

SENTENCE TYPOGRAPHY EVALUATION

IN DAYS OF OLD WHEN MINUTES PASSED more slowly and the personal computer rode atop one's neck, extended proofreading was done in teams. The copy reader held the *dead copy* (the last edited version of the document) and read it carefully aloud to the copy marker. The copy marker corrected the *live copy* (the latest version of the document) with proofreaders' marks. The reader read words, punctuation marks, type style changes, and spelled out proper nouns or easily misinterpreted words, using a steady, exaggerated, monotone style. Punctuation marks and unique typographical situations were described aloud with abbreviated words, such as *com* for comma, *stop* for period, *kwes* for question mark, and *bang* for exclamation point. The sentence *The little piggies went to market, stayed home, and had roast beef?* was proofread aloud as *Cap the little p-i-g-g-i-e-s went to market com stayed home com and had roast beef kwes.* An experienced proofreading team caught errors easily using this method.

apostrophe	*pos*	close parenthesis	*close pren*
single capital letter	*cap*	period	*stop*
all capital letters	*caps*	question mark	*kwes*
colon	*cole*	open quotation mark	*quo*
comma	*com*	close quotation mark	*close quo*
ellipsis	*three dots*	semicolon	*sem*
exclamation point	*bang*	slash	*slash*
hyphen	*hyph*	7	*fig seven*
open parenthesis	*pren*	seven	*spell seven*

FIGURE 5-5: *Proofreaders' words for punctuation and type treatment*

Today many type artists proof their own documents. Proofreading a document is difficult, especially after working with it for the past two hours, two days, or two weeks. An adaptation of the team-proofing style, coupled with electronic proofing techniques, enables today's solo proofreader to produce error-free documents. An effective proofreader is not born with this ability—although some are more predisposed to it than others. Experience, spelling skills, and practice are the keys to developing a critical eye. The local newspaper is a good place to practice. While newspapers follow

different typographic rules, they are a ready practice sheet for the fledging proofreader.

Proofreading on the sentence level focuses on copy accuracy, character usage, spacing, kerning, spelling according to usage, and obvious grammatical bloopers. A type artist is not an editor and does not have the authority to change the style or content of the text; but if the level of responsibility includes catching embarrassing grammatical errors, they will be caught on the sentence level. (Blooper checks, if authorized, are done at the end, when the document is free from proofmarks and the type artist is reading it for almost the last time.)

SOFTWARE DEVELOPERS CONTINUE to upgrade their products with faster, more comprehensive features. Most type-savvy software has a search-and-replace feature (SARF) capable of finding individual characters, words, and spaces quickly and replacing them with alternates. This is an efficient way to insert ligatures, to replace words (including those consistently misspelled), and to delete extra spaces. Once the type artist establishes the parameters of a search, a replace-all feature can implement all substitutions. This is tempting, but it can create other problems unbeknownst to the type artist. By approving each substitution, the type artist can catch problems in the search parameters or identify exceptions in the text. Reviewing each replacement is worth the extra minutes it requires.

Once the obvious spelling errors are eliminated in the paragraph level, it is safe to insert ligatures. The type artist works from the longest to the shortest ligature (*f-f-l, f-f-i, f-f, f-l,* to *f-i*). Ligatures replace lowercase letter-groups only and require a case-sensitive search. The SARF feature also replaces titling figures with text figures. The type artist enters the figures *o* through *9* one-by-one and approves each substitution. SARF can replace a word set incorrectly throughout the document. If the client unexpectedly changes the product *Bugaway* to *BugAway,* SARF also can find each occurrence and correct them all in a single search. The type artist approves every substitution.

Many type-based applications for word processing and page layout can display word spaces as single, nonprinting dots. It is an optional feature. Checking word spacing on screen is risky because of video resolution. For rookie type artists still sharpening their eyes to see subtle proportional spacing problems, scrutinizing spacing dots on screen is helpful. A spell checker can identify an absence of word spacing because, without word spacing, the words *and* and *the* appear as

andthe. An excess of word spacing or a space between a comma and a word is not flagged by the spell checker.

Fortunately, some SARF programming is space sensitive. Setting the search parameters to look for two adjacent spaces quickly eliminates those hard-to-see extra proportional spaces. SARF can identify a space-comma combination and replace it with a single comma. If this is a frequent problem, the type artist can set up a search for excess spaces before common punctuation marks. If placing one space after a terminal punctuation mark is still sporadic, the type artist can use this feature to find and fix those also. Seasoned type artists rely on the electronic proofers to minimize the number of remaining errors their tired eyes must identify.

With the document as computer perfect as possible, the type artist prints it on an inexpensive stock. There is more to do, so using good paper is a waste. While the document prints, the type artist takes a break. This is a good time to go get a drink of water, go get a snack—just *go!* A 10-minute break is better than a 5-minute one, and so forth.

SOLO SENTENCE-LEVEL PROOFREADING TECHNIQUES

A SOLO PROOFREADER PARTNERS with a large dictionary. The thickest, most up-to-date dictionary is the best proofing partner. The *Webster's Collegiate Dictionary* is revised frequently. The *Webster's Third New International Dictionary* is comprehensive. There are others—the thicker the better. Thin dictionaries have limited vocabularies, they do not show helpful examples, and they never have interesting illustrations. Computer spell checkers do not scratch the surface of the existing word pool. Also, a type artist should not ask a colleague how to spell a word. There are too many opportunities for unintentional error.

In addition to a dictionary, the type artist needs a colored ballpoint pen, the dead copy, a typography resource (this book), a ruler or reading guide, a highlighter, and a comfortable, quiet spot—this takes a while. It is better to keep distractions to a minimum when proofing. A quiet place or headphones connected to silence will keep the dedicated proofreader off-limits to interruptions.

Check one or two errors with each proofing wave.

Proofreading on the sentence level is executed in a series of waves. With so many different errors to find, the type artist should look for one or two of them at a time. It is too easy to forget something. The chance of catching all errors is enhanced markedly by proofing the same document several times.

WAVE ONE: Check doubles and bad page breaks.

The first wave checks for doubles and bad page breaks and that all parentheses and quotation marks have a beginning and an end. The bottom

of a page should not end with a hyphenated word. The proofer's eye skims the surface, checking for these pairs and checking page breaks.

The second wave checks kerning. It is easy to be overzealous here. Headline and subhead letterspacing problems are more noticeable and require fixing. Text kerning problems are rare if document-wide letterspacing and word spacing were set properly. There are three rules of thumb for text kerning. If a bus can drive through the space, the type artist should change it; if nothing could squeeze through it, change it; if it is anywhere in between, forget about it. With that in mind, the type artist checks for kerning problems in four key spots—before and after an isolated italicized word, before and after words inside parentheses, around ligatures, and before exclamation points and question marks. These are the most likely offenders.

The third wave checks typographic form and accuracy of content against the dead copy. The type artist places the dead and live copies side by side on a desk or table and uses a finger, ruler, or paper edge to keep position on the dead copy. The pen indicates position on the live copy. The type artist reads aloud in a soft, slow, steady pace and pronounces each word in an exaggerated, syllable-by-syllable style. Enunciating each and every syllable sets up the proper proofreading pace and puts the proofreader eye-to-*i* with every letter in every word. The proofer reads two words from the dead copy, shifts to the live copy and checks the same two words, shifts back to the dead copy to read two more words, and shifts to the live copy, and so forth. Some type artists believe that verbally identifying punctuation marks and typographic style changes (as a team reader does) improves their accuracy.

Every proofreader establishes a comfortable pace. The first proof job is always slower than the second. Speed should keep abreast of accuracy. A speedy proofing job is no proofing job if it leaves errors in its wake. Errors come in groups. All corrected words need rereading to make sure that a second error was not overlooked.

Some proofers do not like stopping during the third wave to consult the dictionary or a type resource. It is easy to lose page position and train of thought. It is during this wave, however, that those problems of usage-specific spelling and font characters are questioned. If the problem is an isolated one that will not affect the rest of the document, the type artist can highlight or query the word or character and return to it later with resource in hand. If the problem reoccurs and becomes a distraction, the type artist must mark the stop-spot carefully (a double vertical slash after the last word) and consult the proper resource.

WAVE TWO: Check kerning.

WAVE THREE: Check against dead copy.

Like birds of a feather, errors flock together.

Double-check doubt.

The years 1919-25 are … N ⑦
Query proofmark

Create a style check sheet for proofing.

Some type artists also find it helpful to create a style check sheet while they create a document. This saves them from looking up the same items repeatedly. They use this sheet during proofing to check spelling and usage consistency.

Once the live copy is marked, the artist enters the changes, prints it, and proofs it again. This time, proofreading is more focused. The type artist proofs each *correction*. Using the proofmarked live copy (the new dead copy), proofmark locations are checked against the corrected locations on the latest printout (the new live copy). The type artist looks to make sure a new error (extra space, misspelled word) was not introduced and that the kerning adjustments were sufficient. The rest of the document has remained untouched, so it does not need reproofing. In all corrected paragraphs, the type artist checks again for bad breaks, end-of-paragraph widows, and hyphenation problems. If any corrections are made to the live copy, the type artist proofs the newest corrections and checks hyphenation, breaks, and widows once a new live copy emerges from the printer. This continues until no proofmarks are placed on the live copy.

Proof corrections to check for unintentional errors.

<center>℀</center>

ALL TYPE ARTISTS STRIVE for good typographic form through the correct use of font characters. Good typographic form is beautiful to those who love type and transparent, but functionally necessary, for those who read it. As Bringhurst said, "Good typography is like bread: ready to be admired, appraised, and dissected before it is consumed."

SETTING
TYPE
FOR
SPECIAL FUNCTIONS

Within a sentence there are words, figures, and punctuation marks that by their unique appearance identify a special relationship for the elements they represent. These type characters collectively describe an item or modify a word, such as the name of a book, the age of a child, or the time of day. As a collective, its meaning is complete when all components are read as a whole. Some of these linked words require hyphens to define their common bond; but for others, the type treatment, such as italic type or small caps, identifies this union. The words *entry* and *level*, for example, are linked by a hyphen when they function as a modifier, as in *entry-level typographer*. This is not type treatment for emphasis or accent, but type treatment for clarity. Compound modifiers are joined and released as needed. Some type treatments appear and reappear with such frequency that their appearance becomes second nature to a seasoned type artist. It is these special typographic treatments within a sentence that this chapter explains—those words and numbers that type artists see every day as their fingers dance across the keyboard and as their lines of words pursue the blinking cursor across the screen.

Authors and copywriters create meter and tempo with the syntax of their words. Type artists create typographic form with specialty characters and type treatments that communicate the author's message. Many authors are accomplished wordsmiths, aware that the form their

Letters in combination may be satisfying and in a well-composed page even beautiful as a whole, but art in letters consists rather in the art of arranging and composing them in an appropriate and pleasing way.

———————————Goudy
The Alphabet and Elements of Lettering

TYPOGRAPHIC ARTISTRY

words take clarifies the intended meaning. Most are not typographers and do not know the full range of stylistic subtleties their words can display. This knowledge is the type artist's contribution to the text and the key to typographic form—or typographic artistry—on the page.

Expert typographers talk about letters in terms analogous to music, fine wine, and the fluidity of dance. Just as fine wine swishes across the connoisseur's tongue or ethereal music floats past the aficionado's ear, type to the master typographer is a visual symphony complete with flow, grace, and rhythm. Access to stalwart small caps, graceful text figures, and elegant swash and alternate characters infuses a text page with the nuance and harmony of expert typographic form. For those type artists just discovering these additional characters and their uses, it is an area of typography that challenges its practitioners and rewards them with visual artistry when done well.

TYPOGRAPHY AND CONTENT

Text for a special function is best understood in the larger sense of context. A memo to a co-worker looks different than a flyer for a shopper. A short story in a literary magazine filled with dialogue and punctuated with quotation marks looks different than a research article in a mathematics journal filled with equations and theorems. Generally, text falls into several categories—humanistic or technical, continuous or discontinuous, formal or informal, and factual or opinion. As with other things, these categories overlap.

Humanistic text is literary text written for continuous reading concerning broad cultural learning or human experiences. It encompasses diverse topics of general interest and uses a minimum of numbers or statistical data. *Technical* or *scientific text* is written for discontinuous reading due to the complexity of its content. It encompasses topics with particular or practical knowledge about a specialized subject. Examples of statistical or mathematical data, the use of charts and tables, or enumeration to support its conclusions are abundant. The text's complexity forces the reader to reread passages to ascertain the precise meaning.

Formal text, such as a book, magazine, report, or catalogue, is written for presentation to a wide audience. *Informal text,* such as a letter, memo, or note, is text designed for limited distribution. *Authoritative text,* such as newspaper articles, textbooks, or factual reports, is written to communicate specific knowledge, facts, or documentation. *Opinion text* , such as editorials, autobiographies, letters, or memos, is written as one person's viewpoint.

The importance of these text classifications for the type artist is their effect on typographic form. Rules that strictly dictate manuscript preparation for a novel (humanistic continuous text) are altered when setting copy for a step-by-step repair manual (technical text with discontinuous sections). Rules that require writing out numbers and eliminating all abbreviations in humanistic text are modified when setting technical or scientific documents or tabulated lists. The distinction drawn here is one of frequency and the need for clarity.

In humanist text, numbers are infrequent and information is presented in a more relaxed and thoroughly articulated style. The rules for typography in a novel, a book of poems, or a journal article on mythology follow those of humanist text. In this environment, setting numbers as figures and shortening words into abbreviations makes the information appear informal and rushed. An isolated figure or lone abbreviation would jar the otherwise smooth flow of the text and its typography.

In technical text, numbers are frequent and the information is detailed, quantitative, and exact. The text is punctuated with diagrams, tabulated material, equations, and charts. Figures, abbreviations, and symbols are legitimate devices for explicitly communicating complicated statistics, concepts, or theorems within the accepted form of the discipline. Eliminating these devices in technical text denies the author the tools needed to clearly and accurately present the message.

For type artists working with promotional copy that highlights comparative quantities and prices, dimensions and percentages, warranties and component parts, the rules of technical text apply. Clarity of communication is paramount here. This same copy, however, also benefits from some humanist text characteristics. There needs to be a *promotional text* category that emphasizes formality—by eliminating needless abbreviations and inappropriate symbols—and clarity—by relaxing rules that outlaw the use of figures below one hundred. Setting promotional text correctly relies on the type artist's knowledge of context distinctions, typeface characters, and typographic form.

BEFORE SETTING TYPE, a type artist reads the material and determines its appropriate context (humanist, technical/scientific, or promotional). Once the decision is made, the rules for numbers and abbreviations apply throughout the entire document—not just on one page, or one panel, or one chapter, or one section—but the entire document.

SENTENCE TYPOGRAPHY FOR SPECIAL FUNCTIONS

Titling Caps
and Small Caps

- Use small caps in text for abbreviations and acronyms.
- Use small caps for formal-looking subheads.
- Do not use small caps for personal initials and personal acronyms.
- Use small caps for three-letter geographic acronyms.

GG JJ
PPRR

Letter-pair comparison showing
titling caps (left) and uppercase (right)

ABABCabc
ABABCabc

True-cut small caps (upper) and fake
small caps (lower) comparison for
stroke weight

TITLING CAPS AND SMALL CAPS are as distinctly different as uppercase letters are from lowercase letters. Their use is specific as well. Titling caps are capital letters designed within the entire point size of the font (the ascent and the descent). A typical uppercase or capital letter sits on the baseline and confines itself to the font's ascent. (Occasionally, the cap *J* in a font descends below the baseline, but not always.) A capital letter is designed for use with lowercase letters in text. Titling caps are designed for use as headings, 18 points and larger. Their strokes are proportioned for all-cap headings and are not designed to accompany lowercase letters in a text line. Beside a lowercase letter, a titling cap looks spindly. Titling caps, due to their size, display more design refinements. The detail included in a serif, for example, is appropriate for its viewing size.

Small caps are capital letters designed within the font's *x*-height for use in text. Their strokes are proportioned and spaced to fit optically with lowercase letters. Their structure distinguishes the words they display as special, but they do not attract undue attention, as uppercase letters would in the same situation. Some type applications can create *fake small caps* (an uppercase letter scaled to the type's *x*-height). The stroke weights of the fake small caps are too thin in comparison to the adjacent lowercase letters. The words they set are too light and create a hole in the text's color.

Small caps are necessary in a typeface with a short *x*-height. The small caps for such a typeface, Adobe Garamond, for example, relieves the size differential between the cap height and the *x*-height. Type artists who do not have small caps for their typefaces should choose a typeface with a large *x*-height for documents requiring small caps. By minimizing the contrast between the cap height and the *x*-height, the use of uppercase letters in place of small caps is visually acceptable.

TYPO GRA phy · TYPO GRA phy · TYPO GRA phy

FIGURE 6-1: *Adobe Garamond (left)—small x-height with small caps; Clearface (center)—medium x-height with caps; ITC Leawood (right)—large x-height with caps*

All punctuation marks blend properly with small caps, except for the question mark, the exclamation point, and the ampersand. A small-

cap font includes these resized marks for the rare times they are needed. The ampersand is useful for decorative headlines, because ampersands usually are not appropriate in continuous text.

Type artists use small caps in continuous text for abbreviations, initials, and acronyms. They are not acceptable with personal acronyms, such as *FDR* or *JFK,* personal initials, such as *J. F. Kennedy,* or with two-letter geographic acronyms, such as those used for states—*NY* and *FL.* Abbreviations for academic degrees set in small caps, such as B.A., M.F.A., PH.D., M.D., or D.D.S., blend better when an upper- and lower-case name precedes them, as in *Albert Schweitzer,* M.D. Acronyms, such as NATO, UNICEF, USS, HMS, and OSHA, and three-letter geographic acronyms, such as USA, look better in text as small caps. Acronyms set in uppercase letters in continuous text are reminiscent of roadside billboards—looming large as the reader passes. Set in small caps, these acronyms have a typographic distinction that links them visually and identifies them correctly, but does not blow a hole in the type's texture. Small caps require loose tracking to maintain proper text color.

- ▲ The NATO countries meet this week in Geneva.
- ▼ The NATO countries meet this week in Geneva.
- ▲ The USS *Eisenhower* sails later this month.
- *lc* The <u>nato</u> countries meet this week in Geneva.

Caps and small caps, or small caps alone, are appropriate also for elegant subheads. They call attention to a pause in running text and set up a change in thought without creating a sharp break (as would a change of typeface).

When a small-cap word or word grouping starts a sentence, the first letter is capitalized and the remainder is small caps. For example, if the acronym NATO starts a sentence, the *N* is capitalized—*NATO.* (See "Time of Day" and "Years, Decades, Centuries, and Eras" later in this chapter and "Initial Letters and Versals" in chapter 7 for other small-cap uses.)

THE SIMPLE QUESTION, What about numbers? can cause a conscientious type artist to groan aloud. It is easier to use a multitude of dashes in a document than it is to answer that seemingly simple question. It does not have to be so. The response to this question is another question: Is the text humanist or technical? Or more precisely, the question is: Is the text filled with numbers?

AB?!& AB?!&

Adobe Caslon punctuation and symbols for uppercase (left) and small caps (right)

- ▲ Correct typographic form
- ▼ Incorrect typographic form

Numbers in Text

For example, a magazine article discussing the behavioral phases of a toddler and the appropriate sanity-saving strategies for parents is humanist text. It appeals to a general audience and uses numbers infrequently. These numbers are spelled out easily without jeopardizing the reader's comprehension of the material.

A magazine article, discussing the use of lemons in springtime cuisine, that includes several time-saving recipes is technical text. Such an article does not demonstrate a theorem for finding the area of a complex geometric figure, but it is filled with measurements and quantities explaining how to prepare complicated recipes, such as "Stir-Fry Lemon Chicken" or "Linguine with Lemon-Zested Scallops." All struggling neophyte cooks would agree that, for them, this text is technical, filled with ½ cup of this and ¼ teaspoon of that. Writing out these measurements would lengthen such an article considerably and make the measurements difficult to understand. Within the definition of technical text as text in which "numbers are frequent and the information is detailed, quantitative, and exact," the springtime-cuisine article is at home.

The treatment of numbers in text applies to cardinal as well as ordinal numbers. A *cardinal number* is a number that represents a quantity, such as *25, 43,* or *127.* An *ordinal number* represents an ordering or ranking, such as *25th, 43rd,* or *127th.* A type artist treats both kinds of numbers in text according to the same guidelines.

<div align="center">

1 2 3 4 5 6 7 8 9 0

1 2 3 4 5 6 7 8 9 0

11 22 33 44 55 66 77 88 99 00

</div>

FIGURE 6-2: *A titling figure (top) and text figure (middle); comparison (bottom)*

TITLING FIGURES AND TEXT FIGURES

- Titling figures are used with all capital letters.

- Text figures are suitable in uppercase and lowercase text.

AFTER DETERMINING ITS CONTEXT, the type artist decides which kinds of figures to use. There are two figures available—*titling figures* and *text figures.* Titling figures, also called *lining figures* and *ranging figures,* are to numbers as uppercase letters are to the alphabet. These figures are confined to the font's ascent. Titling figures are used with uppercase letters. Their size and proportions fit with these ascent-only letterforms. Text figures, also called *hanging figures, lowercase figures,* or *old style figures,* are the lowercase of numbers. The bulk of the figure is

positioned in the font's *x*-height with ascenders and descenders protruding outwards. Their size and proportions fit with lowercase letters.

Text figures are the original number symbols used in typography starting in 1540 (Bringhurst 1992). Their grace and elegance produce a document of distinction. Titling figures were the latecomers to the page. The precursor of the titling figure (Eason and Rookledge 1991) was introduced in 1788 by the British Letter Foundry of typographer John Bell (1746–1831). By the nineteenth century, true titling figures were the predominant number style.

Today's type artists use titling figures with all capital letters and text figures with upper- and lowercase letters. And they can mix them on the page according to their location with respect to either capital letters or uppercase and lowercase letters.

$12 30¢ *$12 30¢*

Currency symbols with titling figures (left) and old-style currency symbols with text figures (right)

| He called 555-1234 at 3:00 P.M. from 123 Chester Road. The operator broke in at 3:01 P.M. and said the new telephone number was 555-3456. | He called 555-1234 at 3:00 P.M. from 123 Chester Road. The operator broke in at 3:01 P.M. and said the new telephone number was 555-3456. |

He called 555-1234 at 3:00 P.M.
from 123 Chester Road. The
operator broke in at 3:01 P.M.
and said the new telephone
number was 555-3456.

FIGURE 6-3: *Adobe Garamond (top left) with text figures; Clearface (top right) with titling figures; and* ITC *Leawood (bottom) with titling figures*

NUMERIC QUANTITIES, VALUES, and denotations are pervasive in daily communication. From the length and weight of a newborn to the years celebrated at a septuagenarian's birthday party to a street address, people use numbers liberally. Numbers define the magnitude of an experience, such as the length of the one-that-got-away, and they quantify an accomplishment, such as a high Scholastic Aptitude Test (SAT) score for a promising student. Numbers are represented in two different forms—by symbols, such as *1, 2, 3, 4,* and *5* (hereafter called *figures*), and by words, such as *one, two,* and *three* (hereafter called *number-words*).

NUMBER-FORM GUIDELINES

+ Apply the NONN decision consistently in humanist text.

When determining which form to use, a type artist categorizes numbers by four factors: context, size, specificity, and purpose.

In general, humanist text allows the use of figures on the page according to numeric size. There are a few exceptions determined by specificity and purpose; but as a general rule, size is paramount. Technical text, as a general statement, allows the use of figures for all measurable, quantitative distinctions, wherever they occur. There is a location exception here, but with slight rewording it can appear as a figure too.

There are two schools of thought on representing numbers in humanist text. One school, espoused by the *Chicago Manual of Style,* prefers number-words for all whole numbers through ninety-nine. Number-words representing the numbers *twenty-one* through *twenty-nine, thirty-one* to *thirty-nine,* and so forth through *ninety-nine* are hyphenated. The other school, espoused by the *New York Public Library Writer's Guide to Style and Usage,* uses number-words for only those whole numbers through nine. The nine-or-ninety-nine (NONN) decision—depending upon which school of thought the type artist adopts—affects a variety of numeric distinctions and is applied consistently throughout a document.

The adverse effect on typographic quality of the NONN decision is diminished if the type artist uses text figures rather than titling figures. The text figure *24* blends more smoothly with the letters in running text than the titling figure *24*. If the type artist only has titling figures for a short–*x*-height typeface, spelling out quantities through ninety-nine is the better typographic choice.

If the type artist's decisions were limited to context (humanist or technical) and size (nine or ninety-nine), the choice between figures and number-words would be easy. There are a few general statements regarding form, however, that are context independent.

A number is spelled out when it starts a sentence—always—regardless of context. A figure is not suitable as a visual indicator of a new sentence. It may appear odd if the number is the first in a series, but in this circumstance, inconsistency is accepted. Rewording the sentence can eliminate the problem, but unless the type artist is also the author, the artist rarely has such authority.

▲ Forty-five toddlers were tested for pet preferences.
▼ 99 bottles of beer on the wall …
sp ㊺toddlers were tested for pet preferences.

Insert (⟨) old style dollar sign $\underline{\$}$

Insert (⟨) old style cents sign $\underline{\cent}$

Insert (⟨) dollar sign $\underline{\underline{\$}}$

Insert (⟨) cents sign $\underline{\underline{\cent}}$

Insert (⟨) titling figure *3*

Insert (⟨) text figure *5* (*text fig*)

Specialized figure and currency proofreaders' marks

Context-Independent Number Guidelines

- Use a number-word, not a figure, if a number starts a sentence.
- Use figures for a decimal or percentage.

In some instances, a number is set as a figure—regardless of context. A type artist always sets a percentage or a decimal value as a figure. The use of the percent symbol (%) or the word *percent* falls under the rules for context. (See "Abbreviations and Symbols" later in this chapter.) Type artists use figures for street numbers (although numbered streets are written out according to the NONN decision, such as *123 Fifth Street*); zip codes; phone numbers; social security numbers; interstate, highway, and roadway numbers; years; days; eras; time (when it specifies a precise point in time); and academic grades. If the text refers to a publication's numbered chapter, section, or table, a figure accompanies the word, such as *chapter 3, section 4,* and *figure 7.* (Some of the above categories require additional clarification, which follows later in this chapter.)

THE MAJORITY OF EXCEPTIONS for numbers occur in humanist text. They are framed primarily by the need to clarify and less frequently by appearance. Once made, the type artist maintains the exception in treatment throughout the document. For example, if a single sentence in humanist text includes multiple values, the reader might find number-words difficult to compare and awkward to read. In this instance, the type artist uses figures. If the figures represent numbers of voters, for example, every time a number of voters is cited, the type artist continues to set it as a figure. This applies throughout the document—before and after the series occurs.

▼ Of the forty-five toddlers tested for pet preferences, twenty-one preferred dogs; fifteen, cats; eight, birds; and one wanted the bird to do lizard impressions again.

▲ Of the 45 toddlers tested for pet preferences, 21 preferred dogs; 15, cats; 8, birds; and 1 wanted the bird to do lizard impressions again.

IF A WORD, SUCH AS *HUNDRED, thousand,* or *million,* follows a number, the NONN decision applies. The type artist writes out the number, such as *fifteen hundred* when using ninety-nine as the number-word cap and *15 hundred* when using nine. The guiding principle is consistency. Type artists treat like numbers in a like manner throughout the document.

When punctuating large figures, commas separate groups of three digits (working right to left) in numbers of four or more, such as *1,234* and *15,678.* No space follows this comma, but it often needs kerning.

▲ The dog chased 12,345 cats yearly, but only 2,334 mail carriers.

USAGE-SPECIFIC NUMBER GUIDELINES

◆ Treat like number-words and figures consistently.

LARGE NUMBERS

Age

THE TYPE ARTIST DETERMINES how to write the age of a person, place, or thing, according to its context and the NONN decision. When the age modifies a noun, it is hyphenated; when it stands alone, it is not.

▲ The 12-year-old camper wanted to bring her dog to camp.
▲ The twelve-year-old camper wanted to bring her dog to camp.
▲ The toddler is two years old.
 The camper is ~~twelve~~ years old. *12* *(text fig)*

Fractions

◆ Hyphenate fractions when written as number-words.
◆ Use a case or piece fraction when representing fractions with figures.

WHEN USING COMMON FRACTIONS alone, such as *one-half* or *one-fourth,* type artists treat them as they would any other number in the same context. Fractions are hyphenated when spelled out. When mixing whole numbers and fractions in humanist text, type artists use figures to improve clarity and reader comprehension.

Fractions appear frequently in discussions of dimensions or portions. The sentence *The paper size, 8½ inches by 11 inches, is suitable for many printing jobs* uses figures to express dimensions because a fraction is included with a whole number. Since this is a humanist-text example, the type artist writes out the words *by* and *inches* within the dimension. (See "Abbreviations and Symbols" later in this chapter.) In the humanist sentence *The sheet was one-half its original size,* the fraction is used alone and written out and hyphenated.

The type artist uses *case fractions* for proper typographic form when setting a fraction as a figure. If a case fraction is unavailable, a *piece fraction,* formed with superior and inferior figures separated by a solidus, is an acceptable alternative. The *level fraction 1/2* is not good typographic form. Type artists should have at least one font with the appropriate figure alternatives when setting figure-frequent text.

▲ The sheet was one-half its original size.
 The paper size, 8 inches by 11 inches, is suitable....$^1/2$ *(case fraction)*
sp The sheet was ½ its original size.

Dollars and Cents

◆ Use the currency symbol when the monetary value is a figure.

THE USE OF CURRENCY IN TEXT falls under the guidelines of context. If context requires the type artist to spell out the numerical value, then the denomination is spelled out also, as in *fourteen dollars.* Fractional amounts of a dollar fall under the guidelines of decimals and are set as figures, such as *$1.25,* in any context. The dollar symbol ($) or cent symbol (¢) accompany figures in text but are not mixed with comparative figures. Text figures require the old style dollar ($) and cent symbols (¢).

These symbols are included in the expert collections and are proportional to the text figures.

▲ The cost of their pet treats is $1.00, $.50, and $1.10.
▼ The cost of their pet treats is $1, 50¢, and $1.10.
The cost of their pet treats is $1, $.50, and $1.10. ⌐00 *text fig* /lc

If a whole-dollar amount is used alone in context-appropriate text, the type artist drops the decimal point and the double zeros, as in $5. If the whole-dollar amount is in a series with other dollar-and-cent amounts, the type artist restores the decimal and two zeros (or *ciphers*). Large-dollar amounts can be expressed in figures and words, such as $4 *million,* for ease of reading when the NONN decision dictates figures.

In a promotional brochure or advertisement, the type artist uses figures and symbols for prices. Figures improve reader comprehension and strengthen the impact of this kind of document. Consistency with dollar and cent symbols and decimals and zeroes is important here as well.

▲ The cost of dog, cat, and bird food has risen from $4.25 to $5.00, from $1.00 to $1.50, and from $2.39 to $2.50, respectively.
▲ Collar prices begin at $4 and vary according to the animal's size.
▼ The cost of dog, cat, and bird food has risen from $4.25 to $5, from $1 to $1.50, and from $2.39 to $2.50, respectively.
▲ The cost of their collars is still $4, $5, and $1.
The cost of dog, cat, and bird food has risen from 4.25 to $5.00. $⌐/lc

TYPE ARTISTS SET TIME-OF-DAY NUMBERS according to context. In humanist text, when times are approximate and rounded to the hour, half hour, or quarter hour, the type artist spells out the time, such as *four fifteen* or *quarter past six.* When specifying the hour, the word *o'clock* accompanies it, such as *three o'clock*—but never *3:00 o'clock.* When the author pinpoints a precise moment in time, such as the start of a public event or an airline departure, or when setting time in technical text, the type artist uses figures.

▲ She began practicing the piano at seven o'clock in the evening.
▲ The eleventh runner crossed the finish line at 11:53 A.M.
▲ The train leaves at 7:15 in the morning.
She started her homework at 3 o'clock. *sp*

TIME OF DAY

• Use figures to pinpoint a precise moment in time, as for a public event or service.
• Use small caps for time-of-day abbreviations with figures only (periods are optional).

The time-of-day abbreviations *A.M.* and *P.M.* accompany figures, not number-words. The type artist uses text figures and small caps, such as *7:15 A.M., 12:00 M.,* or *4:00 P.M.* The abbreviation *A.M.,* from the Latin *ante meridiem* (before noon), distinguishes morning hours; *M.,* from the Latin *meridies* (noon), differentiates between noon, *12:00 M.,* and midnight, *12:00 P.M.;* and *P.M.,* from *post meridiem* (after noon), distinguishes the afternoon and evening hours.

A single space separates the figures from the abbreviations. No space occurs within the abbreviation itself. Line breaks should not occur between the figure and the time-of-day abbreviation. It is acceptable to eliminate the periods within the abbreviation, appearing as *10:00 AM.* If small caps and text figures are not available, regular caps are acceptable for typefaces with a tall *x*-height. When using short–*x*-height typefaces without small caps and text figures, the type artist uses lowercase letters with periods to minimize texture disruption. The combination of text figures and small caps creates a distinctive document.

▲ The lecture will commence in the green room at 10:30 A.M.
▼ The lecture will commence in the green room at 10:30 A. M.
◡ The lecture will commence in the green room at 10:30 A͡M.
▲ The New Year's Eve celebration began on Times Square at 12:00 P.M.
▲ The flight to London left at 12:00 M.
m̲ The flight to London left at 12:00 P̸.

DAYS OF THE MONTH

✦ Use figures in all contexts.
✦ When both day of the month and year are present, a comma follows each figure.

WHEN USING A DAY OF THE MONTH in any context, the type artist uses figures. Although when one reads dates, the date sounds like an ordinal, it is written as a cardinal number and no comma follows it. When a year follows the month and day, commas set off the year. With inclusive dates in lists, with tabulated material for schedules, or in technical text, the type artist can use an en dash as long as the dates are not preceded with the preposition *between* or *from.* (See "En Dash" in chapter 5.) In humanist text, writing out the inclusion, such as *from May 5 to 13,* is preferred.

▲ Valentine's Day is on February 14, 1995, and is a Tuesday.
▲ We celebrate Valentine's Day on February 14 every year.
▼ We celebrate Valentine's Day on February 14th.
▲ The experiment was performed May 5–8, June 1–4, and July 3–6.
▼ The experiment was performed from May 5–8, June 1–4, and July 3–6.

A YEAR IS SET AS A FIGURE in all contexts. If, in running text, it is set alone or with a month, the year is not set off with commas. When used as part of a specific month and day, it is set off with commas. If an event or time period encompasses part of two calendar years, it is set with a virgule, such as *1994/95*. The type artist drops the century reference in the second year and does not replace it with an apostrophe.

In an informal context when the century is obvious, a calendar year is abbreviated by dropping the century reference and replacing it with a single apostrophe, such as *the blizzard of '93*. Even a calendar year yields its figures and is spelled out when it starts a sentence.

- ✦ Always set a year in figures.
- ✦ Decades are set consistently as number-words or figures.
- ✦ Centuries follow the NONN decision.

- ▲ His date of birth was July 4, 1988, not June 24 as his mother predicted.
- ▲ The Valentine's celebration of February 1992 was more festive than usual.
- ▼ 1992 was a joyous year for the family.
- ▲ Nineteen ninety-two was a joyous year for the family.
 The winter of 1992/93 was the coldest on record. / *virgule*

Decades are set as figures or are spelled out, as with *the 1990s, the '90s,* or *the nineties*. With figures, the plural distinction *s* is necessary and no apostrophe precedes it. Centuries are spelled out as ordinals, such as *the fifteenth century.* Those type artists using number-words through nine, spell out centuries below ten and use ordinal numbers with the others, such as *the fifth century* and *the 12th century.* Once again, text figures are preferred here because they do not disturb the texture of the paragraph as titling figures do.

Eras are distinguished by the appropriate abbreviation, such as A.D. or B.C. The abbreviation A.D. is from the Latin *anno Domini* (in the year of the Lord) and precedes the figure, as in A.D. 600. The abbreviation B.C. (before Christ) follows the figure, as in *450* B.C.

- ▲ The sixties were tumultuous years.
- ▲ The '60s were tumultuous years.
- ▼ The 60's were tumultuous years.
- ▲ The mid–fifteenth century hosted the introduction of Gutenberg's invention.
- ▲ Beatrice B. Warde (1900–69) worked in England for Monotype.

- ▲ Correct typographic form
- ▼ Incorrect typographic form

If a type artist cites inclusive years in text, they are written with the en dash, as long as the words *from* or *between* do not precede the

number. If calendar years span two centuries, such as *1887-1902,* all figures are needed. If the years are contained within the same century, the century reference is not repeated, such as *1902-4* or *1887-92.* An inclusive era distinction with dates using the abbreviation A.D. follows the same guidelines, such as A.D. *43-4* or A.D. *67-78.* Dates using the abbreviation B.C. are not shortened within an inclusive number grouping because the information might be misinterpreted. The type artist uses full figures for both years, such as *125-123* B.C.

NAMES IN TEXT

* Italicize names of large publications, such as books and periodicals.
* Set in quotation marks the names of the subcomponents of those same publications.
* Capitalize personal names always and names of parks, streets, and buildings when the full name is used.

IDENTIFYING NAMES IN TEXT uses a system of hierarchical typographic treatments. From personal names to book titles to newspaper articles, a type artist uses different type treatments to alert the viewer that the name is for a person, a large publication, or a landmark. All words in a personal name, for example, are capitalized. This treatment links these words into a single multiword, such as *Giambattista Bodoni* and *William Addison Dwiggins.*

Publications in text receive unique typographic treatment and, in doing so, identify their role. A type artist italicizes the names of newspapers, periodicals, and books to distinguish a large publication. A small portion of a large publication, such as a chapter or an article, is capitalized and set off in quotation marks. The use of italics or quotation marks shows the hierarchy between publications and their subdivisions. This same hierarchy is applied to movies and television shows (italicized) and television episodes (capitalized and quoted); symphonies and songs; and cookbooks and recipes.

Quotation marks can cause a visual problem in text if used to extreme. For example, when writing a chronology of character development through a season of television episodes in a single television series, it is acceptable to italicize the episode names rather than quote each one. In such abundance, the open and close quotes appear as annoying bird tracks tap dancing across the page. Switching to italicizing the episode names is a smoother typographic distinction. The quantity dictates a change in typographic treatment. The type artist maintains the same treatment throughout the document.

In running text, when an italicized or quoted name starts with the word *The,* it need not be included with the special treatment, if it sounds or looks awkward. If it is not treated specially, it is not capitalized.

There are unusual times when part of a name is italicized and part is not. The name of a ship, such as the USS *Eisenhower* or the

HMS *Ajax,* is set with the name italicized, but the military distinction is set roman in caps or small caps.

Other, more common names, such as the name of an office, park, monument, bridge, building, military branch, society, or association, are capitalized when the full name is used, such as *Washington Monument,* but when it is referred to as *the monument,* it is not capitalized.

- ▲ The bird enjoyed reading the *New York Times* from the perch in his bird cage.
- ▲ The schoolchildren visited the Washington Monument, the Smithsonian Institution, and the Lincoln Memorial. They agreed that the memorial was the most spectacular.
- ▲ Her favorite dessert recipe in the *Joy of Cooking* was the "Fudge Meringue Cake."

ABBREVIATIONS ARE THE SOURCE of interesting lore from the past. It is believed that the exclamation point and the question mark developed from the Latin form of abbreviated writing that positioned letters of short or shortened words on top of one another. The exclamation point evolved from the Latin word *Io* (joy). The question mark developed from the Latin word *quaestio* (question). To abbreviate the word *Io,* the scribes placed the first letter *I* atop the last letter *o.* The question mark evolved from placing the word's first letter *Q* atop its last letter *o* (Firmage 1993). The abbreviation for the word *et cetera* appeared as *&c* in some early texts; but unlike the abbreviations for the exclamation point and the question mark, it disappeared from use (Haley 1994, 5).

Type artists should avoid using abbreviations in running text. Abbreviations for words that could be spelled out easily appear informal—as if the author did not have time to write the word. The names of states, for example, look hastily written, as with *CA* or *Calif.,* when abbreviated in running text. The type artist should spell out those words, as in *California,* unless they appear in tabulated material, in which case *Calif.* is preferred. This applies to months, *February* rather than *Feb.,* and to days of the week, *Tuesday* rather than *Tues.* Symbols for trademarks and registered names,™ and ®, are not included in running text.

Aside from guidelines for the abbreviations A.M., P.M., B.C., and A.D. discussed previously (which are exceptions to this rule), other exceptions occur in personal names, such as *John J. Jingleheimer, Jr.* With the full name preceding it, the abbreviation *Jr.* or *III* is an acceptable part of a person's full name. The example, *Mr. Jingleheimer, Jr.,* is incorrect,

- ✦ Avoid abbreviations in continuous text.
- ✦ Abbreviations are suitable in lists, tabular material, and notes.

$$\frac{I}{O} \rightarrow !$$

Abbreviation of the Latin word *Io* is the precursor of the exclamation point.

$$\frac{Q}{O} \rightarrow ?$$

Abbreviation of the Latin word *quaestio* is the precursor of the question mark.

since the full name does not precede the abbreviation. The full-name distinction applies to abbreviations at the front of names as well, for example, *Gen. George Washington* or *General Washington*. When writing the names of ships, which are always italicized, the letters preceding them are part of the name and are set in roman small caps, as in RMS *Titanic.*

Abbreviations for academic degrees also are acceptable in text, when they follow a full name. Abbreviating a person's given name in text is not acceptable. Abbreviations such as *Wm.* and *Benj.* should appear as initials or as spelled-out names, *William* and *Benjamin.*

▲ The USS *Enterprise* has been cruising around the galaxy for decades.

Unit-of-measure abbreviations are appropriate only with figures. They are suitable for tabulated material, in lists, or within equations. In some instances a symbol replaces the abbreviation and further streamlines the material for improved reader comprehension. In an equation or dimension, such as $4" \times 9"$, the dimensional symbol (representing the word *by*) is an actual symbol, not the lowercase *x* of the text font. The symbol for the unit of measure is repeated with each figure.

A common exception occurs with percentages. In any context, a figure represents the percentage quantity and the percent symbol (%) follows in technical text. The word *percent,* however, follows the figure in humanist text.

▲ The cat ate only 75 percent of her breakfast.
sp The dog ate 100% of her breakfast and 25 percent of the cat's.

When abbreviations are acceptable in running text, the type artist should not allow a line break to separate the abbreviation from its quantity or name. Some applications enable the type artist to insert a non-breaking space or to join figure-and-word groupings so a line break cannot occur. This shortens proofreading time by eliminating these never-acceptable errors.

FOREIGN TERMS AND DEFINITIONS

◆ Italicize an unfamiliar foreign-language word or term.

FOREIGN TERMS IN TEXT can confuse a reader if they appear unexpectedly. An isolated German word might appear misspelled within English text if it is not identified properly. Italicizing the word alerts the reader that the term (one or more words) is special. The type artist does not set off the word with commas. The change in letter style is sufficient. Over time some foreign-language words, such as the French term *hors*

d'œuvre (outside of the work), are used so frequently that they are accepted into the domestic language and are no longer italicized. These words are then included in English-language dictionaries.

▲ The art opening was exciting and the hors d'œuvres were scrumptious.

If a definition follows the foreign term, the type artist has two alternative treatments. Placing the definition in parentheses after the word clarifies the meaning for the reader immediately. The definition might be critical for understanding the sentence fully; but if it ranks with the same importance as the other words, it might confuse the reader. No additional punctuation marks are needed. This typographic treatment causes the least text disruption. The second type treatment requires inserting four, rather than two, additional punctuation marks. The type artist uses quotation marks around the definition and sets it off with commas.

▲ *Gesundheit* (good health) is heard after someone sneezes in our family.
▲ *Gesundheit,* "good health," is heard after someone sneezes in our family.

WHEN AN AUTHOR USES A WORD or term outside its functional capacity, the reader needs a visual signal indicating the word's change of purpose. In the following sentence, the words *old style* are identified by a style change so the reader does not misunderstand the sentence:

Some typographers disagree with the term *old style* to describe text figures.

The italicized type signals the reader to view both words as a single entity, just as an italicized book title indicates the name of a single object. Some typographers prefer to set off the word with quotation marks, but this adds too much clutter to a type line, especially when multiple words are cited. Authors also use letters outside their normal functional capacities. By italicizing the letter, the author identifies its role in the sentence as the topic of conversation rather than a component of it—the letter *M.* Many times, letters and words used in this capacity are preceded by the words *the letter* or *the word,* respectively.

WORDS AND LETTERS
AS WORDS
AND LETTERS

• Italicize a word or letter used outside its functional capacity.
• Set letters used as shapes in sans serif type.

Letters are used also as shapes to describe other objects. Letter shapes are so distinct and visually descriptive that they are an acceptable shorthand in text. These letters are set in a sans serif typeface within the text. This unique typographic treatment identifies their special function, just as italic type identifies the foreign word. If the shape of a slab serif typeface represents the shape more accurately, the type artist can use it.

The use of letters as shapes is infrequent. If, on the rare chance, there are several in close proximity, the type artist should keep the sentence from looking like a type catalogue by limiting the number of typefaces.

▲ The letter *M* represents one thousand when used as a Roman numeral.
▲ The A-frame house reminded me of our vacation in Switzerland.
▲ An A-frame house uses many I-beams in its construction.
The skyscraper used many I-beams in its construction. I *(slab serif)*

ॐ

ERIC GILL IS QUOTED as saying, "There are now about as many different varieties of letters as there are different kinds of fools" (Gill 1936). An appropriate rewording of this quote fits this chapter: There are now as many special functions requiring specific typographic treatments as there are typefaces. Using these treatments improves the readability and the typographic form of the page.

TYPESETTING
AS
DESIGN

For those who love working with type, augmenting and embellishing it is a natural outgrowth of this penchant. Incorporating typographic design elements into a page of text is an age-old practice that has served a variety of purposes. Italian printers Giovanni and Alberto Alvise are thought to be the first printers to use *fleurons* (floral foundry ornaments), in the 1478 book *Ars Moriendi.* The fleurons completed short measures of text type for justified alignment and decorated the title page, integrating the fleurons with the display type. Aldus Manutius used ornaments in a 1499 text to complete an inverted triangular-shaped text block when the measures in the tapering shape became too short. These typographic ornaments were suitable design additions to the typeset page because they were designed as characters within a specific type family. Giambattista Bodoni designed many accompanying ornaments for his typefaces in the late eighteenth and early nineteenth centuries. The design features of the ornaments were identical to those of his typeface characters, and consequently, their visual characteristics supported the mood evoked by the typeface.

Even as typographers actively supported, designed, and used ornaments, they expressed concern that improper use of these elements would detract from the main goal of typographic printing—the communication of content. Typical of their concern was Frederic Warde's 1928 warning that excessive adornment of type would distract the reader with "a dangerous diversion." Warde wrote that ornaments, or

The ornamentation of printing is … charming because of its power to add beauty to the strict simplicity of type; dangerous because all matters of decoration call upon the utmost discretion and sense of fitness for their effective use.

————————— F. Warde
Printers Ornaments
on the 'Monotype'

Through the Looking Glass

Semibold headline in one point size

Semibold italic headline in two point sizes

Headline using regular small caps, semibold italic, and rules

Headline using regular small caps, italic with swash cap, semibold small caps, and bullets

Through the
Looking
GLASS

Headline using regular weights with swash e and titling caps

printer's flowers, were a preferred choice for type ornamentation because of the family resemblance with the corresponding typeface (McLean 1995). Warde's advice to typographers was to use "the utmost discretion and sense of fitness for the effective use" of these ornaments—still good advice today.

In a famous 1932 address to the British Typographers Guild at the St. Bride Institute in London, Beatrice Warde (1900–69), an American typographer, type historian, and eloquent spokesperson for typography, equated the role of a well-set type page to that of a crystal wine goblet. Both the type page and the crystal goblet, she wrote, transport their contents in an elegant and unobtrusive vessel that enhance the recipient's appreciation and understanding. "Everything about it [the crystal goblet] is calculated to reveal rather than to hide the beautiful thing which it was meant to contain." Warde believed that the most important goal of printing was to convey "thought, ideas, images, from one mind to other minds." She went on to state that there was a maze of typographic practices born from excessive enthusiasm that subverted the attainment of that goal, such as inappropriate typeface selection, oversized type, and insufficient word spacing (McLean 1995).

Frederic and Beatrice Warde could only anticipate the mishandling of type possible with the contemporary techniques of the early and mid–twentieth century. They could not begin to imagine the adornment potential for digital typographers at the end of the twentieth century with access to vast type libraries, infinite size and transformation capabilities, and the structure-altering multiple master technology available on desktop computer systems. Even so, Frederic Warde's advice from 1928 still holds true for these technologies: Digitally generated design elements should support and clarify the content by maintaining the "utmost discretion and sense of fitness." If the enhancement of type through inclusion of design elements facilitates the author's link to the reader's mind, then these elements support the author's goal, rather than divert from it. For the type artist seeking to incorporate design elements into display or text type, selecting from a palette of type family styles, sizes, alternate characters, and ornaments is a prudent beginning that helps ensure a consistent page design. The more expert digital typographer can create effective design additions by combining typefaces or using multiple master technology. With the goal clearly in mind—facilitating communication—the type artist's contribution can be both sophisticated and effective—similar in elegance and beauty to a crystal wine goblet.

Adding typographic design elements to a page can begin by controlling the type sizes and styles in the headline. Why is it necessary that all words in a headline be the same size or style? By controlling the type size, type style, and placement of words in a headline, a savvy type artist can introduce a strong, eye-catching typographic design element to the page.

The italic styles of many type families contain elegantly proportioned letters suitable for a unique, graceful headline. The Adobe Caslon, Adobe Garamond, and Minion type families include swash characters that add another level of visual interest while conveying a message of sophistication. The italic and roman styles of these typefaces contain alternate characters with swash endings suitable for a decorative headline. A complementary script typeface can add the flourish a headline needs for a script-appropriate article. A well-placed ornament with a rule or two can give a headline a more pronounced presentation. Type artists can use all the possibilities a typeface provides, but should keep in mind that too much of a good thing dilutes its impact. Effective type artists must choose and use these type elements judiciously.

Benjamin *Franklin* (1706–1790) *writer inventor & statesman*

Headline using italic word with swash cap, regular small caps, ornament, and rule

a MAN FOR ALL *SEASONS*

Headline using Minion semibold italic, caps, small caps, italic caps with swash *S*, ornament, and rules

FIGURE 7-1: *Caflisch Script headline*

Typefaces have a uniform design structure that moves the eye through the letters and words to the conclusion of a thought. Applying these same fluid movements to a designed headline is a natural application of the design inherent in most typefaces. Calligraphic typefaces, such as Caflisch Script (fig. 7-1), Ex Ponto (fig. 7-2), Boulevard, Bickham Script, Spring, Aristocrat, Ruling Script Two (the list goes on and on), with their quick, expressive strokes, transform a staid, tightly corseted headline into a symphony of movement and a celebratory display of energy and awe.

WORKING WITH ALTERNATE CHARACTERS

WITH A 256-CHARACTER LIMIT, a standard digital typeface has little room for multiple designs of the same letterform. Fortunately, certain type families come with customized branches on their family tree. The Adobe Garamond family has an alternate regular and an alternate italic that add several roman lowercase letters, swashed surrogates for all italic capitals, ornaments, and extra ligatures.

Other typefaces differentiate alternate characters into use groupings. Ex Ponto has three: beginnings, letters with swashes that extend from the letter's left side, suitable for use at the beginning of a line; endings, letters with swashes that extend from the letter's right side, suitable for use at the end of a line; and alternates, structurally altered substitute letters, suitable for more extensive type customization. When a type artist becomes familiar with these unique typeface letters, the number of design enhancements possible increases significantly.

Adobe Garamond regular and italic with selected alternate characters, ornaments, and ligatures

Original Ex Ponto typeface

FIGURE 7-2: *Ex Ponto type graphic for quote by Keats*

Substituted alternate characters for improved design

Ex Ponto (created by Jovica Veljović) is used in the Keats quote about beauty (fig. 7-2). The original letterforms demonstrate the calligraphic beauty and expressive flair inherent in the typeface. After altering word placement and size, the typeface's design characteristics become more actively involved in the delivery of the message, thereby diminishing their role as "transparent" messenger. In the final iteration two beginning alternates, two ending alternates, and four alternate characters enhanced the graphic's design and helped determine each word's final location. In its lowered position, the *J* in *joy* was an uppercase letter; the horizontal stroke at its head better defined the word's mean line. All letters were set in the regular weight regardless of point size. This gave visual emphasis to the words *beauty* and *joy* just as a speaker would give audible emphasis when reading the quote aloud. In this instance of type for discontinuous reading, typeface transparency is not

an overriding principle; graphic concerns dominate, enhancing the message and also attracting the reader to it.

The typeface Galahad (created by Alan A. Blackman) has an array of alternate characters that expand the typographic design possibilities throughout a graphic. The letters in the first version of the Arts & Crafts Movement graphic (fig. 7-3) are set in Galahad Regular. After resizing selected words for improved emphasis, ten different alternate characters were inserted to improve the visual movement through the words. The *f-t* ligature in the word *Crafts* nestled these two characters together so the ascender of the *f* flowed smoothly into the stem of the *t*. A shared crossbar joined the two characters. The letters *r* and *t* in the word *Arts* would have benefited from a ligature, because their positioning with regular and alternate characters was not satisfactory. Aligning the end of the alternate *r*'s swash ear with the stem of the *t* caused an overlap that darkened the texture and diminished legibility. The solution was a fake ligature. By duplicating the *r,* changing it to white, and using it as a spacer, the two letters aligned nicely, while legibility and typographic texture improved.

Original Galahad Regular typeface

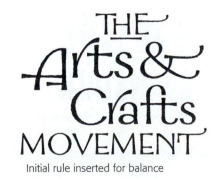

Original letter placement (left);
fake ligature solution (right)

FIGURE 7-3: *Arts & Crafts Movement graphic in Galahad*

With word and letter placement finalized, a rule was inserted beneath the word *THE*. The rule was intended to balance the double horizontal rules in the alternate *A*, but it was insufficient. In the final iteration (fig. 7-3), a double rule (similar to those used in the letter *A*) was

Initial rule inserted for balance

positioned under the word *THE* and within the counter of the capital *O* in the word *MOVEMENT*. The Galahad em and en dashes were used as the long and short rules to maintain the typeface design style (rough calligraphic strokes with flaired endings).

WITH THE VOLUME OF TYPEFACES and families available in the digital type environment, it is not uncommon for enthusiastic type artists to overindulge. If more than two type families are being used in a document or on a page, the type artist's internal alarm should sound and a good design case made for this use. Just as setting an important document in all caps to signify its noteworthiness is counterproductive to the point of being unreadable, so too is employing multiple type families merely for their attention-getting characteristics. This visual clash has the same effect as a roomful of arm-waving kindergartners all trying to answer a question simultaneously—visual chaos (without the noise). Design is organization. Too many competing typefaces defy organization, confuse the reader, and do not speak with one voice.

Alternate lowercase *d* suggests sprouting bean

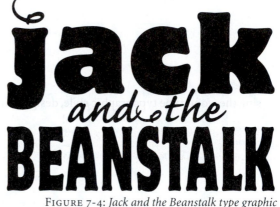

FIGURE 7-4: *Jack and the Beanstalk type graphic*

A well-chosen combination of two typefaces can make an otherwise plain headline into a visually enhanced statement. The key component to a successful visual marriage is contrast. Using two similar typefaces, such as Times and Minion, in a document would have a puzzling effect on the reader. Some readers might not realize they are seeing two different typefaces, but will suspect something is wrong with the type. Once readers start puzzling about the type, they are no longer listening to the author. Contrasting typefaces eliminate the uncertainty; the

Preliminary typeface treatments for words *and* and *the*

design difference is obvious. If they are an appropriate selection, both typefaces add or emphasize something about the subject matter.

In the Jack and the Beanstalk graphic (fig. 7-4), the typeface Motter Corpus (designed by Othmar Motter) was used for the words *jack* and *BEANSTALK* to emphasize the giant's size in this well-known tale. The words *and the* were set in Caflisch Script because the script is visually reminiscent of the beanstalk's vining tendrils. The sprouting-bean shape used to dot the lowercase *j* and as ornamentation between the words *and* and *the* was a flipped and rotated alternate character for the letter *d*. Several iterations illustrate the design process for this headline. The final graphic (fig. 7-4) shows a light touch with the design elements that strikes a balance between readability and graphic enhancement.

The use of multiple typefaces on a page was in its heyday with wood type during the period from 1830 to 1870. Wood type was used primarily for display faces in advertisements and posters, because above 144 points, a single metal sort was extremely heavy, awkward to use, and its manufacture was problematic.

Darius Mills was the champion of wood type. He imported English boxwood because of its fine grain for the manufacture of these typefaces. The fine grain was less prone to splintering and enabled the production of intricately designed typefaces. The detailed designs of this period were later revived in the 1960s when phototypography proved to be an equally flexible medium for a wide range of typeface designs.

When using the wood type typographic style, design principles still dictate what typefaces work together well. In the example (fig. 7-5), the words *WOODEN TYPEFACES,* set in Thunderbird and Rosewood, respectively, deliver the primary message. Size, intricacy of design, color, and proximity all work to make this the most eye-catching element in the type graphic. The date *1830–70* is set in the heavy black Madrone typeface. It is reminiscent of the color and weight of *WOODEN,* thus linking it visually to the primary type elements. The secondary pieces of information *ENGLISH BOXWOOD* and *DARIUS MILLS* border the piece on top and bottom. They serve as bookends holding the graphic together while relating back to the primary type elements in the interior. The curves of the Juniper typeface, along the top, relate back to the curves in Thunderbird and Madrone, while the shadowed Horndon typeface, along the bottom, balances the white of the Rosewood typeface in the interior.

The choice of appropriate ornaments is important also. The ornaments were chosen for their style and mimic the typefaces' heavy,

Alternate placements for lowercase *d* ornamentation

Wooden Typefaces typeface legend

FIGURE 7-5: *Wooden Typefaces type graphic*

carved design features. The date-line ornaments were put together to create the weight and emphasis required for their location. They relate to the pointed ornament directly below and above the primary type message (fig. 7-5). These tapered diamond shapes are repeated inside the Rosewood typeface. The heavy floral ornaments at the top and bottom are style appropriate and effectively balance the color of the heavy Thunderbird and Madrone typefaces. Two curved, dotted ornaments were added on each side of the floral ornament to extend their width.

Unifying and balancing the style of these visual elements throughout the type graphic emphasizes its overall rectangular shape. In a design variation of the graphic, the delicate, open style of the ornaments relates to itself, but does not relate strongly to the heavy typefaces. Consequently, ornament areas are lighter in color, causing the overall shape of the graphic to be a top-heavy hourglass rather than a rectangle. This affects the delivery of the message. The ornament flourishes accentuate the curves and points of the Thunderbird typeface, increasing its visual impact. The quantity of white added by the ornaments diminishes the

Variation of graphic with alternate ornaments

CHAPTER SEVEN

impact of the Rosewood word *TYPEFACES,* weakening the link between the two primary type elements *WOODEN* and *TYPEFACES* and jumbling the message. While the graphic is still well designed and visually interesting, this design change alters the message—the primary reason for the typography.

THE USE OF ORNAMENTS FOR graphically enhancing display type can emphasize the elegant lines of a well-designed typeface, such as Robert Slimbach's Poetica (1992). In the graphic of the word *fleurons,* a host of typeface characters—ornaments, alternates, and punctuation marks—come together to make this unique visual (fig. 7-6). Poetica is a challenging typeface to use because there are so many alternate characters from which to choose. For example, there are nine swash capitals available for *each* letter. There are separate groupings for lowercase alternates, lowercase beginnings, lowercase endings, ligatures, ampersands, and ornaments.

Original Poetica typeface

FIGURE 7-6: *Fleurons type graphic in Poetica*

The original word *fleurons* was set in Poetica Chancery III, a heavily swashed chancery cursive typeface with long ascenders and descenders. The increased emphasis on swashes made it the best selection from the Poetica family. When designing a single-word type graphic, the ability to balance the chosen letters is a major concern. Poetica offers many alternate letterforms, but only the ones used at the beginning of the word that can be successfully balanced at the end of the word would be suitable. Several alternatives for the beginning were considered before the final selection was made. The final word used three lowercase beginnings, one lowercase ending, and one lowercase alternate.

The letters in *fleurons* do not share a common baseline. The visual flow between adjacent letter swashes dictated their positions, resulting

Preliminary alternate beginnings

Curved baseline placement

Poetica ornaments (left, center) and
apostrophe (right)

USING MULTIPLE MASTER TYPEFACES

in a curved baseline. The interior of the curve was the perfect location for the ornaments. From Poetica's 44 available ornaments, two were chosen to best continue the word's visual movement and maintain the swash-heavy style of the graphic. The ornaments were angled and, as with the letters, optically aligned with the swashes in the word. The design's final iteration used an apostrophe as an ornament to complete the movement from the ornaments back into the word.

MULTIPLE MASTER TECHNOLOGY OFFERS the type artist typographic controls that alter the fundamental structure of a letterform. It is the next best thing to being a type designer—only with a safety net. As explained in the first chapter, a type artist can create a typeface or font along four available axes—size, style, width, and weight. These controls go beyond those available from standard type formats or available from professional graphics software. The size axis, for example, enhances certain letter details for each size and generates better reproduction quality beyond that available with hinting. The width axis maintains stroke weights more accurately, as the letter's set width condenses or expands, than the horizontal scaling feature in professional graphics software (fig. 1-5).

The extent of these structural changes, such as stroke weight, depends on the length of the typeface's dynamic range. For example, both Ex Ponto and Caflisch Script are multiple master typefaces with a weight axis. Ex Ponto's dynamic range extends from 175 Light to 450 Bold—a range of 275 possible weight increments. Caflisch Script's weight axis has a dynamic range of 360 increments from 280 Light to 640 Bold. The number of iterations possible for each multiple master axis depends upon the length of its dynamic range. In the hands of an experienced digital type artist, multiple masters enable fine-tuning of typefaces or single letters, which can produce technically accurate and exciting solutions to typographic problems.

Similar controls have always been possible with calligraphy. For example, a skilled calligrapher maintains a consistent letter style (typeface) and stroke attributes with a single nibbed pen. If a customized letter is needed, the same style and attributes are applied to the altered structure. By maintaining a consistent nib angle throughout the work, the calligrapher achieves the same stroke endings, stress placement, and stroke weight for all letters regardless of size. If the calligrapher makes the first letter of a word larger than the remaining letters, the stroke

weight for the word stays consistent, because the tool and its handling remained the same.

The same example using a digital typeface would not produce identical results. Scaling a digital letterform increases not only the overall size, but the relative stroke weights as well. The larger letter has a heavier stroke than the rest of the letters in the word. Visually, the first letter dominates. While this is a useful design technique for a versal at the beginning of a paragraph, it may not be appropriate in a single word within a headline, where evenness of color unites the design elements.

Calligraphic Expressions

Original Ex Ponto typeface

FIGURE 7-7: *Second design iteration*

Depending upon the size differential between the scaled and original letters, changing the weight of the letter from bold to regular might put the stroke weight back in proper proportion to the rest of the word. In other instances, a custom weight, available from a multiple master typeface with a weight axis, is necessary. In the Calligraphic Expressions

Calligraphic Expressions

FIGURE 7-8: *Calligraphic Expressions type graphic*

90 point 290 Reg

140 point 290 Reg

226.8 point 290 Reg

194.4 point 290 Reg

145.8 point 290 Reg

FIGURE 7-9: *Third design iteration with visible baselines*

graphic (fig. 7-8), Ex Ponto maintains unified stroke weights in words using several letter sizes. The original typeface characters are full of energy, but the two words do not form a single design unit. After altering word size to emphasize the word *Expressions,* alternate characters with similar structures were added to improve the visual movement and balance throughout the words (fig. 7-7). The third design iteration shows letter placement (fig. 7-9), where letter structure dictated the visual flow through the word. In the same stage, the uppercase *C, E,* and the first lowercase *s* were enlarged. As a result of this scaling, the word *Calligraphic* contained two type sizes, and the word *Expressions* contained three. Changing the weight in the *C* and *E* from 290 Regular to 175 Light unified the stroke weights with the 290 Regular weight of the lowercase letters. The first lowercase *s* in *Expressions* required a custom 235 weight to unify the strokes. Proofing the results of this precise fine-tuning requires an output device that closely approximates or matches the final output resolution of the finished piece. Without it, the stroke weights may not match.

TEXT TYPE DESIGN

FOR THE TYPE ARTIST READY FOR the next level of typographic design, similar opportunities are possible with paragraphs of text. Text design has an increased level of difficulty for creative design, but nothing that care and thought cannot handle. Beyond the text decisions for alignment, measure, type size, and leading, the type artist can integrate text type with other page elements (type or visuals) through the use of text wraps. *Text wrapping* is a text-design technique that embeds a letter, type block, photograph, or illustration into a block of text. The wrapping of text around the element occurs by controlling where lines of text

type stop and start. In addition, shaped-text blocks are possible, but are the more challenging.

Text and headlines usually maintain a polite distance from one another with the headline first, then a band of white, followed by the text paragraphs. It is easier to distinguish these elements one from another with this traditional placement, but it is not the only way to present the information. When these two mingle, or visually connect, they present a more varied visual environment within which to move the reader's eye. There are three kinds of text wraps—runarounds, contoured wraps, and shaped-text wraps.

A *runaround* refers to a rectangular shape, such as a photograph, illustration, or initial letter set into a block of text (fig. 7-10). The paragraph's measure is shortened to make room for the rectangle and then lengthened to its original distance beyond the shape. When a graphic is inset into the text, the type artist aligns the bottom of the inset or its caption (if it has one) with the nearest baseline. This alignment unites the text with the graphic.

A *contoured wrap* refers to an organic shape, such as an illustration or type, set into a block of text (fig. 7-10). In this situation, the text lines follow the contour of the shape or create a contrasting white shape within which the organic shape rests. Type artists use contoured wraps with illustrations, shaped photographs, initial letters, pull quotes, and inset headlines and subheads. Baseline alignment with the inset element is important for all text wraps.

The artist must leave sufficient white space between the inset element and the text. Page-layout and graphic applications provide graphic boundaries that the type artist manipulates to form text-repellent

In kitchens throughout the United States, famil breakfast of eggs each morning. There are as there are chickens—to cannibalize a quote. Son soft boiled, over easy, sunny-side up, and oth hard boiled, or jus cooking style, the freshest, biggest, the chicken house

Egg producers foll between the farm prevent breakage freshness. First, th Malformed or weak removed. The healthy eggs are packaged amo size. Second, the eggs are chemically stabilize injected into the egg to prevent any further de

In kitchens throughout the United States, fami breakfast of eggs each morning. There are as there are chickens—to cannibalize a quote. Sc soft boiled, over easy, sunny-side up, poached, hard boiled, or just fried. style, they all require the freshest, egg from the chicken house.

Egg producers follow between the farm an breakage and maint eggs are sorted. Mal eggs are removed. Th packaged among others of similar size. Secon chemically stabilized. A chemical is injected int any further development of the yolk. In the sto

FIGURE 7-10: *Runaround (left) and contoured wrap (right)*

Chickens Prefer B

In kitchens throughout the United
to a breakfast of eggs each morn
egg styles as there are chickens-
Some like scrambled, soft boiled
up, and others prefer poached, h
Whatever the cook
the freshest,
egg from

Egg p
preca
and t
break
freshn
sorted. M
eggs are rem
are packaged amon
Second, the eggs are chemically
injected into the egg to prevent a
of the yolk. In the store, the eggs
display case that keeps the yolk a

Contrasting white egg-shape formed
by contoured wrap

For the
egg-eaters of
the morning world,
there are as many egg
styles for breakfast as there
are chickens. Some like soft
boiled, scrambled, over easy,
sunny-side up, and others prefer
poached, hard boiled, or just
fried. Whatever the cooking
style, they all require the
freshest, biggest, most
perfect egg from the
farmer's chicken
house.

Shaped text block formed by shaped-
text wrap

fences. The fence determines where the text lines stop or start. If the text is too close to the graphic, the page looks crowded and cramped. If the text is too far away from the graphic, the reader might not realize the relationship between the two elements. Shaping the graphic boundary on screen without the text creates a false impression of adequate white space. The text's gray color makes the white space look smaller when viewed with the text. Leaving a generous amount of white space around the graphic actually can prove to be just right once the text is in position on the page.

A *shaped-text wrap* uses the graphic boundaries or an unpainted path to confine a block of text and control its exterior shape. Some applications make this easier to do than others. The type artist uses this technique to create a text block inside a shaped element or as a free-standing text block. A freestanding shaped-text block interacts with other graphic elements on the page, as would any graphic.

All three text-wrap alternatives present several text-related problems from which to steer clear. When shortening the measure to make room for an inset element, the type artist needs to monitor the character count so it does not fall below the 40-character minimum. If the measure gets too short, the application may not have the number of options necessary to break lines unobtrusively. In the worst-case scenario, a single word is stretched to fill the space like knots along an elastic thread. Reading comprehension slows to a crawl while the reader quickly assembles the isolated letters. The measure adjacent to the inset element must contain sufficient characters to maintain readability and paragraph texture. If a letter or a type block is inset, the type artist uses the intraparagraph spacing techniques (see chapter 4) to maintain correct vertical rhythm and baseline alignment.

Text wraps enable the type artist to insert a graphic element anywhere in text, including inside a block of text. For example, a type line could begin to the left of the graphic and continue on the right. Just because the application can do something, however, does not mean it is worth doing. All text lines should remain readable as a cohesive unit. If excessive word spacing interrupts a reader's progress along a measure, leaping over an overgrown graphic planted in the middle of a measure can be a real puzzler. In most cases, a single text block should remain to the left or right of the graphic—not both. Positioning text on either side of a graphic requires two columns of text and is a better solution. The graphic is inset into the right side of the left column and into the left

side of the right column. The reader easily reads through both columns of text without negotiating the graphic roadblock.

THE SCRIBES OF PRE-GUTENBERG DAYS functioned as the "printing presses" of their time. Readers dictated to batteries of scribes who carefully transcribed what they heard. Once the text was complete, there were just as many new copies of the book as there were scribes. It was a slow process and kept the number of available books to a minimum. Despite the shortcomings, there were benefits. The skill of the individual scribe provided subtle style variances to each text. The resulting book was not perceived as one copy out of thousands emerging from the anonymous press, but one unique, handcrafted treasure. The scribes incorporated unique flourishes that distinguished their work from that of others. These hand-drawn documents frequently featured an individualistic focus on the text's first letter.

Initial letters, or *versals,* evolved from enlarged heavy letters of the sixth century, which called attention to the beginning of the book, into eloquently illustrated letters of the fourteenth century. By the fourteenth century, these ornate versals cascaded down the side of the text and extended up and around the top of the page. Religious texts, in particular, received this grand adornment signifying the text's religious importance. Intricate decorations enhanced texts up to and including full-page illustrations. The use of versals in text was such an important page element that Gutenberg left blank space in his printed text for the scribes' artistic embellishments.

There are two kinds of initial letters—the drop cap and raised cap. A *drop cap,* or *cut-in letter,* is embedded within the first few lines of text. The top of the letter aligns with the cap height of the first text line and the drop cap's baseline aligns with the nearest text baseline. The baseline alignment of the drop cap is essential for the letter to be solidly positioned within the text. A *raised cap,* or *stick-up letter,* sits on the same baseline as the first line of text and towers above the adjacent text block.

Initial letters draw attention to the beginning of a chapter. Not every paragraph merits the attention of the first paragraph. Type artists also use initial letters as typographic section markers and as elements adding visual interest to a page of gray when a document does not contain illustrations, graphic elements, or subheads. Without them, the seemingly endless paragraphs might overwhelm the reader.

An initial letter also determines the amount of white space that precedes the paragraph. A drop cap draws attention to the beginning of

INITIAL LETTERS AND VERSALS

WITH THE ADVENT OF DIG easier to incorporate int and linecast type. There are tw raised cap. A drop cap or cut-i few lines of text.

Embedded drop cap with small cap text transition

WITH THE ADVENT OF DIGIT easier to incorporate into text t linecast type. There are two kin raised cap. A drop cap or cut-in few lines of text.

Raised cap with small cap text transition

With the advent of digital to incorporate into text th linecast type. There are two kin raised cap. A drop cap or cut-i few lines of text.

Isolated drop cap without text transition

*W*ITH THE ADVENT OF became easier to incorpor type and linecast type. There ar cap or raised cap. A drop cap o the first few lines of text.

Text transition using regular caps

*W*ith the advent of digita easier to incorporate into t linecast type. There are two kin raised cap. A drop cap or cut-i few lines of text.

Text transition using larger point size

ROME PROVIDES THE BACKDROP for a vacation of spectacular proportions. In the moonlight the Mediterranean sparkles like

Before the dawn's light aroused the good people of the kingdom to another day of toil in the king's fields, the cows began to rustle in their stalls.

Text transition using initial-letter typeface

the paragraph without adding white space to the page. A stick-up cap inserts additional white space (determined by the initial letter's point size) in front of the paragraph.

Initial letters also aid eye movement around the page. For example, if the headline is embedded in the text (to function as a type graphic when no illustrations are available), it leads the reader's eye away from the first paragraph. An initial letter would attract the reader back to the first paragraph. This technique also works in other situations where the reader enters the page at a point beyond the first paragraph.

Type artists create initial letters with caps, titling caps, lowercase letters, swash letters, script, illustrated letters, or letter and graphic combinations (fig. 7-11). There are many possibilities. Although the letter is a graphic attraction, it also functions as the first letter of the first word or just the first word in the sentence. The size and graphic treatment of this letter requires a visual bridge into the text.

If the initial letter is the first letter of the first word, then the first text line should hug the initial letter. The proximity of the two enables the reader to see all the letters of the word together. If the letter is a word by itself, such as *A* or *I,* a larger word space can separate the initial letter from the text line.

SUPER HEROES as a group currently find liability insurance a major cause for concern. Ever since a rescue-ee was inadvertently dropped during her rescue, the premiums for the beloved crime fighters have skyrocketed.

FIGURE 7-11: *Initial cap with a few dingbats gives pizzazz to a content-appropriate paragraph*

In either situation, the size difference between the initial letter and the first text line remains a concern. Although not widely practiced, it is necessary to provide a size transition here. Without a transition, an elaborate initial letter functions as an isolated graphic and does not lead the reader into the text. The transition is made by setting the first few words (approximately 12 or more characters) in small caps. Regular caps are an alternative if the typeface does not need, or the type artist does not have, small caps. Setting these first words in type noticeably larger than the text type (and in a style matching the initial letter) also provides the same transition into the text as the small caps. As with line

166

breaks in a headline, the small caps are applied to a logical collection of words. If the sentence starts with a phrase, it is better to set the entire phrase in small caps. If this technique is used properly, the reader cannot help but read those first few words. Besides adding graphic interest to a page full of text, the initial letter functions as a lure out trolling for readers. Once snagged, they are hauled into the boat (text).

PULL QUOTES ARE SEVERAL LINES OF TYPE used to break up large quantities of continuous text. Pull quotes, also called *quote-outs, breakers,* and *grabbers,* serve both a content and a graphic function. They attract the reader to the text's content and provide a visual resting spot. Unlike a subhead, which has a precise location in the text, a pull quote's location is not restricted.

Pull quotes range from one to five lines in length. The rules of discontinuous text and headlines apply—lines are divided logically and not hyphenated. The type artist sets pull quotes in a larger type size than the text, coordinates their style with the headline or text, and sets them off with rules, white space, or ornaments. Quotation marks are not needed with excerpted material, but can be effective as a graphic element. Pull quotes, like subheads, break the vertical rhythm of the text. In a multiple-column document, the rules of intraparagraph spacing apply. (See chapter 4.)

For its role in content, the type artist selects a pull quote that reflects the flavor of the article—much like quotes from critics used to advertise a movie or headlines broadcast to solicit viewers for the late-night news. The pull quote repeats or paraphrases information contained in the text. Readers quickly skim pull quotes when considering whether to read a document. Arranging these items according to article content is recommended.

A type artist can embed a pull quote into the text and wrap the text around it, as discussed earlier in this chapter. For example, positioning several lines of text within a diamond shape created from two adjacent text columns can add an additional level of visual interest.

With more than one pull quote on a page, the type artist balances and coordinates them with other page elements. Although some type artists position pull quotes close to the headline for clarification, the pull quote's primary function is breaking up long quantities of text. At the other extreme, locating a pull quote at the bottom of the page may maroon readers, unless another graphic entices them back into the page.

PULL QUOTES

Crime fighters fly without net!

Subject-appropriate graphic embellishments

"There are as many egg styles as there are chickens"

Quotation marks as graphic elements

King's fields produce royal crop

Mood-appropriate typeface selection

SHAPED-TEXT BLOCKS

*Alice fell down a
hole at the bottom of a tree.
Many have read her story with
fervor and glee. All the creatures
she met in Wonderland were mad
or ill-bred. A pink Cheshire Cat
told her this as he sat
upon his head.*

Swash capitals identify beginning of
paragraph or line

SHAPED-TEXT BLOCKS ARE ONE OF the most difficult type design techniques to use effectively. All the techniques that make them effective graphically make them more difficult to read. When a type artist uses this technique, there is a constant tug-of-war between readability and graphic success. This is definitely an advanced technique that a novice type artist should save for later—much later.

A shaped-text block maintains the integrity of the shape by using justified text alignment. The beginning and ending of each measure creates the shape. The integrity of the whole requires an even texture to prevent holes from appearing. If the shaped block appears within a graphic, a centered alignment with manually selected line breaks is more successful. The graphic itself maintains the integrity of the shape, and the text functions as a gray fill. Leaving sufficient white space between the block and the graphic's edge prevents the text from appearing cramped.

A stand-alone shaped-text block is the most challenging. This technique involves a large quantity of text, but the paragraph breaks and indents undermine the overall shape. The type artist could solve the problem by running the paragraphs together and eliminating the paragraph breaks. The reader, however, needs the content separation the paragraphs provide. In order to balance the graphic and readability needs, the type artist can use a *pilcrow* (¶), an ornament, or a swash letter at the beginning of every paragraph. This adds white space to the line and indicates a break between each paragraph. (Oswald Cooper [see chapter 9] used the swash letter technique effectively in the Packard automobile advertisements.) This technique requires a light touch. Too strong a break riddles the text with graphic elements that detract from the overall shape and distract the reader.

❦

TODAY'S DIGITAL TYPE ARTISTS ARE asked to work typographic magic in many environments: electronic media (web pages, video presentations) and traditional print (advertisements, posters, brochures, annual reports). With varying amounts of distractions present in each venue, a resourceful type artist emphasizes different features of the typographic material to improve message delivery on a case-by-case basis. A display-type graphic on a web page or advertisement, for example, can get the reader's attention, before transitioning quickly into the text type where

readability is paramount—the same task a graphically enhanced versal performs as the gateway into a lengthy text block.

Visually competitive typographic environments challenge type artists to experiment with new techniques while trying to achieve the same goal from centuries past—successful communication of the message. With all the typographic options available within type families, there is an extensive, well-equipped type palette from which to select.

Figure 7-12: *Tlingit logotype*

GRAPHICS
AS
TYPE

Wʜᴇɴ ᴛʜᴇ ᴅᴇsɪɢɴ ᴄᴏᴍᴍᴜɴɪᴛʏ ᴇᴍʙʀᴀᴄᴇᴅ the use of phototypography in the 1960s, designers found new ways to express their ideas typographically. Phototypography went beyond the practice of integrating type and visuals as adjacent elements on the page. It also enabled a physical union of letterforms and graphics. Gone were the limitations of typeface, letterspacing, size, and type style that were ever-present with foundry and cast type. Gone too was the strict separation between typesetters and designers. Through the use of lenses, for example, type could be slanted to a designer-specified angle. By the manipulation of film and developing during typesetting, typesetters could superimpose one letter on another. With this technology, the purview of designer and typesetter began to overlap. Designers depended on typesetters to execute their graphic ideas within the walls of the type foundry.

Designers, such as Milton Glaser, Seymour Chwast, and Herbert Lubalin, to name only a few, embraced this technology and explored its capabilities. Their design work encouraged an explosion of type manipulation and a recognition that type was a graphic as well as a readable element. Illustrations served as letters within words or were interwoven into the letters as if they were three-dimensional, stand-alone elements. Letters and typefaces were created from anything—people, animals, and inanimate objects.

Such type treatment was not invisible. Its goal was twofold—readability and graphic expression, but not necessarily in that order.

Compromises between readability, legibility, and graphic communication were struck on a project-by-project basis. As illustrative or graphic elements, these typographic solutions fell into the category of typography for discontinuous reading. A highly manipulated word or two would not suffer diminished readability because the amount of text was small. The type's attention-getting capabilities far outweighed the effects of a change in word shape for such a limited use. This form of typographic exploration continued into the next generation of typesetting technology—digital typography.

With digital typography, the world of the designer and the typesetter merged. High-resolution output devices, professional-grade graphics programs, and new font technologies enable type artists to impose graphic effects on an existing letterform; create designer-specific weights, widths, and styles; and manipulate the fundamental structure of each letter. An experienced type artist with an eye for the subtle nuances of strokes, endings, and spaces can create exciting display-type graphics.

SPECIAL TYPE EFFECTS STRENGTHEN a word's impact and at the same time provide a graphic element to the page. Different techniques are possible with various computer-graphic applications. For example, Adobe Dimensions can take a letter's outline and create a three-dimensional letter. Other applications can place type on a curving, even freeform baseline, so a sentence wanders up and down on an invisible path. Some effects maintain the standard type controls, such as kerning, tracking, and word spacing. Others do not.

Adobe Dimensions requires converting the type to outlines before applying the three-dimensional effect. Converting type to editable paths or outlines means the letter or word is a graphic image shaped as a letterform. The type controls for kerning and such are no longer available. The special effects that require type conversion are the most complicated. Executing them requires drawing, design, and type skills.

Graphic applications offer many transformation techniques that artists apply to all graphic elements. By converting a type block to outlines (making it a graphic element), the type artist can apply these same transformation techniques to create interesting type effects. The following sections demonstrate some of the many special effects possible with type. As with all graphic effects, a light touch provides a focal point for a page; a heavy touch overwhelms, rather than dazzles, the reader.

SPECIAL TYPE EFFECTS

Setting type on a path

Arcing the word's bottom edge

Shaded emboss

Texture emboss

Arc. There are two ways to approach the arc effect—setting type on a path or arcing the bottom or top edges of a word or words. The first simply places a line of text on a shaped path. The type artist sets it on a circle or on a wavy line with text above and below. All standard type controls remain with text on a path.

The second approach requires converting the word to outlines and manipulating the structure of the letter to arc the bottom or top. In order for a bottom or top arc to succeed, the type artist must maintain the stroke width of the arced strokes. In some letters, the entire stroke curves; in others, it is just the bottom edge.

Embossing. Embossing is an easy technique to use. The type artist controls the fill of the type and its placement on the page to create the embossment illusion. There are two embossed effects—the shaded emboss and the texture emboss.

The *shaded emboss* uses two copies of the same type block. The copy on top (closest to the viewer) has an opaque white fill. The copy in back has a tint fill and defines some of the white type's edges. Neither type block has an outline. The depth of the emboss is determined by adjusting how much of the tinted type block shows on the edge of the white copy.

The *texture emboss* creates a textured surface and then embosses type in it. It requires three copies of the type block on top of an area of texture. This special effect makes a striking initial letter. First, the type artist creates a shaped area of texture. Coarse textures do not work well for this effect. This shaped area of texture functions as the background for the initial letter. Second, the type artist converts the letter to outlines and makes two additional copies. One letter receives a fill of the same texture as the shaped background. Another letter receives an opaque white fill, and the last letter receives a black fill. The type artist places the black letter on the textured background first. Third, the white letter is placed a few points to the left and up from the position of the black letter. Lastly, the textured letter is placed on top of the two, so some of the black letter shows to the bottom right of the textured letter and some of the white letter shows to the top left of the textured letter.

Shadowing. The shadowing effect includes two kinds of shadows— a drop shadow and a cast shadow. A *drop shadow* is a simple effect to achieve. The type maintains its integrity as a type block with all appropriate type controls. The type artist makes a copy of the type in solid black and positions the copy behind the original, but down and to the right of its original location. The type on top receives a different fill, or it

CHAPTER EIGHT

has an outline with an opaque white fill. The visual result makes the outlined type appear to be floating above the surface of the page. The greater the size of the black drop shadow, the greater distance above the page. (Variations in color and texture may be used also.)

Some typefaces come with a drop shadow. In those cases, the type appears three-dimensional. The shadow is achieved by seeing two sides of the letters. This effect occurs by converting the type block to paths and creating a three-dimensional letter. Adobe Dimensions can create this illusion from a letter converted to paths and extruded, with or without a beveled edge.

The *cast shadow* effect requires two copies of the text block. The first remains as a text block and the second is converted to outlines, filled with a gradient, and angled. The position of the angled shadow (in front of the word or behind the word) makes the word appear to be casting a shadow onto an imaginary surface.

Zooming. The zoom effect creates a three-dimensional type block that appears to be coming closer to the viewer and leaves a gradient trail in its wake, extending from its original position to its final position. A type artist creates this effect in a graphic application by creating a blend between a small version of the type block (converted to outlines) and a larger outline version of the type block. Some graphic applications prepackage the effect and essentially talk the artist through the zoom development; others provide the capabilities that the artist applies to the type's outline. In either case, an effective zoom is achieved by controlling the size and color of the two type blocks and the number of blend steps between them.

SPECIAL TYPE EFFECTS EMBELLISH the original appearance of an existing typeface letterform. Designing graphic letters involves creating a new, one-of-a-kind letterform for use with existing typeface letters. Type and graphic designers have used a host of items representing various objects, animals, vegetables, or minerals to create single letters or entire alphabets. Designing an alphabet from a ballet slipper or a fire hydrant is a challenge of the type designer's design, structure, and style skills. (See "Designing Graphic Alphabets" in chapter 9.) Designing a single letter for an unusual initial letter or to fit within a single word adds a graphic element to the headline and possibly eliminates the need for an illustration. If the letter is the only one of its kind, as is a graphic versal in text, for example, the type artist is free to design the letter according to any design structure appropriate for the subject matter. If

The word *FAIR* set in Rosewood, a true drop shadow typeface

Cast shadow effect on word set in Berthold City type

Drop shadow effect on word *SUPER* and zoom effect on *HERO*

DESIGNING GRAPHIC LETTERS

Adobe Dimensions' drop shadow

the letter appears within a word set in an existing typeface, the letter must adhere to the design style and structure of the typeface (fig. 8-1).

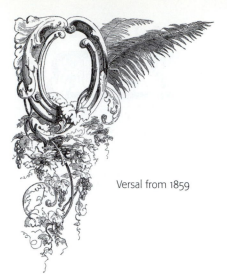

Versal from 1859

FIGURE 8-1: *The b-rabbits adhere to the Garamond style* (Source: Wheeler, *Pencils to Pixels*: *Exploring FreeHand Version 3.1.* 1993, William C. Brown Publishers. Reproduced with permission of The McGraw-Hill Companies)

As discussed in chapter 7, the use of versals in text is an age-old practice from before the time of Gutenberg. Designing letters from other objects is not new either. The versal *O* (see margin graphic) comes from the 1859 two-volume set the *Pictorial Field-Book of the Revolution* by Benson J. Lossing (Harper *&* Brothers, New York). This versal is a combination of leaves, grapevines, and feathers. All elements are intricately woven to make this unique letter a dramatic introduction to the first chapter of the second volume. All other chapters of both volumes start with more diminutive versals (fig. 8-2), some incorporating existing letterforms into an illustration, such as a letter displayed on a building, and others created from existing objects, such as the letters *T* and *S* made from malleable tree stumps and branches. Objects from nature are particularly good images for these letters because of their flexibility. As the type artist becomes more familiar with designing letterforms, it is easier to see how virtually anything can be redesigned to make a convincing, legible letterform. The bicycle *S* versal is appropriate for an

Bicycle versal for letter *S* follows subject-matter design structure

Oak leaf letter *A* versal

FIGURE 8-2: *Versals from 1859 pictorial field-book*

CHAPTER EIGHT

article on summer cycling, and the stylized oak *A* versal is suitable for an article on the environmental contributions of oak trees.

Use of graphic letters is not restricted to text. Incorporating this form of design into display type, either as first-letter designs or interior-letter designs, can produce a one-of-a-kind graphic that replaces the need for an illustration. In both cases the design style of the letter should adhere to the design style of the typeface. The first priority of such a graphic is readability, but its second goal is graphic. Designing these display-type graphics is a balancing act between the needs of the letterform and the needs of the graphic. It is an exciting challenge, and the rewards are unique and eye-catching design solutions.

The Humpty Dumpty graphic (fig. 8-3) uses eggshell versals for the *H* and *D*. Together, they form a single, cracked egg, with each half contributing a letter. The typeface Florentine Light is a graceful, delicate typeface with appropriately egg-shaped elliptical bowls and curves.

During the design process, only the letters *H* and *D* were altered; the rest of the letters were letterspaced properly and aligned vertically. (The *p* emphasized vertical movement down to the second word by aligning with the stem of the *m*.) Originally the curved stroke of the altered *D* joined its stem on the perpendicular. This produced a harsh join that was out of style for the typeface. By magnifying an unaltered letter, the *p*, it was easy to duplicate the same join and maintain an important style characteristic. The legibility/graphic compromise required for this design problem focused on the question of how much the *D* could tilt and also how close to position the *H* and *D* to form the total egg-graphic.

Humpty
Dumpty

Original Florentine Light typeface

Maintain all typeface characteristics for a convincing graphic letter

Humpty Dumpty

FIGURE 8-3: *Humpty Dumpty graphic with eggshell versals*

Tempest in a Teapot

FIGURE 8-4: *Tempest in a Teapot versals create graphic*

Original Charme *T* (left) and resulting tempest *T* (right)

Original Lydian Cursive *T* (left) and resulting teapot *T* (right)

The Tempest in a Teapot graphic (fig. 8-4) is another example of two versals forming a single image while maintaining their role as the first letter of two different words. The Charme typeface (designed by Helmut Matheis in 1958) projects a fluid, informal style perfect for this design. Selecting the right typeface is the single most important part of this unique design technique. A typeface design style that evokes the correct graphic-related images makes the designer's job much easier and the end result more convincing.

This graphic used two different *T* structures to form the single teapot with tumultuous steam. Knowledge of the letter *T*'s structural variations among myriad typefaces made this possible. The tempest *T* was an altered version of the original Charme uppercase *T.* Similar in style to a traditional lowercase *t,* the informal typeface design style was altered easily to be more steam- and tempestlike. The teapot, based on the *T* from the Lydian Cursive typeface, was revised and re-created in the Charme style. The entire display-type graphic was originally planned for the Lydian Cursive typeface. Lydian was more condensed and formal, and the swirling tempest was difficult to achieve.

The Garbage graphic (fig. 8-5) is an example of an initial versal designed to further the meaning of the word while drawing attention to its beginning. It is also an example of the design problems that arise when the mix of letters does not blend smoothly. The original typeface Eccentric is a condensed typeface with proportions similar to a metal outdoor garbage can—tall, thin, and rectangular. Eccentric has a high bar and middle arm placement throughout the alphabet that emphasizes its tall, thin appearance. In the word *GARBAGE,* however, the *G*'s

horizontal serif placement contrasts with that of its neighboring letters and causes a dip in the visual flow through the word. The design of the versal and an adjustment to the final *G* eliminates this problem.

FIGURE 8-5: *Garbage graphic in Eccentric typeface*

Several Eccentric letters *H, T,* and *E* contributed letter parts to the garbage-can versal. These letter parts served as the major structural components of the can. Joining the serifs at the foot of the *H* and widening the crossbar of the *T* finalized the versal. Using sections of preexisting letters saved the type artist a significant amount of time by keeping stroke weights and ending treatments consistent. Redrawing would open the door for error. After positioning the versal, the vertical stroke of the second *G* was elongated to align with the middle arm of the *E*.

FIGURE 8-6: *Garbage graphic first iteration*

Review of the first design iteration (fig. 8-6) pointed out several design weaknesses. The horizontal strokes in the middle of the letters (bars, arms, serifs, and can handle) did not align. In the design/typeface comparison graphic (fig. 8-7), the differences in stroke location were apparent. The middle strokes of the *R* and *B* shared a common location,

GARBAGE

Original Eccentric typeface

First garbage can (left) created from altered black letter parts (right)

FIGURE 8-7: *Design/typeface (outline) comparison*

Agincourt typeface (upper) and
Fette Fraktur typeface (lower)
comparison

with the bars of the *A* higher and the middle arm of the *E* and the gar-
bage can handle lower. This bouncing of adjacent strokes was noticeable
at display size and was distracting in a graphic context. Adjustments
brought all horizontal strokes and endings into common alignment
with the *R* and *B*. The redesign of the original versal (fig. 8-5) by angling
the lid and elevating the handle solved the handle-alignment problem
and increased the versal's attention-getting ability. The angled lid re-
peated the angles in the head serif of the *E* and second *G*, thus unifying
the two ends of the word and strengthening the design.

Subtle letter-structure adjustments are common and necessary
when designing display-type graphics. A legible typeset headline, on the
other hand, requires only correct line breaks and letterspacing to com-
municate its message. It is the graphic component of a display-type
graphic that changes the type artist's mode of working. This graphic
form is a design element subject to the rules and principles of good
visual design. The unique mix of letters (highlighting structural differ-
ences), the larger point size (making discrepancies more visible), and
the word's graphic purpose all make these design adjustments critical
for the overall strength and effectiveness of the graphic.

FIGURE 8-8: *Lion, Witch, and Wardrobe graphic*

Preliminary lion-versal evolution
(left to right)

The Lion, the Witch, and the Wardrobe graphic (fig. 8-8) is a com-
plex initial-letter title for the classic children's book by C. S. Lewis—the
first book in the *Chronicles of Narnia*. Both the words *Lion* and *WARD-
ROBE* use a single versal as a graphic component. The remaining letters
of each word are letterspaced, but unaltered. The word *Witch* is a logo-

Final lion display-type graphic

type (see chapter 9) where all letters, except the *c,* are altered to make a single typographic unit.

The word *Lion* started out in the typeface Fette Fraktur, a high-contrast, period typeface. The black letter style was appropriate for the old kingdom, knights, and castle images associated with Narnia's lion-king, Aslan. As the lion-head versal evolved, the lion's mane continued to be unsatisfactory even after the challenges of his face were resolved. After perusing all the black letter options, the typeface Agincourt stood out as the answer. Agincourt was similar to Fette Fraktur, but its upper-case letters were more ornate, reminiscent of the hand-held banners knights carried into battle. The lion-head versal was revised easily to the Agincourt design style, resulting in vast improvements. Fette Fraktur's simplified face was replaced by a more curved, detailed style that projected the pageantry of the time period and created more interesting facial features. The notched stem of the original Agincourt *L* served as a billowing mane with a windswept piece over the eyes. Once the correct typeface was found, the design quickly came together. The importance of the right typeface for these designs cannot be overstated.

The word *Witch* started out as a single witch-hat versal. The typeface Eckmann Script evoked the right rumpled look for the witch's hat, but also provided pointed descenders that suggested the long witchlike robe, nose, and fingers. It was those qualities that catapulted this simple graphic into a more complicated logotype with alterations to every letter except the *c.* In the original typeset word *Witch,* the letters all remained on the baseline. As the design progressed, the dot of the *i* was replaced by the diamond-shaped period, the *t* was extended below the baseline by adding the *j*'s descender, and the vertical strokes of the *h* were extended by adding the stem of the lowercase *p* at different lengths to each stroke. Finally, the crossbar of the *t* was extended on the right side to make a better visual connection to the top of the *c.* (See design steps in margin.)

The word *WARDROBE* was an idea that came together quickly with the typeface ITC American Typewriter Condensed. The coat-hanger versal was created from several letters including the question mark. Once completed, the difficult part was matching the stroke weights. The versal used the regular weight, but the weight difference was noticeable either with the regular or light for the rest of the letters. Finally, a thin white stroke was placed around all the regular-weight letters, except the versal, thinning them to the versal's stroke weight. The serifs on the *A* and *R* were joined after that because the white stroke was

ACFGLWbejp

Eckmann Script typeface sample

Witch

Witch

Witch

Witch

Design evolution from original typeface (top to bottom)

Final witch logotype

Coat-hanger versal (center) created from solid black letter parts

WARDROBE

Final wardrobe display-type graphic

visible when the two serifs overlapped. With resizing, placement, and the addition of Univers words, the Lion, the Witch, and the Wardrobe graphic was complete (fig. 8-8).

FOR TYPE ARTISTS WHO ENJOY the challenge of designing graphic letters, the ampersand is an amendable letter to alter and redesign. The ampersand assumes a variety of shapes and structures, from its more evident *e-t* origins to those not as apparent. These variations offer a type artist a satisfying array of structures that accommodate most ideas. As an abbreviation, the ampersand's role is an important one, as well as its design link to the words it joins. Designing the ampersand in a stand-alone illustration style (fig. 8-11) will disrupt readability by causing confusion or misinterpretation of the message; maintaining the stylistic link to the surrounding typeface eliminates that problem by preserving the visual unity with the words on either side (fig. 8-10).

The Guarneri *&* Sons graphic (fig. 8-9) creates a content-specific ampersand graphic that links the members of the seventeenth-century Italian violin-making family. Andrea Guarneri of Cremona, Italy, started the family business in the mid–seventeenth century. Violin production continued with his two sons and other family members. Andrea's nephew, Giuseppe, became the most noted of the family for his pursuit of tonal quality over form.

This display-type graphic uses the typeface Florentine Light. Its elongated, vertical proportions, strong contrast between stroke weights, and vertical stress placement relate visually to the graceful elegance of a violin's shape. The original typeface shows a figure-8 ampersand—not at all violinlike in structure. This ampersand does not emphasize the tall *x*-height that was important to its selection. With all the variations of ampersands that are in the public consciousness, it is easy to substitute a more suitable structure without diminishing recognition.

Ampersand sampler

FIGURE 8-9: *Guarneri & Sons ampersand graphic*

When designing any letterform to be both a graphic and a typeface character, the type artist seeks to strike a compromise between the two visuals. The violin, for example, cannot be a direct replica of a Guarneri original, or it will not read as an ampersand. Conversely, if the ampersand is too faithful to its master design, it will not look like a stringed instrument. The challenge to the type artist is to determine which ampersand and violin features are essential and which are not.

Once the correct compromise is reached, the final graphic is rendered in the style of the typeface. Maintaining this style visually links the violin ampersand to the adjacent words, so the text reads as a unified thought, not two words separated by an illustration. Rendering a typeface style accurately requires an eye for subtle detail. Type designers are to be respected for their accuracy of style in letterform after letterform. (Two hundred and fifty-six characters might seem insufficient for a type-hungry type artist, but for their designer it must be more than enough.) The recommended approach for constructing this unique graphic letter is recycling existing strokes and endings from other letters in the type font. The uniform size maintains stroke consistency. The violin ampersand is constructed from the Florentine Light capital *C* and the lowercase letters *s, l,* and *t.* The end result shows its *e-t* roots clearly.

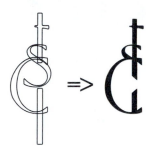

Guarneri & Sons
Original Florentine Light typeface

Violin-ampersand construction
diagram

FIGURE 8-10: *Tea & Crumpets ampersand graphic*

The Tea *&* Crumpets graphic (fig. 8-10) is another example of an ampersand graphic created in a specific typeface design style. The design route for type graphics varies—in some instances the typeface triggers an idea, and in other cases the opposite is true. The original ampersand for this typeface, Binner, is an easily identified *e-t* combination with tightly curled stroke endings. Within the context of the entire typeface, the curled ampersand blends with other similarly designed letters. Within the context of Tea *&* Crumpets, the curled ampersand is too visually distinct to blend with the other letters and is not reminiscent of a teapot.

Tea *&* Crumpets was an idea in search of a typeface. The teapot was designed originally as an isolated graphic. When incorporated into the display-type graphic (fig. 8-11), the teapot needed redesigning to

Original Binner ampersand

TEA & CRUMPETS

FIGURE 8-11: *Graphic with original doodle ampersand*

match Binner's design style, whose high contrasting stroke weights were similar, but not identical, to the teapot's. The teapot ampersand was a combination of same-point-size letter parts from the *S, E,* and the *P.* The steam was the bar from the *H,* narrowed and rotated.

When creating a graphic letter with a beautifully curved typeface, such as Binner, curved sections are redrawn to join letter sections or endings taken from existing letters. These require multiple proofs to check the curve's smoothness, as well as structural modifications to strike the right compromise between teapot, typeface style, and ampersand. Any glitch in the bézier outline weakens line quality and diminishes the display-type graphic's overall effectiveness. A typeface with rough edges, such as Berliner Grotesk, is more forgiving.

Evolution of a teapot ampersand
(top to bottom)

Hansel
& Gretel

FIGURE 8-12: *Hansel & Gretel with gingerbread ampersand*

The Hansel & Gretel graphic (fig. 8-12) uses both a graphic versal and a graphic ampersand. Selecting the typeface Berliner Grotesk set the correct informal, edible tone. Its rounded stroke endings and uneven, rough edges are suited to a gingerbread visual. The graphic versal, the letter *H,* has to read easily with the rest of the word, while simultaneously suggesting the gingerbread house.

The house was achieved by converting the bar of the *H* to a caret-shape, indicating the peaked roof, and by elongating the *H*'s right stem, indicating a subtle chimney. These changes introduced just the right amount of graphic without compromising legibility. A wider *H*-house

Hansel
& Gretel

Original Berliner Grotesk typeface

was tried, but Berliner Grotesk's condensed proportions made that unsuccessful.

As with Binner's ampersand, the original Berliner Grotesk ampersand did not provide a suitable structure for a gingerbread-cookie shape. A straighter, more masculine ampersand was tried, but the ampersand needed curved bottom strokes to relate to the curved top stroke, as well as the curved letters in the names. In the final iteration (fig. 8-12), the alignment was changed so the reader saw the word *Hansel* and the *H*-house before being led to the gingerbread ampersand and the second name. Due to the uniqueness of the ampersand, it was necessary to tuck it under *Hansel* to assure proper reading order.

Wider *H*-house and straight-legged ampersand design iteration

FIGURE 8-13: *Salt & Pepper with pepper-mill ampersand*

The Salt *&* Pepper graphic (fig. 8-13) is another example of both a graphic versal and ampersand. The latter is more pronounced, but the versal is a design of subtleties. The original typeface Eccentric (designed by Gustav F. Schroeder in 1881) is a cap-only, elongated, monoline, bracketed slab serif typeface. It has a high-waisted or long-legged quality achieved by locating the bars of the *A, H,* and the middle arm of the *E* in the upper third of the letter. This design characteristic is ideal for the pepper mill and salt shaker graphics. The typeface's original ampersand is a unique, signature character, exceeding the starkness of the Eccentric face, but giving a mark of distinction that would add pizzazz to a display type block.

SALT & PEPPER

Original Eccentric typeface

Original graphic design solution

Preliminary salt shaker designs

Salt & Pepper was a graphic that required several iterations before its final form emerged. The original solution, which closely followed the layout, deleted all the typeface's line endings from the two graphics. The starkness of these two graphic letterforms made them unable to blend with the rest of the letters. By using the arm of the *L* and adding the top half of a period (.), the revised crank for the pepper-mill ampersand blended smoothly into the typeface. The salt-shaker versal took many wrong turns while exploring various options for success. The final salt shaker kept the proportions consistent for a letter of its increased size, while maintaining the stroke weight of the smaller letters. This assured even color within the word *SALT*. A long bracketed serif was added to the end of the spine and an altered short serif was added to the top of the spine. Both line endings successfully linked the shaker to the rest of the letters through consistent design treatment. The sans serif shaker could not achieve this.

The Cream & Sugar graphic (fig. 8-14) uses a graphic versal on each word along with a graphic ampersand. The original typeface Tango has a figure-8–style ampersand that triggered the idea for a spoon. With the pitcher as the capital *C* and the sugar bowl for the capital *S*, a stirring spoon was the logical subject for the ampersand.

FIGURE 8-14: *Graphic with stirring-spoon ampersand*

The pitcher versal was a study in evolutionary subtlety. Through trial-and-error with dips, points, and angles, the pitcher's spout finally emerged. In the end, several sections from unsuccessful iterations were combined to produce the final, successful pitcher versal. The original pitcher had a pointed spout that never suggested a cream pitcher. The angled spout used in the final solution required a slight reshaping of the pitcher's body. The reshaping blended the right amount of curve with

Original Tango typeface

the right amount of blockiness. The original swash of the *C* served as the pitcher's handle.

The original sugar bowl incorporated the bottom swashed bowl of the *B* as the sugar container and the mirrored loop from the capital *G* for the lid. A shortened hyphen created the handle. The result was a segmented sugar bowl that did not blend as smoothly as expected. Two revisions solved the problem. First, the handle was attached to the lid by using the top vertical stroke from Tango's dollar sign. This eliminated the overly segmented appearance that is not characteristic of Tango. Second, the center horizontal stroke was "dipped" slightly, as it is across the top of swashed capitals. This eliminated the starkness of the precise horizontal midstroke of the original design and added a softer, informal quality to the stroke—a characteristic of Tango.

The stirring-spoon ampersand incorporates a spoon with an E-shaped stirring-swirl to create a convincing ampersand in the Tango style. When viewed separately, readers might not see the ampersand immediately, but within the context of a display-type graphic, readers receive clues that lead them to the correct visual association. The spoon's design starts with the leg of the original ampersand and then springboards into the realm of original creation. Using the Tango style as a recipe for line endings, counters, and strokes, the unique stirring-spoon ampersand is convincing.

Original Cream & Sugar graphic with pointed-spout pitcher and segmented sugar bowl

Slight dipping of horizontal strokes is characteristic of Tango

FIGURE 8-15: *Owl & Pussycat graphic with cat ampersand*

The Owl *&* the Pussycat graphic (fig. 8-15) evolves from the unique ampersand of the Oz Handicraft typeface (based on lettering by Oswald Cooper), which suggests the back view of a sitting feline. The original

The Owl &
The Pussycat

Original Oz Handicraft typeface

Ampersand construction diagram

Ampersand evolution from original
to final (left to right)

typeface is a vertically proportioned, lettering-style typeface with low contrast between stroke weights and rounded stroke endings.

After changing the letter case and size for the words and repositioning them, the alterations began. The sitting-feline image was integrated into the ampersand successfully by using pieces from a capital *S* to extend the cat's tail. The cat's ear came from the curved stroke of the capital *J*, much like an ear on a lowercase *g*. Originally, a comma was used for the ear but the thinning of the stroke at the ear's base appeared stylistically incorrect. (See margin graphic.)

The second *the* was placed on a path to follow the *P*'s shoulder. The bottom and middle arms of the *E* were curved to blend better with the graphic. In the word *Pussycat*, the baseline of the second lowercase *s* was dropped to form a downward diagonal along the bottom edge of the *s-s-y* letter sequence. The original letters *c* and *a* curved into the *x*-height area, forming an enclosed unit. By splicing the bottom of the lowercase *s* to the *c* and the top of the lowercase *s* to the top of the *a,* the angles of the *s* were visually linked back to the rest of the word, thereby unlocking the *c-a* unit present in the original typesetting.

From fairly simple beginnings, this entire design evolves into a medley of letter placement and letter structure alterations for a tightly designed display-type graphic. These alterations employ techniques used in chapter 7 and introduce techniques to be discussed thoroughly in chapter 9. The Owl & the Pussycat graphic is complete at this point, but two variations are possible.

FIGURE 8-16: *First variation of Owl & Pussycat graphic*

In the first variation (fig. 8-16), the descender of the lowercase *y* replaced the terminal of the lowercase *t.* By itself, this change worked well within the word *Pussycat,* but weakened the entire graphic by drawing too much attention to the word. Extending the left arm of the lowercase *w* in *Owl* balanced this last alteration and unified the graphic. The second variation (fig. 8-17) added the words *went to Sea* to the end of

the original graphic. The words *went* and *to* were stacked vertically aligning the lowercase *t* in each word. The stem of each *t* was elongated to suggest a ship's mast. The letter *a* in *Sea* was repeated from *Pussycat* to visually link this new section to the original. The lower half of the spine of the *S* was embellished by adding the lower curved section of the original ampersand and by finishing the stroke with the ending from the original *S.* This made a type graphic for the first line of Edward Lear's famous nursery rhyme *The Owl and the Pussycat.*

ℰℐ

DESIGNING LETTERS FOR USE AS versals, ampersands, or others, requires the type artist to be very familiar with three design components: (1) the different letter structures available for each letterform, (2) the design characteristics of typefaces, and (3) the thousands of available typefaces. Knowledge of alternate letter structure opens up more design options when fusing letters with graphics. Maintaining typeface design characteristics enables the new graphic letter to function successfully within the typeface. The right typeface propels a design much faster along its evolutionary design path.

Digital typography gives the type artist access to the structural bézier points for altering letterforms and creating new graphic letters. It calls on all of the type artist's understanding of typeface legibility and typesetting readability as well as design and illustration skills. It is a unique area of design that, although technologically possible, has not been fully explored. The 1960s has more examples of this kind of design, and the type designs of that decade are a source of inspiration for the type artist new to this design technique. This is an exciting area of design that is both challenging and satisfying when executed successfully. Something every type artist should try.

FIGURE 8-17: *Second variation of Owl & Pussycat graphic*

TYPOGRAPHS
AS
TYPOGRAPHIC ART

Through typographic means, the designer now presents, in one image, both the message and the pictorial idea ... the excitement created by a novel image sometimes more than compensates for the slight difficulty in readability.

—Lubalin
Type Directors' Club speech

Tʜᴇ ʀᴜʟᴇs ᴏf ᴛʏᴘᴏɢʀᴀᴘʜʏ have a single intent—beautiful typography with enhanced readability. In this context, the word *beautiful* connotes a freedom and a creative spark that enlivens a page. The words *enhanced readability* refer to the uniformity and order that enable the reader's eye to move effortlessly along the text lines. Grace, power, elegance, and whimsy are all possible with type. Typographic rules are the underpinning of this creativity. They are the unifying backdrop on which the type appears. Yet, most rules of type usage pertain to continuous text; discontinuous text offers the type artist the freedom to try new things and to push the limits of type.

It is erroneous to conclude that the sheer number of type rules leaves no room for creativity. Such a statement ignores the works of innovative typographers, such as Oswald Cooper (1879–1940) and Herb Lubalin (1918–81), as well as examples of art nouveau and art deco typography. Each of these demonstrates the limitless possibilities for designing with type.

Oswald Cooper was a designer, typographer, lettering genius, and a student of Frederic Goudy. Cooper's hand-lettered advertisements, announcements, and posters display his gift for using lettering as the major component of design. His lettering ability became the focal point of his Chicago advertising and typography firm, Bertsch & Cooper. Cooper's ads for the Packard Motor Car Company (Haley 1992), for example, show how his lettering style established a mood and projected

an elegance associated with this product. (The American Type Founders later developed this lettering into the Packard typeface.) Oswald Cooper also designed the Cooper typefaces from a lettering style he created, starting with Cooper in 1918 and followed by the immensely popular Cooper Black in 1925. Several variations followed, including Cooper Black HiLite, Condensed, and Italic (Eason 1991; Haley 1992).

Herb Lubalin started as a designer in 1939 after graduating from the Cooper Union School of Art and Architecture in New York. By the end of his career he had won hundreds of professional awards, including the prestigious American Institute of Graphic Arts (AIGA) Medal (Muller 1981, 5), and he had designed three typefaces—Avant Garde Gothic (1970), Lubalin Graph (1974), and Serif Gothic (1974). His love for typography inspired many designers to take another look at the alphabet's 26 letters. Lubalin took type from the confines of text and headlines and used it to express ideas graphically, as typographic designs or typographs. By merging graphic design and typography, Lubalin demonstrated that in addition to being read, type could represent the meaning of those same words. It could imply a nuance that the reader might not discern from the words alone.

It is not essential to be a master typographer on the scale of Oswald Cooper or Herb Lubalin to add typographic design elements to a page. Additions can start on a small scale, as discussed in chapter 7, with the headline. Design elements can expand to include headline-compatible elements within the text, such as initial letters and pull quotes. Typographic special effects, such as three-dimensional type, text on a path, and graphic letters are next, as discussed in chapter 8. Finally, typographic design can go all out with the restructuring of type to form typographs, logotypes, and graphic alphabets.

The mantra of typographic design is still consistency. For display type, it is consistency of style. Placing multiple conflicting typefaces on a page creates chaos, not beautiful design. Type artists undertaking typographic design for the first time have a tendency to overdo—too many typefaces, too many styles, and too many points (too large). Having a small number of typefaces from which to choose is not always a hardship; it can be a blessing. It forces the type artist to uncover the always-present design possibilities inherent in all type. The possibilities are there, only often overlooked when more flashy faces are available.

A similar problem occurs with ice cream. When faced with a vast array of brightly colored, scrumptious-sounding ice cream flavors, the salivating consumer often overlooks vanilla and chocolate. Chocolate

ABCDEFGHIJKLM
NOPQRSTUVWXYZ
abcdefghijklmno
pqrstuvwxyz1234
Avant Garde Demi

ABCDEFGHIJKLM
NOPQRSTUVWXY
Zabcdefghijklmno
pqrstuvwxyz1234
Lubalin Graph Bold

ABCDEFGHIJK
LMNOPQRSTU
VWXYZabcdefg
hijklmnopqrst
uvwxyz1234
Cooper Black

ABCDEFGHIJKL
MNOPQRSTUV
WXYZabcdefghi
jklmnopqrstuvw
xyz1234
Cooper Black Italic

connoisseurs, however, argue that there is chocolate and then there is *Chocolate!* Just because a type artist does not have multiple folios of fonts with the expert collections to match does not mean that a tasteful, well-designed document is not possible. A basic typeface with limited style options provides a design safety net for the type artist just entering the typographic design sweetshop.

TYPOGRAPHS

THE WORD *TYPOGRAPH* REFERS to the art of designing a graphic using and manipulating typeset letters and words. It requires a thorough understanding of a typeface's design style and structure. A logotype is an example of a typograph. A *logotype* is a single word or words designed to be a cohesive whole in the style of a typeface. It goes beyond being a collection of typeset words, such as a pull quote, subhead, or headline. It becomes an intricate interlocking design achieved by connecting, aligning, and adjusting strokes, serifs, angles, and endings.

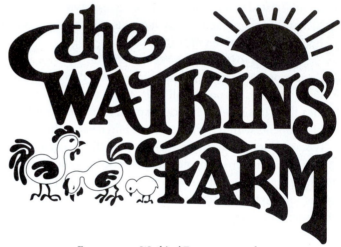

FIGURE 9-1: *Watkins' Farm typograph*

Typographs focus on only those letters involved in the designed unit. The type artist strengthens the design bond between those letters by adjusting the letters' structure according to the principles of design, which include unity, balance, focal point, positive/negative shapes, rhythm, and proportion. Typographs do not abandon the typographic design principles that apply to alphabets and typefaces, but rather they hone them. When incorporated effectively, these underlying principles make the end result appear as a natural union of letters (fig. 9-1). This is

the application of typography that is the most fun; it is also the most challenging. The subtleties that make a typograph successful and the nuances that control the reader's eye movements through the typograph appear to require the precise touch of a surgeon and the knowledge of a master typographer.

The result of this work is not unlike watching an athletic performance. A flawless performance by a professional figure skater, for example, appears effortless as the athlete weaves intricate movements in and around a carefully chosen musical accompaniment. Gone from view are the times spent sitting on the ice when the intricacies got the better of the athlete's ability to bend and twist. The outward simplicity of a well-designed typograph belies the stacks of tracing paper layouts littering the floor and the countless false starts and U-turns from dead-end design paths. The end result is fun and beautiful to view, but its development was far from happenstance or luck.

Latté typograph

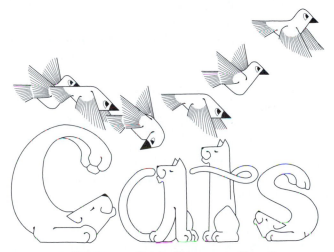

FIGURE 9-2: *Original letters united by style*

DESIGNING A GRAPHIC WORD OR A LOGOTYPE (a designed word-unit functioning as a graphic identity for a product, company, or service) challenges the type artist to visually unify multiple letters as a readable graphic unit. Letters in a single graphic word either adopt a similar style that identifies them as a typeface (fig. 9-2) or are united by subject matter (fig. 9-3) and/or illustration style. In all cases, the more stylistic, structural, and color similarities shared by the letters, the easier the word is to read.

DESIGNING
GRAPHIC WORDS
AND LOGOTYPES

FIGURE 9-3: *Original letters united by subject matter* (Source: Wheeler, *Pencils to Pixels: Exploring FreeHand Version 3.1*, 1993, William C. Brown Publishers. Reproduced with permission of The McGraw-Hill Companies)

Original letters united by illustration style

(Source: Wheeler, *Pencils to Pixels: Exploring FreeHand Version 3.1*, 1993, William C. Brown Publishers. Reproduced with permission of The McGraw-Hill Companies)

Graphic word integrating text with illustration

Designing a word from original letterforms is comparable to designing a limited-letter alphabet. The graphic word *Over,* designed for the unpublished children's picture book *If Cats* by S. G. Wheeler, serves both as part of the text and as part of the illustration (fig. 9-4). The design of the word is both readable and illustrative—it serves as a clump of trees. Its style, structure, and color are similar throughout the four letters. This consistency strengthens readability, and the use of familiar letter structure strengthens legibility.

The graphic word *Under,* designed for the same picture book, also serves as part of the text and illustration (fig. 9-5). The letter shapes are not as traditional, but for such a limited use and within the context of a continuing story, readability is not diminished significantly. What it adds to the story, and to the fun that the reader has, far outweighs any departure from convention.

A logotype differs from a graphic word because the logotype is a single, intertwined designed unit rather than individual graphic letters.

If cats were like birds, they'd fly the trees.

FIGURE 9-4: *Graphic word in children's picture book spread*

FIGURE 9-5: *Graphic word in children's picture book spread*

These categories are not rigid; consequently overlap occurs, but for this discussion, a distinction is made. When designing a simple logotype, the type artist can start with an existing typeface and add a graphic element that functions as a single letter within the unit. Many logotypes use actual identifiable graphics; many do not. Some *suggest* an image or style and let the viewer's imagination provide the graphic association; the logotype is just the trigger. Through the use of organized curves, for example, the type artist can suggest rolling water, a waterfall, or a riverboat, without ever showing the actual object. Other logotypes are well-designed, nonobjective words that project an appropriate mood, style, or time period suitable for the subject.

Graphic word uniting text and graphic

Graphic element as letter within simple logotype

ESPRESSO

FIGURE 9-6: *Espresso Pot logotype*

The Espresso Pot logotype (fig. 9-6), an example of a simple logotype, had the first two letters of the word restructured to suggest the espresso pot. Originally this idea was a quick sketch in a sketchbook without reference to a particular typeface. Once the idea was ready for finished art, the angled typeface Harvey (designed by Dale Kramer in 1989) was the natural choice for this espresso pot. A major design goal was to unify the angles in the spout of the *S*, the unaltered *P* and *R*, the elongated *Ss*, and the restructured *O*. The *O* was constructed from an

ESPRESSO

Original Harvey typeface

Construction of letter *O* from combined letters *R* and *C*

Original Espresso Pot logotype scan

STIRRUP

Original ɪᴛᴄ Benguiat Gothic typeface

Original Stirrup logotype scan

upside-down *R* and *C*. The original letter *O* lacked the angles included in the word's other letters. Its uniqueness made it a soloist rather than a member of the group. All letter alterations supported and balanced the graphic, so the entire logotype functioned as a single designed unit.

FIGURE 9-7: *Logotype comparison with typeface* (outline)

With the right typeface, a logotype's execution goes smoothly. The type designer should remain open, however, to any design alterations the actual typeface suggests, as with the selection of Harvey. Without the right type, executing the logotype is tantamount to teaching a dinosaur to sing—it is not going to happen.

FIGURE 9-8: *Stirrup logotype*

The Stirrup logotype (fig. 9-8) repeats two letters in the center as the graphic element and angles the surrounding letters to support and balance it. The original typeface ɪᴛᴄ Benguiat Gothic (designed by Ephram "Ed" Benguiat in 1979) has a unique capital *R* with an arced tail that suggests the curve of the stirrup iron beautifully. Shortening the *R*'s stem, extending its tail, and adding the horizontal bar creates the stirrup's right half. The flipped image creates the stirrup's left half and completes the graphic element.

Angling the letters on either side of the graphic required letter restructuring and optical balancing. The letter *S* was restructured to repeat the elongated look of the graphic. It was created by combining the top of the *S* with a horizontally flipped capital *C*. Shortening and

lengthening the stems of the *T, I,* and *P* completed the mirrored arc on either side of the graphic. Letterspacing was critical, since three letters balanced two. This logotype was not as effective without the correct *R* to suggest the stirrup iron. The original layout was very similar to the completed logotype, but selecting the right typeface added the correct style to the final work.

The Aviary logotype (fig. 9-9) and the Coffee logotype (fig. 9-10) increase in complexity by expanding the number of restructured type-face letters. At this point, many type artists question the need to work from an original typeface. They reason that with such extensive letter restructuring, why not create the entire thing from scratch? The consistency of detail in a well-drawn typeface results from time, skill, and experience—from the consistent bracket on every serif to the identical arc of multiple curves. Such consistency is impossible for many type artists to achieve due to time constraints and inexperience. It is much more efficient to relocate an existing swash from one letter to another than it is to redraw that beautifully balanced stroke accurately. The Aviary logotype uses many swashes and arced strokes to suggest feathers. These are all found in the original typeface Poetica. Poetica is a swash-lovers delight with its vast supply of alternate characters. For this logotype, swashes are relocated, crossbars commandeered, and stems redistributed for use in the six restructured letters.

FIGURE 9-9: *Aviary logotype in Poetica*

The Coffee logotype (fig. 9-10) suggests graphics throughout the word, from the coffeepot in the *C, O,* and *F* to the coffee mug in the two *E*s. The first priority of this design is to produce a readable, designed unit; the second is to suggest graphics that only continued perusal will reveal. This design, which took many wrong turns, proves the you-get-what-you-pay-for adage regarding inexpensive typefaces.

Restructured *S* created from *S* and flipped *C*

Aviary

Original Poetica typeface

Original Coffee logotype scan

Original Avenida typeface

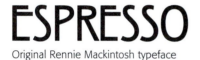

Original Rennie Mackintosh typeface

Original Espresso logotype scan

This design used a version of Plaza from an inexpensive typeface collection for the layout. During the design process it became apparent that the width of the letter strokes was not consistent. This was a problem easily solved by buying the correct typeface from the International Typeface Corporation for the finished art. The inexpensive typeface collection provided the typeface for layout purposes only. Once the finished art was needed, it was time to buy the high-quality version. The amount of time saved using quality type made it money well spent, and it rewarded the type designer for a job well done. In this case, Plaza (designed by Alan Meeks in 1975) turned out to be too thin for this design, and a perusal of ITC's collection uncovered Avenida (designed by John Chippindale in 1994), which was very similar in structure but heavier in weight. The quality of Avenida was excellent—important even when the finished work only displays four different letters. Several other letters were incorporated into the restructuring of the *C, O,* and *E.*

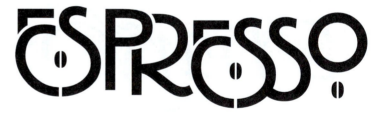

FIGURE 9-11: *Espresso Bean logotype*

The Espresso Bean logotype (fig. 9-11) is a nonobjective series of letters that project a subject-appropriate mood and style using a few coffee-bean graphics for accent. This logotype, executed in ITC Rennie Mackintosh (designed by Phill Grimshaw in 1996), is an uppercase-only typeface with alternative caps in place of the lowercase. Mackintosh is

CHAPTER NINE

based on the handwriting of Charles Rennie Mackintosh, a Scottish architect and designer.

The Espresso Bean logotype started out as an idea without a typeface. The first *E* and *S* shared some strokes, but they read as separate letters. The last two *S*s intertwined to form the bottom of a graceful cascade of extended letters. In the production of the design, the crossover of spines never intertwined smoothly as they did in the layout. This snag started an interesting design evolution that demonstrated the merits of another author-embraced design adage: When stuck, repeat something already present in the design.

The *E-S* combination became the centerpiece of the design. It was constructed from the top arm of the *E,* the top of an alternate *G,* and the bottom of the third alternate *S.* The overlapped *P* and *R* are alternate characters with the right stroke placement and swashes to help lead the viewer's eye to the repeated *E-S* combination. The final *S* is the second alternate *S* that tucks nicely back into the *ES.* The letter *O* is actually the figure *0* (zero). The original letter *O* was too small, the alternate was oblong, and the zero was just right. With its shorter stature, the zero continues the roller-coaster flow through the word. The three coffee beans were created from an alternate *O.* Here the oblong shape is ideal and the white stroke relates to the white breaks in the *E-S* combination.

Creating new letters from original letter parts

Letter *O* (left, center) and zero (right)

Four letter *S* alternates

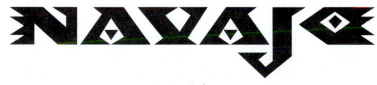

FIGURE 9-12: *Navajo logotype*

The last series of logotypes have style characteristics appropriate for two American Indian tribes. Careful study of tribal artwork, textiles, and pottery suggests these characteristics and makes selecting suitable typefaces relatively easy. Research is a sometimes overlooked precursor to good design. Designing without research is comparable to mountain climbing without ropes—it will be slow going and without success.

The Navajo logotype (fig. 9-12) develops from the typeface Latin Wide, a heavy, extended typeface with wedge serifs. The wedge serifs are ideally suited to the triangular design characteristics of Navajo rugs. The original idea (fig. 9-13) is similar to the final iteration, but with one fundamental difference—the Navajo style elements are placed *between*

Original Latin Wide typeface

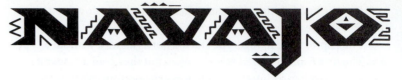

FIGURE 9-13: *Original Navajo logotype*

the letters, rather than incorporated *into* the letters. Reading the first logotype is possible only after seeing through the adornments. In the final iteration, the stylistic elements are decreased, simplified, and incorporated into the letters. The resulting logotype is more readable and more powerful.

ANASAZI

Original Avant Garde typeface

FIGURE 9-14: *Anasazi logotype*

The Anasazi logotype (fig. 9-14) evolves directly from research. Only the basic structure of the typeface, Lubalin's Avant Garde, is used for consistent stroke widths and letter proportions. Tribe style characteristics are manifest in strokes of four hand-drawn parallel lines, two lines of roughly drawn circles, and a freehand outlining of the entire logotype. The restructured *A*s are similar to the alternate *A* in the typeface with the addition of a curved bar. The letter *S* is restructured to function as the centerpiece of this symmetrical design.

The final Anasazi logotype is a successful evolution of a credible initial idea. Many poor designs are actually credible ideas that are halted too soon. A good designer knows when to keep going, when to put it on the back burner to simmer, and when to start again. Every idea follows a unique design path.

Design evolution (top to bottom)

DESIGNING
TITLES, PHRASES,
AND QUOTES

DESIGNING LONG TYPOGRAPHS, such as titles, phrases, or quotes, relies on the type artist's accumulated typographic knowledge and experience. Typefaces, type families, alternate characters, graphic letters, type weights, and type sizes are the tools on the typographic toolbelt. With

these, the type artist leads the reader through the words and sets the proper pace, much like a poet controls the tempo of a verse.

The typograph for the title *The Little Engine That Could* (fig. 9-15) uses URW Egyptienne, an extended slab serif typeface with a variety of similar weights and widths. The viewer is attracted first to the left side of the typograph by the large engine graphic in the word *Engine* and the smoke created by the curved word *THE*. This starts the visual movement through the title. The engine-smoke graphic is balanced by the horizontal bar extending through the letters *g, i, n,* and *e,* which is reminiscent of the linked wheels of vintage train engines. Without this balancing element, the design is optically heavy on the left side.

The Little Engine That Could

Original Egyptienne typeface

FIGURE 9-15: *Little Engine title typograph*

The Sky quote (fig. 9-16) is set in Caflisch Script, a one-axis (weight) multiple master typeface. Control of weights, use of large caps, and selective placement of alternate characters aids visual movement through the quote while controlling its pacing.

The sky is that beautiful old parchment in which the sun and the moon keep their diary

Original Caflisch Script typeface

FIGURE 9-16: *Placement and size pace quote by Kreymborg*

the heart of the fool is in his mouth but the mouth of the wise man is in his heart

FIGURE 9-17: *Poetica's myriad alternate letters provide flair for a quote by Franklin*

Oh a dainty plant is the ivy green that creepth o'er ruins old!

Original Ex Ponto typeface

Typefaces with alternate endings and beginnings, such as Adobe's Ex Ponto or Poetica, give the type artist even more options for crafting long typographs. By using the type designer's letters, the style of the typeface is maintained while still giving the type artist freedom of expression (fig. 9-17). Integrating a style-consistent graphic (fig. 9-18) or a single redesigned letter (fig. 9-19) into the typograph is another option for the type artist who wants a unique typograph without redesigning an entire alphabet for the occasion.

FIGURE 9-18: *Calligraphic beauty of Ex Ponto creates elegant typograph for a quote by Dickens*

CHAPTER NINE

* *⸲ Early
to bed ⸲⸲ Early
to rise
Makes a man
healthy
wealthy
& wise

FIGURE 9-19: *Ampersands as contributing graphics*

Effective use of alternative characters as well as all the other available type tools is a mark of typographic quality in typographic art. An eye for detail is a hallmark of high-quality typography and is appreciated by those familiar with it. Each of these options is challenging and fun, but requires a knowledge of typography and typefaces that can push the limits of the letterforms without diminishing the letter's role in the word or statement.

MANY TYPE ENTHUSIASTS EVENTUALLY entertain the idea of designing a typeface. Some type artists develop their graphic words into full-fledged graphic alphabets (fig. 9-21). In this chapter, a distinction is made between an original typeface and a graphic alphabet. A typeface is designed for setting words into type, is professionally hinted for accurate letterspacing, is either *unicameral* (a typeface with one letter case, such as a cap-only typeface) or *bicameral* (a typeface with two different cases, usually upper- and lowercase), contains punctuation marks and figures, and is contained within a font file—available with keystrokes. Its style or graphic component does not dominate its appearance because readability is the primary goal. A graphic alphabet restructures the familiar 26 letters according to a dominant graphic style or subject, such as cats. Sometimes graphic alphabets are limited to the capital letters, ignoring completely the lowercase letters, figures, and punctuation

*Early to bed & early to rise
Makes a man healthy,
wealthy, & wise.*

Original Caflisch Script typeface

DESIGNING
GRAPHIC ALPHABETS

marks. Other graphic alphabet designers create all font characters and produce alternate characters (fig. 9-20).

FIGURE 9-20: *Alternates for cap* G *and lowercase* f, g, *and* q

For graphic alphabet designers, the fun is twisting, restructuring, and reproportioning an existing object into recognizable letters. These alphabets are viewed as graphics and typically are not placed into a font format to be accessed from a keyboard. Their application is limited, such as to a single letter or word, because more would be difficult to read. Many view graphic alphabets as pieces of art and frame them for display. It is a true form of typographic art that is time intensive, but very satisfying when complete—the personal culmination of years of appreciating the typeface designs of others.

❧

THE PURSUIT OF LETTERS from the scribe's calligraphy to Gutenberg's invention to phototypography to today's digital typography has intrigued typographers, typesetters, and designers for centuries. Communicating with type for most is a simple, straightforward task—one that does not go beyond proper use of language, punctuation, and syntax. For a typographer, communicating with type is so much more. It is a form of graphic expression that improves and therefore clarifies the message. Manipulating type and integrating type and graphics are avenues of typographic exploration that continue to intrigue typographers. Type is not only the conveyor of the message, but a contributor to it as well. For some documents, the type delivers the message smoothly with invisible ease. In other documents, it is expressive and delivers the words with pizzazz and aplomb—invisible it is not. No matter which technology is used to set type in the future, type artists will continue to find new ways to design and influence this powerful, exciting communication language.

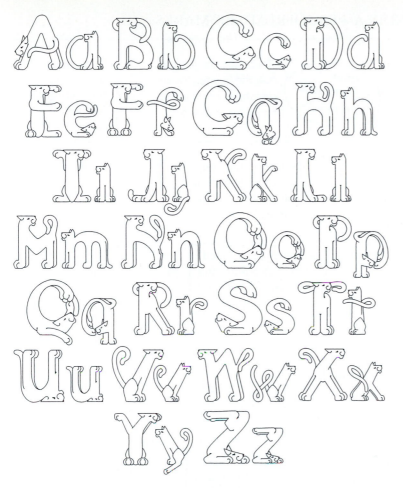

FIGURE 9-21: *Schuster graphic alphabet*
(designed by S. G. Wheeler in 1999)

▶ PARAGRAPH-WIDE PROOFMARKS	*set in Times Regular 11\|15 × 25* (circled)	The brown dog jumped over the lazy red fox and sent the entire chicken house into a frenzy.	Set text block in specified typeface, size, leading, and measure
▶ PARAGRAPH-ALIGNMENT PROOFMARKS	*fl*	The brown dog jumped over the lazy red fox and sent the entire chicken house into a frenzy.	Flush left
	fr	The brown dog jumped over the lazy red fox and sent the entire chicken house into a frenzy.	Flush right
	justify	The brown dog jumped over the lazy red fox and sent the entire chicken house into a frenzy.	Justify
	ctr	The brown dog jumped over the lazy red fox and sent the entire chicken house into a frenzy.	Center
	align	The brown dog jumped over the lazy red fox and	Align text
▶ LINE-PLACEMENT PROOFMARKS	[The brown dog jumped over the lazy red fox and	Move left to location indicated
]	The brown dog jumped over the lazy red fox and	Move right to location indicated

eq # > Humpty Dumpty sat on a wall, Humpty Dumpty had a great fall. All of the King's horses and All the King's men,	Equal leading for all lines	
Humpty Dumpty sat on a wall, Humpty Dumpty had a great fall. *reduce #* > All of the King's horses and…	Reduce leading (general)	
add 2 pts > Humpty Dumpty sat on a wall, Humpty Dumpty had a great fall. All of the King's horses and…	Add leading (specific)	
ld in > Humpty Dumpty sat on a wall, Humpty Dumpty had a great fall. All of the King's horses and…	Add leading (general)	
Humpty Dumpty sat on a wall, Humpty Dumpty had a great fall. ϑ# > All of the King's horses and…	Delete line space	

ϑ After awaking late, the White Rab- bit rushed to dress.	Delete line-end hyphen and close up word	
although the dic- tionary set thumb- nails on edge; ther- mometers were dis- turbed and simple.	*break up*	Too many consecutive hyphens
The newly hired ~~typ-~~ *ty-pog-ra-pher* ~~ographer~~ needed help.	Bad break (shows alternatives)	

▶ INDENTION PROOFMARKS	☐ The brown dog jumped over the lazy red fox and	Indent 1 em
	◣ The brown dog jumped over the lazy red fox and	Indent 1 en
	☐◣ The brown dog jumped over the lazy red fox and	Indent 1½ em
	[2] The brown dog jumped over the lazy red fox and	Indent 2 ems
▶ LINE-MANIPULATION PROOFMARKS	*break up* The fox (for the one) day; the dog (for the one) bone dinner and the entire	Fix knothole
	widow The brown dog jumped over the lazy red fox and sent the entire chicken house into a fren-zy.	Fix widow
	break The brown dog jumped over the lazy red fox and⌐sent the entire chicken	Take down to next line
	move up The brown dog jumped over the lazy red fox and⌐sent the entire chicken	Take back to previous line
	¶ "I am late!" "No, you are not!"	New paragraph
	(no ¶) house into a frenzy. Later that day the farmer	Run in
	(run in) The brown dog jumped over the lazy red	Run in

bf	The premiere Parisian proofreader	Set in boldface
ital	was not persuaded that	Set in italic
rom	the Peruvian's *predominance*	Set roman
bf + ital	as a precise proofreader was	Set in bold italic
lc	properly and Positively proven	Set in lowercase
lc	to the PERUVIAN's peers.	Set all in lowercase
caps	The end (probably)	Set all in caps
sc	p.s. The probe was not perfunctory.	Set in small caps
P.P.S.	And perfectly practical!	Insert small caps
caps titling	The END! (positively)	Set in titling caps
J	(ust in time!)	Insert cap (uncertain)
D	(efinitely!)	Insert cap (obvious)

out, see copy	Mary had a little lamb, the lamb was sure to go.	Large omission of copy
N (?)	The mid-fourteenth century is …	Query to check later
fix spacing	Mary had a little lamb its fleece was white as snow, and every where that Mary went, the lamb was sure to go.	White rivers in text
score	*Newsweek* arrives at my house on Tuesday.	Delete underscore (or underline)
align	ad a little every where t leece was Mary went, th	Align baselines of adjacent type blocks

▶ Letterspacing and Word Spacing Proofmarks	*kern* Peruvian Proofreader	Kern letters (close)
	ls **Achieves Profitability!**	Add letterspacing
	eq #// The ✓perfect ✓Peruvian proofreader	Use equal word space
	# parlayed his perfectionist perusals	Insert word space
	less # and his‿penchant for	Reduce word space
	‿ pencil pushing in‿to a practical	Close up word space
	hr # and (profitable) profession.	Insert hair space
▶ Deletion, Relocation, Insertion, and Substitution Proofmarks	*the* In‿morning, the dog	Insert word(s)
	cat watched the ~~dog~~ and	Substitute word(s)
	ℛ the cat watched the ~~the~~ bird.	Delete word
	stet In the ~~afternoon~~,	Let it stand
	h t̸e dog slept and	Insert letter
	ℛ the cat sle̸pt. The bird	Delete letter and close up
	wf (did) lizard impressions.	Set in correct font
	al‿ Things are not‿ways	Add to beginning of word
	‿*y* what the‿seem.	Add to end of word
	tr (End / The)	Transpose lines
	tr (from Quoted)	Transpose words
	lc/// *Pet /And Pal Post /For Pets /And Pals*	Set in lowercase three times
	ℛ (used with̸ permission)	Delete letter

Apostrophe	ᵛ'	ᵛ'	Quote, closed single
Brace, open	{ *(brace)*	;/	Semicolon
Brace, closed	} *(brace)*	/*(solidus)*	Solidus
Bullet	• *(bullet)*	⌤ *(sq bracket)*	Square bracket, open
Colon	:/	⌐ *(sq bracket)*	Square bracket, closed
Comma	∧,	/*(virgule)*	Virgule
Dash, em	M̲		
Dash, en	N̲		
Dash, figure	—/*(figure)*		
Dash, threequartersem	3/4M̲		
Ellipsis	⟨•••⟩		
Exclamation point	! *(set)*		
Hyphen	=/		
Midpoint	⊙ *(midpoint)*		
Parenthesis, open	€		
Parenthesis, closed	⋺		
Period	⊙		
Prime	∨' *(prime)*		
Prime, double	∨'' *(dbl prime)*		
Question mark	? *(set)*		
Quotes, open double	∨''		
Quotes, closed double	∨''		
Quote, open single	∨'		

PUNCTUATION ◀
MARGIN PROOFMARKS
(*Use with standard insertion
or substitution text marks.*)

▶ NUMBER PROOFMARKS

lc	John Baskerville (1706–75)	Set as text figures
1706 *(text fig)*	John Baskerville (born∧	Insert text figures
caps	BASKERVILLE (1706–75)	Set as titling figures
1706	BASKERVILLE BORN∧	Insert titling figures
sp	An 18th century …	Spell out
\vee^2	The first answer: 14∨	Insert superscript
\vee^2	The first answer: 14\vee	Make superscript
\wedge_2	The answer is CO∣	Insert subscript
\wedge_2	The answer is CO\wedge	Make subscript
⅓ *(case fraction)*	Take 1/3 cup of butter,…	Substitute case fraction

▶ SYMBOL AND LIGATURE PROOFMARKS

& *(ampersand)*	Deberny and Peignot	Substitute ampersand
¢	75∧SALE	Insert cent sign
¢	75∧SALE	Insert old style cent
✹ *(starburst)*	✹ 75¢ SALE ∣	Substitute dingbat
Æ	Aelfric, or Grammaticus,…	Create A-E diphthong
$	∧.75 SALE	Insert dollar sign
$	∧.75 SALE	Insert old style dollar
fi	The first-place winner …	Create f-i ligature
f i	first place	Set as separate letters
❧ *(fleuron)*	∧The End ❧	Insert ornament
%	25∧SALE	Insert percent sign
sp	the 25% revenues …	Spell out

BOOKS AND MAGAZINES ◄

U&lc Online
www.itcfonts.com/itc/ulc/index.html
International Typeface Corporation's typography journal. Magazine archives for articles on typographical issues and typographers with links to related sites specific to each article. A must see for type history information.

Type Books: For The Well-Read Typographer
www.typebooks.org
Extensive collection of typography books and periodicals linked to other significant sites. Includes author interviews.

Adobe Magazine's Online Archive
www.adobe.com/products/adobemag/pastissues.html
Downloadable PDF files of articles concerning typography issues and Adobe products.

Internet Type Foundry Index
www.typeindex.com
Online magazine containing a rich collection of typographic links in multiple categories.

FontZone
ww2.fontzone.com/zine
News, features, events, and reviews relating to typography.

FOUNDRIES AND RESELLERS ◄

Adobe Type Collection Browser
www.adobe.com/type
Browse the Adobe typeface collection alphabetically or by classification. Full character viewing with excellent explanation of each typeface's history and development.

ITC Typeface Collection Browser
www.itcfonts.com/itc/fonts/index.html
The ITC browser FontsNow! for viewing the collection, previewing typefaces, and making purchases. Excellent site.

EyeWire Type Viewer
www.eyewire.com/type/viewer
View a specific word or phrase in a chosen typeface from several manufacturer's collections. View sizes up to 72 points.

Publish **Magazine's Directory of Type Foundries**
www.publish.com/directories
Publish magazine, online magazine for electronic publishing professionals, directory of over 100 type foundries and their corresponding links.

Scriptorium Fonts and Art
www.ragnarokpress.com/scriptorium
Ragnarok Press source of fonts and art with links to their *Scriptorium* magazine.

▶ HISTORY

Graphion's Online Type Museum
www.slip.net/~graphion/museum.html
Information on the history and practice of typesetting sponsored by Graphion Typesetting and Systems. Information on famous typographers with examples, an excerpt from Beatrice Warde's Crystal Goblet speech to the British Typographer's Guild, and extensive history of phototypesetting.

Fabius Library, Graphic Arts & Technology
webcom.net/~nfhome/library1.htm
Information and examples concerning typographic history (typographers, point system, printing, Canadian type design history) and typographic design examples.

▶ MUSEUMS AND COLLECTIONS

Goudy International Center for Font Technology and Aesthetics
www.rit.edu/~goudyctr/goudycenter.html
Sponsored by the Rochester Institute of Technology, includes typographic links and information about Frederic Goudy. Site maintains a database of typeface names for determining if a proposed name is currently in use.

Cary Collection: Graphic Arts Library/Digital Image Database
wally2.rit.edu/cary
Sponsored by the Rochester Institute of Technology, includes information regarding famous historic typographers, examples, typecasting methods, and bookmaking technology. Links to the *Journal of American Printing History Association.*

Herb Lubalin Study Center of Design and Typography
www.cooper.edu/art/lubalin
Links to its collection listings (Herb Lubalin Collection, Lou Dorfsman Collection, Poster Collection, and private papers), exhibitions, and the National Graphic Design Image Database.

National Graphic Design Image Database at the Cooper Union
www.ngda.cooper.edu/index.html
Examples of a wide range of graphic design and typographic work. Twenty percent of the collection is visible to all. Registered educators may view entire collection.

Microsoft Typography
www.microsoft.com/typography
Links to other type sites and type foundries.

TypeArt Foundry Incorporated
www.typeart.com
An information-packed site from Vancouver, British Columbia, Canada, includes several chapters of Frederick W. Goudy's *Typologia: Studies in Type Design and Type Making,* typesetter and type-design tips, and keystrokes for Mac and PC font characters.

&Type!
www.graphic-design.com/Type
Part of the Design and Publishing Center, includes book reviews, type articles, and interviews with type professionals.

Communication Arts Magazine
www.commarts.com
Archived articles on graphic design–related issues.

▶ ORGANIZATIONS	**TypeRight** *www.typeright.org* Organization of professionals working to "promote typefaces as creative works and to advocate their legal protection as intellectual property." **Type Directors Club** *www.tdc.org* **Association Typographique International (ATypI)** *www.atypi.org* International typographic organization for type and typography founded in 1957.
▶ TECHNOLOGIES AND FORMATS	**TrueType Technology** *www.truetype.demon.co.uk* Extensive TrueType format information. TYPE*links contains links to a variety of typographic web sites, such as foundries, periodicals, and societies. **Type-High: The Site for Wood Type** *www.type-high.com* Information, examples, book listings, and resources (museums, collections, suppliers) related to wood type.
▶ TYPOGRAPHIC DESIGN	**WordPlay** *design.coda.drexel.edu/faculty/johnlangdon/wordplay.html* Innovative typographic design examples by a Drexel University faculty member. **Ideabook** *www.ideabook.com* Design and marketing idea examples in multiple design categories.

Alphabet A set of letters or other characters (arranged in a customary order) with which one or more languages are written.

Alternate characters Design variations of letterforms included in a typeface family to provide typographic design options.

Ampersand A character used to symbolize the word *and*; ligature formed by the union of the lowercase letters *e* and *t*.

Ampersand

Angle bracket A type of bracket, commonly found in pi fonts, used to separate text.

Aperture The amount of space between two points in a letter forming an opening into an interior portion of a letterform.

Apex Section of the top of a letter where two straight strokes or stems join and create an angle.

Arm A horizontal or upward diagonal stroke that is attached to the letter on one end and unattached on the other.

Ascender A portion of a stroke in a lowercase letter that extends beyond the mean line.

Ascent The vertical distance from the baseline to the top of the highest character in a type font.

Back margin The inside margin of a spread; also called *gutter margin*.

Backslant A typeface that slants or leans to the left as it rests on the baseline.

Bar A horizontal stroke that connects two strokes.

Baseline The imaginary horizontal line upon which all typeset letters appear to stand or rest.

Bicameral A typeface with two different cases, usually upper- and lowercase.

Bitmapped font Digital letterforms created by groups of dots (with an on-screen density of 72-dpi—dots per inch) arranged on a grid with *x,y* coordinates; also called *screen font*.

Black letter Heavy, condensed gothic letterforms used by Gutenberg and other typographers in his time period.

Block quote A quote in running text that exceeds four lines and is set as a separate text block.

Bowl A curved stroke that creates an enclosed space within a letter.

Brace One of a pair of marks used to enclose text; also used in mathematical equations.

Braces

Bracket A curved or sloping shape that smoothly joins a serif to a

Brackets

215

Bullet — • —

Caret — ∧ —

Case fraction — ½ —

Diacritics _ é ü _

Dingbats _ ✔ ☛ _

Diphthongs _ æ Æ _

stroke or stem; also called *fillet;* one of a pair of marks used to enclose text identifying it as a single unit.

Bullet A large dot included in a typeface used to separate text or identify items on a list.

Cap height The vertical distance from the baseline to the cap line.

Cap line The imaginary horizontal line that denotes the top of the uppercase, or capital, letter *X.* Indicates the tops of the capital letters, although curved uppercase letters, such as the *o* and *c,* will extend beyond it slightly.

Caret An upside-down–V-shaped proofreaders' mark used to identify the location of additional text or space; from the Latin, meaning *it is missing.*

Cardinal number Number that represents a quantity.

Case fraction A fraction drawn as a single character in a typeface that maintains typographic quality within the text block.

Character window The amount of horizontal space allocated on the page for a particular letter; the side bearings plus the set width of a letter.

Chase A large type tray for holding a page of foundry type sorts.

Composing stick A typesetter's shallow hand-held, adjustable-width metal tray for holding several lines of foundry type sorts during typesetting.

Contoured wrap An organic shape set into a block of text.

Copy Typewritten or handwritten material to be typeset.

Copyfitting Process to determine how much space a block of typeset type will occupy on a page.

Counter The fully or partially enclosed negative space within or adjacent to a letterform.

Crossbar A horizontal stroke that crosses another stroke.

Dead copy The last edited version of a document.

Descender A portion of a stroke (not limited to lowercase letters) that extends below the baseline.

Descent The vertical distance from the baseline to the bottommost point in a type font.

Diacritic An accent mark or symbol that accompanies a letter to indicate its particular phonetic value.

Dingbat Small informal keystroke graphic.

Diphthong A single, joined character made from two vowels to indicate a particular sound.

Display capital Capital letter designed and drawn separately to

emphasize subtle design details for use as display type or initial letters.

Display type Type set in 14-points or larger, used for headlines, titles, and similar attention-getting situations.

Double prime Linear unit-of-measure symbol for inches.

Double prime

Doubling The rereading of the same line in a type block due to poor typographic quality.

Drop cap An initial letter embedded within the first few lines of text; also called *cut-in letter*.

Ear The short protrusion from the top of the lowercase *g* (and *p*). Also applied to the arm of the lowercase *r*, depending upon the typeface.

Ellipsis A sequence of three periods, set as a single character, that indicates the omission of a word or words from quoted material or the trailing off of a thought.

Ellipsis

Em Unit of measure equal to the size of the typeface.

Em quad In foundry type, a spacing sort whose width and height is an em; also called *mutton*.

En Unit of measure equal to half the size of the typeface.

En quad In foundry type, a spacing sort whose width is an en and whose height is an em; also called *nut*.

Ending Design treatment used to define the beginning and ending of a stroke.

Eszett An *s-s* ligature used when typesetting the German language; formerly used in English-language typesetting.

ß
Eszett

Eye The enclosed counter in the upper portion of the lowercase *e*.

Fake small cap An uppercase letter scaled to the type's *x*-height; displays a thinner stroke weight than surrounding letter strokes.

Finial The tapering end of a stroke.

Fleuron Floral (or leaf-shaped) type ornaments. They could be used to indicate the end of a section within a lengthy document, such as a book chapter.

Fleuron

Font All the letters, numbers, and punctuation marks of one size of one specific typeface, for example, 12-point Minion Semibold.

Foot margin Margin at the bottom of a page.

Foot The bottom of a letter.

Fore-edge margin Right and left margins of a spread.

Formal text Text written for presentation to a wide audience, such as a book and magazine.

Foundry type Pieces of hard, durable metal type used to set pages of type; primary means of setting type from 1454 through 1890.

Fraction bar See *solidus*.

Galley A slanted tray for holding a single column of Linotype slugs, similar to a foundry type chase.

Graphemes The letters of the alphabet.

Graphic alphabet A dominant graphic style or subject restructured to serve as letters of the alphabet. May possibly include only the uppercase letters or all the letter cases plus punctuation marks and numbers.

Grotesque Term originally used to describe a sans serif typeface; also referred to as *grot* (England), *grotesk* (Germany), and *gothic* (United States).

Gutter margin The back margin on a page within a spread.

Gutter The white space between columns on a page.

Hair space A space the size of $\frac{1}{12}$ em, approximately.

Hairline An extremely thin line used as a stroke or a serif.

Hanging indent Starting the first line of a paragraph at the margin and indenting left the remainder of the lines.

Head margin Margin at the top of a page.

Head The top of a letter.

Hints Special instructions programmed into the font file that maintains the quality of a typeface's typographic features for point size and printer resolution. Hints include information concerning character alignment, curves and strokes, and other visual subtleties in a typeface design.

Humanist text Literary text written for continuous reading concerning broad cultural learning or human experiences.

Inferior figures Figures of consistent height, smaller than the font's x-height, positioned on the baseline for use as the demoninator of a piece fraction; used as subscript, when positioned below baseline.

Informal text Text written for limited distribution, such as a memo.

Initial letter An enlarged, first letter of the first word in the first sentence of a chapter or book section. Some are graphic letters or ornately illustrated letters; also called *versals*.

Italic — *f* —

Italic A letterform that is structurally redesigned from its roman original to slant to the right at varying angles as it rests on the baseline.

Kern [*n*] The portion of a letter that extends beyond its foundry type body; [*v*] to incrementally delete or add space between letters or words to improve typographic texture.

Kerning Optically adjusting the letterspacing between two letters; the individual adjustment of spacing between two letters or letter pair.

Leading Vertical space between lines within and between paragraphs measured from baseline to baseline; in foundry type, the white space between lines of type created by the placement of thin strips of lead (measured in points) between lines of metal sorts.

Leg The tail of the uppercase and lowercase *K*.

Legibility The reader's ability to correctly identify individual letters.

Letterspacing Horizontal space between letters in a word or a line.

Level fraction A fraction constructed by the type artist from titling figures and a virgule.

_ 1/2 _ Level fraction

Ligature A single character (and a single sort) created from the physical union or the designed alteration of two or three separate letters to improve typographic quality.

— **ffi** — Ligature

Line skipping Reading the first half of a sentence with the second half of another.

Line spacing Vertical space between lines within and between paragraphs.

Link Short stroke that joins the bowl of the lowercase *g* to its loop.

Live copy The latest version of a document.

Logotype A single word or words designed to be a cohesive, readable visual whole that usually functions as a graphic identity for a product, company, or service.

Loop The elliptical stroke at the bottom of the lowercase *g*.

Magazine Compartment of matrices in a Linotype linecaster.

Majuscules Uppercase letters in a typeface; also called *capital letters*.

Margin The white space surrounding all items that print on a page.

Mat A light weight, reusable letter matrix used in a Linotype linecaster.

Mean line The imaginary horizontal line that denotes the top of the lowercase letter *x*.

Measure The width of a paragraph; also called *line length*.

Middle space A space the size of ¼ em.

Midpoint A small dot used to separate text or identify items on a list. It is smaller and sits closer to the baseline than the larger bullet.

— • — Midpoint

Minuscules Lowercase letters in a typeface.

Mutton See *em quad*.

Nut See *en quad*.

Oblique A roman typeface that slants or leans to the right as it rests on the baseline; also referred to as *machine italic*.

Optical letterspacing Visually balancing space shapes around and within letters in a single word or group of words.

Ordinal number Number that represents an ordering or ranking.

Ornament Typographic symbol or flourish designed to accompany a specific typeface.

Orphan The first line of a paragraph positioned at the end of a page or column.

Outline font Digital letterforms defined as objects using a mathematical formula containing point locations and shaped, connecting line segments; also called *printer font* or *scalable font*.

Page Term applied to a single sheet document or one side of the leaf of a book.

Pi font A typeface consisting of special-usage characters, such as mathematical symbols.

Pica Unit of measure used to measure the depth and measure of a type block; one pica equals 12 points; six picas equal one inch.

Piece fraction A fraction constructed by the type artist from true-cut superior and inferior figures and a solidus.

Pilcrow A symbol used to identify the beginning of a new paragraph; also called *paragraph mark.*

Point Unit of measure used to identify typeface size, indents, and leading. In digital typography, one point is $1/72$ of an inch.

Point size The vertical distance from the bottommost point in the type font to the topmost point in the type font. The point size is the sum of the ascent and the descent.

PostScript A page-description computer language developed by Adobe Systems, Inc., in the early 1980s.

Prime Linear unit-of-measure symbol for feet.

Printer font See *outline font.*

Proof Copy of foundry type made on a proofing press by running an inked roller across the face of the type; a printout of an in-progress digital document.

Proofmarks See *proofreaders' marks.*

Proofreaders' marks Standardized marks used in pairs (one in text, one in margin) by type artists for communicating typographic instructions or changes on typeset copy; also called *proofmarks.*

Pull quote Several lines of text used to break up large quantities of continuous text; also called a *quote-out, breaker,* or *grabber.*

Raised cap An initial letter that shares the same baseline with the first

sentence in the paragraph, causing the letter to tower above the first sentence; also called *stick-up letter.*

Readability The reader's ability to identify and comprehend words, sentences, and paragraphs easily.

Recto The front side of a page or the right page of a spread.

Roman A typeface style whose letterforms are at right angles to the baseline; the open, round letterform structure of the English alphabet based on the 23-letter Roman alphabet.

Runaround A rectangular shape set into a block of text.

Run-in sidebar The lowest-level subhead.

Saccades Small horizontal jumps a reader's eye makes along a line of type while reading. Encompassing approximately 12 characters (letters and spaces).

Sans serif A typeface whose strokes end bluntly, without a decorative finishing treatment, such as a serif.

Scalable font See *outline font.*

Screen font See *bitmapped font.*

Script A typeface that imitates cursive handwriting.

Serif A cross, or finishing, stroke at the beginning or end of the major strokes of a letterform. Some serifs are described by their shape, such as *bracketed, cupped, hairline, slab,* and *wedge.*

Set solid Type set without any white space between type lines.

Set width The width of an actual typeface letter; also called *set.*

Shoulder The curved portion of a stroke that does not create an enclosed space within the letter.

Side bearing The amount of white space on the left and right side of a letter determined by the type designer.

Sink The white space from the top edge of the type page to the topmost ascender of the nearest type block; also called *sinkage.*

Slash See *virgule.*

Slug A single sort containing all the characters and spaces for a single line of type set on a Linotype linecaster.

Small caps Capital letters that are redesigned and recut to the approximate size of the typeface's *x*-height; also called *true cut.*

Solidus A right-leaning diagonal line used to create piece fractions; angles farther to the right than a virgule.

Sort A single piece of metal foundry type.

Space The negative, nonprinting area in and around a letterform.

Spaceband The amount of space (approximately ¼ em) between letters

_ / / _ Slash and solidus

after a single press of the spacebar; size is determined for the typeface by the type designer.

Spine The main curved stroke in the uppercase and lowercase *S*.

Spread Two adjacent verso and recto pages of a book.

Spur Small downward extension on some styles of an uppercase *G*.

Stem A major vertical stroke within a letter.

Stet Word used in proofreading indicating to leave the typeset word as it is; originated from the Latin *stare* (to stand).

Stress The thickened portion of a curved stroke that determines a direction (vertical, horizontal, or diagonal) in which the letterform appears to lean.

Stroke General category referring to the primary structural components that define the overall appearance of a letterform; any straight or curved line used to define a major structural portion of a letter.

Superior figures Figures of consistent height, smaller than the font's *x*-height, positioned to align along the top with the font's ascenders, for use as the numerator of a piece fraction and superscript for exponents and footnotes.

Swash *A*

Swash An extended or decorative flourish that replaces a serif or terminal on a letter.

Tail A downward diagonal stroke attached to the letter on one end and unattached on the other.

Technical text Scientific text; text written for discontinuous reading due to the complexity of its content.

Terminal f

Terminal Stroke-end treatments, such as tapering or adding a shape, that are not serifs.

Text figures 4567

Text figures Figures positioned primarily in the font's *x*-height with ascenders and descenders for use with text type; also called *lowercase, old style, nonranging,* or *hanging figures.*

Text page An area within the type page that contains the primary text area.

Text type Type set below 14-point, suited for type in advertisements, books, newsletters, and other continuous-reading situations.

Thick space A space the size of ⅓ em.

Thin space A space the size of ⅕ or ⅙ em.

Tied letter See *ligature.*

Titling capital A unicameral typeface of capital letters drawn to the full height of the type size; not meant for use with lowercase letters.

Titling figures Figures of consistent height usually confined to the font's cap height for use with display type and in tabulated material; also called *aligning, lining, modern, ranging,* or *capital figures.*

Tracking Uniformly increasing or decreasing the amount of letterspacing within a group of letters, such as a word, headline, or paragraph.

Trim The finished edge of a printed document or page.

TrueImage A page-description computer language created by Microsoft.

Type alignment The positioning of type lines within a type block or paragraph.

Type block A shaped area of display or text type.

Type case A shallow drawer for storing a single font of foundry type.

Type family All stylistic variations of a single typeface, such as light, medium, bold, extra bold, and italic.

Type page The area of a page, usually rectangular, that includes all items that print.

Typeface The distinctive, visually unifying design of an alphabet and its accompanying punctuation marks and numbers. It includes all point sizes of that typeface.

Typograph The art of designing a graphic by using and manipulating typeset letters and words.

Unicameral A typeface with one letter case, such as an uppercase-only typeface.

Versal See *initial letter.*

Verso The backside of a page or the left page of a spread.

Vertex Section of the bottom of a letter where two straight strokes or stems join and create an angle.

Virgule A right-leaning diagonal line used to separate alternate words, such as *and/or;* also called *slash.*

_ / _ Virgule

Widow The last line of a paragraph positioned at the top of the next page or column; a short word (less than four letters) or the tail end of a hyphenated word as the last line of a paragraph.

Word spacing The distance between words on a line of type.

X-height The vertical distance from the baseline to the mean line.

SELECT BIBLIOGRAPHY

Brady, Philip. *Using Type Right.* Cincinnati, OH: Northlight Books, 1988.

Bringhurst, Robert. *The Elements of Typographic Style.* Vancouver, BC: Hartley & Marks, 1992.

Dowding, Geoffrey. *Finer Points in the Spacing and Arrangement of Type.* Vancouver, BC: Hartley & Marks, 1995.

Eason, Ron, and Sarah Rookledge. *Rookledge's International Handbook of Type Designers: A Biographical Directory.* Surrey, England: Sarema Press, 1991.

Eckersley, Richard, and others. *Glossary of Typesetting Terms.* Chicago: The University of Chicago Press, 1994.

Firmage, Richard A. *The Alphabet Abecedarium.* Boston: David R. Godine, 1993.

Gill, Eric. *An Essay of Typography.* U.S. ed. Boston: David R. Godine, 1993.

Glaser, Milton. *Milton Glaser Graphic Design.* Woodstock, NY: The Overlook Press, 1983.

Gottschall, Edward M. *Typographic Communications Today.* Cambridge, MA: The MIT Press, 1989.

Goudy, Frederic W. *The Alphabet and Elements of Lettering.* Rev. ed. New York: Dorset Press, 1989.

Haley, Allan. "Bullets, Boxes and Dingbats," *Upper and Lower Case* 16, no. 2 (Spring 1989), 16–7.

———. "Parts of a Character," *Upper and Lower Case* 11, no. 4 (February 1985), 20–1.

———. "Serif vs Sans," *Upper and Lower Case* 12, no. 1 (May 1985), 28–9.

———. *Typographic Milestones.* New York: Van Nostrand Reinhold, 1992.

———. "'&perseand," *X-height* 3, no. 2 (1994), 5.

Lawson, Alexander S. *Printing Types.* Rev. ed. Boston: Beacon Press, 1990.

———. *Anatomy of a Typeface.* Boston: David R. Godine, 1990.

McLean, Ruari. *The Thames and Hudson Manual of Typography.* New York: Thames and Hudson, 1980.

———. *Typographers on Type.* New York: W. W. Norton & Co., 1995.

Muller, Marion. "Prof File: Herb Lubalin," *Upper and Lower Case* 8, no. 1 (March 1981), 4–5.

Parker, Roger C. *Looking Good in Print: A Guide to Basic Design for Desktop Publishing.* 3d ed. Chapel Hill, NC: Ventana Press, 1993.

Perfect, Christopher, and Jeremy Austen. *The Complete Typographer.* Englewood Cliffs, NJ: Prentice Hall, 1992.

Rand, Paul. *Design, Form, and Chaos.* New Haven, CT: Yale University Press, 1993.

Smith, Peggy. *Mark My Words: Instruction and Practice in Proofreading.* 2d ed. Alexandria, VA: EEI, 1993.

Snyder, Gertrude. *Herb Lubalin.* New York: American Showcase, 1985.

Soppeland, Mark. *Words.* Los Altos, CA: William Kaufmann, 1980.

Sumner, Stone. "Notes from Parma," *Upper and Lower Case* 21, no. 2 (Fall 1994), 8–14.

Swann, Cal. *Language & Typography.* New York: Van Nostrand Reinhold, 1991.

Tinkel, Kathleen. "Typographic 'Rules,'" *Aldus Magazine* 3, no. 3 (March/April 1992), 32–5.

Tschichold, Jan. *Treasury of Alphabets and Lettering.* New York: Design Press, 1992.

CFS R + D

H. B.
Clark

Generalization
and Maintenance

H.B. Clark

Generalization and Maintenance

Life-Style Changes
in Applied Settings

edited by

Robert H. Horner, Ph.D.
Division of Special Education
and Rehabilitation
University of Oregon
Eugene, Oregon

Glen Dunlap, Ph.D.
Autism Training Center
Marshall University
Huntington, West Virginia

and

Robert L. Koegel, Ph.D.
Speech and Hearing Center
University of California at Santa Barbara
Santa Barbara, California

·P A U L·H·
BROOKES
PUBLISHING CO.

Baltimore • London • Toronto • Sydney

Paul H. Brookes Publishing Co.
P.O. Box 10624
Baltimore, Maryland 21285-0624

Copyright © 1988 by Paul H. Brookes Publishing Co., Inc.
All rights reserved.

Typeset by Brushwood Graphics Inc., Baltimore, Maryland.
Manufactured in the United States of America by
The Maple Press Company, York, Pennsylvania.

Library of Congress Cataloging-in-Publication Data

Generalization and maintenance.

 Bibliography: p.
 Includes index.
 1. Developmentally disabled—United States—Life skills guides.
2. Developmentally disabled—Education—United States. 3. De-
velopmentally disabled—Deinstitutionalization—United States.
I. Horner, Robert H. II. Dunlap, Glen. III. Koegel, Robert L.,
1944–
HV1570.5.U65G46 1988 362.1'968 87-27857
ISBN 0-933716-91-5 (pbk.)